Wandering through Virginia's Vineyards

Wandering through Virginia's Vineyards

by Walker Elliott Rowe

apprentice
house

Baltimore, Maryland
www.apprenticehouse.com

Edited by Michael Hilt '05
Editorial Assisstants: Marion Goodworth '05,
Morgan Hillenbrand '05
Design by Kevin Atticks, DCD

Cover photo by Jennifer McCloud, titled:
"First Harvest Morning at Chrysalis Vineyards"

First printing 10 9 8 7 6 5 4 3 2 1

ISBN: 978-1-934074-04-6

apprentice
house

Baltimore, Maryland
www.apprenticehouse.com

apprentice
house

Apprentice House is a non-profit, student-run publisher originating in the book publishing course under Prof. Andrew Ciofalo in the Department of Communication at Loyola College In Maryland. The company is an activity of an advanced elective in our journalism concentration, Book Publishing. When the class is not in session the publishing activities are carried forward by a co-curricular organization, The Apprentice House Book Publishing Club, which pursues publishing activities through Resonant Publishing, whose principal, Dr. Kevin Atticks, is a member of the Communication faculty. Apprentice House is an imprint of Resonant Publishing.

Apprentice House is just one of many experiential learning opportunities available to Loyola students in all our Communication disciplines: journalism, advertising, public relations, digital media, radio and television, and writing. Students are responsible for manuscript selection, editing, author contact, permissions, pricing, production, design, marketing and publicity. Those who complete the course and other students interested in working for Apprentice House can register for a follow-up Practicum in Book Publishing under the direction of Dr. Atticks.

Board of Advisors
Kevin Atticks, Ned Balbo, Andrew Ciofalo
Jean Cole, Gregg Wilhelm

Student Editors (2004-05)

Jeffrey Bradley '05	Morgan Hillenbrand '05
Christine DeSanctis '05	Patricia McNamara '06
Elizabeth Didora '05	Kathleen Nagle '05
Michael Hilt '05	Kerri Reilly '05
Lauren Galvin '05	Erik Schmitz '07
Marion Goodworth '05	

Dedication

This book is dedicated to Philip Wagner and Dr. Konstantin Frank whose pioneering work made possible the cultivation of European and French and American hybrid wine grapes on the East Coast.

Contents

Foreword

Virginia is lucky to have Elliott Rowe wandering among the grapevines – chronicling its burgeoning wine industry. He brings to the reportage the earnest freshness of a seeker along with the imagery and language of a person well-grounded in the liberal arts.

Being a smart student, rather than an authority, Rowe does not become preachy or judgmental. Instead he writes his personal impressions with a breezy erudition that seems quirky at first but quickly draws one into the narrative.

As is appropriate for Virginians, Rowe is assuredly informed by history.

In response to the phylloxera epidemic in France, he writes: "Some French growers packed up their berets and wine thieves and headed for the nearby colony of Algiers. Good grapes were

grown there until teetotaling Muslims grew weary of French domination and kicked that government out of the nation."

Acknowledging the importance of state support for technical expertise and extension services, he posits, "Had Cato lived in modern Virginia instead of ancient Rome he might have turned to Virginia Tech for enological (winemaking) advice. For his salty and perhaps sour wine might have benefited from the technical advice that Virginia Tech provides free to bonded wineries in the state."

When I began planting grapes in Virginia over 30 years ago (a nanosecond in the timeline of wine), there were no estate wineries. In the 1970s, as we assisted in its slow birth, all of us in Virginia viniculture from Secretary of Agriculture Mason Carbaugh to small backyard growers knew each other very well. Today the escalation of vineyards and wineries in the state has increased the numbers of players to the point that the familial intimacy of the early years is impossible. Or is it?

In this book, Rowe's skills as a travel writer and an aficionado of people, takes one inside our world of grapes in a decidedly personal way. His commentary about working with the *campesinos* at Horton Vineyards is funny and insightful. When he writes about people I've known for 30 years and he has just met like winegrower Jim Law, I

can tell that his perceptions are on target.

Rowe is headed to Chile to perfect his Spanish and broaden his knowledge of wines and vines. While we can look forward to his accounts of that experience, we will welcome his return home. The ongoing development of truly local wines, those lovely liquid expressions of Virginia's multifaceted geography and climate, should not go for long without his ongoing narrative.

Lucie Morton, Broad Run, Virginia
December 2004

The Terroir

Terroir, a French word widely used by American winemakers, refers to the region and climate in which a grape is grown; basically, the soil and climate. The best wines are made from grapes that are suitable to the terroir where they are grown. Quite a few of the world's best wine grapes are well suited to the terroir found in Virginia.

It is inside a wide swath of green rolling meadows, mountains, and forests where most of Virginia's premium vineyards and wineries are located. Granted there are vineyards in every corner of the state, but the greatest number of wineries located in the state are found in the Virginia Piedmont area. This area includes the Monticello appellation and a larger area that has no officially recognized viticulture name.

The latter area in national wine competitions is simply referred to as "Virginia." Beyond the Piedmont – from the French *pied* or "foot" and *mont* or "mountain," translating to the "foot of the mountains" – there are excellent wineries further south in the region around Roanoke and east of Fredericksburg.

The various grape-growing regions of Virginia are called "appellations;" this is a French word that groups wineries by terroir. "Terroir," in terms of classifying appellations, refers to an area with similar soil and weather. Tossing aside the more pleasant word appellation, American bureaucrats at the Bureau of Alcohol, Tobacco, and Firearms have embraced the dry bureaucratic, albeit English, term "American Viticultural Area" (AVA). In Virginia there are currently six such AVAs: "Monticello," "North Fork of Roanoke," "Northern Neck George Washington Birthplace," "Rocky Knob," "Shenandoah Valley," and finally "Virginia's Eastern Shore." These names were created by grape farmers and wineries in those areas that petitioned the ATF for official recognition of their terroir, thus these groupings make sense from the point of view of terroir. Grapes at Linden Vineyards, located at 1,500-foot elevation in Fauquier County, could ripen three weeks later than those at 300-foot elevation at Horton Vineyards in Orange County, for example.

While this distance is not more than 100 miles, in terms of viticulture the climates are quite distinct. Similar climate and soils make for similar wines, so-say the French who first devised this system.

In France, some 100 or so years ago, wineries decided to band together to designate which vineyards were growing the best grapes and group them by terroir. The goal was to keep charlatans from mixing good wine with bad thus giving the whole region a bad name. The French, great lovers of grand bureaucracies, whose political elite graduate from the Grande Ecole D'Administration, codified this classification of vineyards into the legal construct known as the Appellation D'origin Côntrollée (AOC). Basically each of the six corners of the hexagon of France are divided into areas that by law can only be planted with certain grape varieties and at certain densities. Those areas outside of the most valued appellations still plant grapes and bottle wines, but those wines are sold as ordinary table wines and cannot carry the prestigious AOC regional names "Bordeaux," "Burgundy," or "Champagne."

Without the guidance of government, it was up to the Virginians themselves to decide what grapes grow best in which locations. Virginia has only been growing premium wine grapes since the 1970s, after all, whereas France and Italy have had two thousand years to carry grapes from the

corners of the Roman Empire, plant them into the chalky, alkaline soils of Champagne or the gravelly soils of Bordeaux and then sort through the resulting wine quality. For Virginia this ongoing debate still rages, however with the genteel civility commonly found in Virginia.

One tool that Virginia does have at its disposal to sort out this quandary: Virginia Tech, which recommends that grape growers do not plant, for example, Pinot Noir, Nebbiolo, nor Gewürztraminer grapes. However, all three of these grapes are still grown in Virginia. Other experts say do not plant Riesling at all, and if you plant Cabernet Sauvignon, do not plant it in deep clay soils. Yet, still, many wineries offer Riesling in their tasting rooms and certain vineyards plant Cabernet Sauvignon on deep clay soils. So, in sorting out this matter, whatever opinion or observation is put forth someone is going to be offended. Thus not everyone will agree with the following observations about what growers and wineries say are the grape varieties most suitable for Virginia and which varieties should not be planted here at all.

When one talks of wines from California, New York, or even Virginia it is natural to look to France. While Italian, Spanish, and Portuguese grapes are grown in Virginia and beyond, the French grapes are most familiar to wine drinkers,

and are most widely planted. Even much of the terminology used in winemaking is, indeed, French – the shapes of the bottles themselves are said to be "Chablis," "Champagne," or "Burgundy." Further, the barrels used by the wineries are classified as either "French" or "American." The difference indicates where the oak tree used to make the barrels was cut down. Thus, to understand Virginia viticulture it is necessary to look at the grape growing regions of France and the grapes grown there. Another piece to the puzzle of Virginia wine, it would seem.

The French refer to their country as a hexagon because it is, albeit roughly, six-sided. All roads lead to Paris, so say the French, and the areas outside of the capital are referred to, sometimes with a sniff of an aquiline nose, as the provinces. The people who live there are merely the "provincials" except of course for the winery and vineyard owners who live in their own rarefied air.

The top-most, right-hand corner of France is called Alsace; Salsburg, the capital of the European Parliament is located there. The grapes grown in Alsace include the fragrant Gewürztraminer white wine grape; this grape, smelling of perfume, turns pink as it ripens. Its name is the German word for "spicy" because it has a spicy flavor. The other grape grown in this region is the Riesling, which is similar to Gewürztraminer but has less of a

floral nose. The French make it dry, that is to say without residual sugar, while across the border in Moselle, the Germans prefer a little sweetness with their wine. In Germany the weather is cooler so the grapes there have more acid. To balance the acid in the wine the Germans leave a little sugar. On both sides of the border the grapes are grown on slopes that in some places approach a mind-boggling 60 degrees.

Gewürztraminer grapes are, as mentioned earlier, grown in Virginia. Their fragrance is such that they attracts hordes of yellow jackets when ripe. Gray Ghost winery, for example, buys Gewürztraminer from an Eastern Shore grower. Prince Michel near Culpeper also bottles this grape. The recommendations from Virginia Tech against the growing of the Gewürztraminer is rooted in the fact the grapes are likely to rot before ripening. Grapes rot because of fungal diseases made worse by rainy weather; certain types of rot can make a wine sour if the rotten grapes are not picked out from the harvest by hand.

Riesling has a similarly dubious standing in Virginia. Some growers and winemakers have said that Virginia is too hot for Riesling, and that the individual grapes in the cluster are so tightly packed that air and fungicide spray cannot penetrate the humid interior of the grapes. Like Gewürztraminer, Riesling grapes are prone to

rot. Still Jefferson winery, Chris Pearmund and others buy Riesling from growers and bottle it as a varietal. They do this because it sells well and it makes a drinkable wine, but it perhaps does not make a premium wine here. But, this does not matter to the winemaker as long the distinction is made clear. His goal is to please both himself and his customer.

In Virginia, Riesling and Gewürztraminer lack the varietal complexity and mineral overtones that mark the best German and French wines of the same grape. But what the wine critics say is best and what the wine buying public wants is not always the same. The average wine buyer buys wine whose name he can pronounce or wine that is familiar to him or her. Perhaps the name issue is why the Australians threw away the umlaut over the "ü," and simply call their Gewürztraminer grape "traminer." Virginians might have similar problems as they try to sell their highly-acclaimed Viognier (pronounced "vee-yon-nah") wines to beer-swilling, wrestling fans that happen to amble into the tasting room.

It should be pointed out here that not all Virginia wine drinkers are looking for complex Bordeaux-style red wines, expensive reserve wines, or Chardonnay mellowed with expensive French oak. The further one gets away from the wealthy enclaves and well-educated suburbs of

Washington, Richmond, and Charlottesville the more provincial the wine taste. Wine snobs would mock those wine drinkers who prefer blush, rosé, or even wines made from fruit like blackberries; still a couple of Virginia wineries cater to wine drinkers with a so-called less sophisticated palette. Clearly, there is a wide market for wine like that.

For example, Dennis Horton of Horton Vineyards says that he sells his blackberry, raspberry, and blueberry wines as fast as he can make them.

But Virginia is just now starting to develop a national and international reputation for premium wines. No doubt the reader of this book, having bothered to buy it off the shelf, is most interested in Virginia and her potential for making premium wines.

Either way, continuing our look at France and her bearing on Virginia, to the North of Paris and to the Southwest of Alsace is the 12th century cathedral of Reims, where French kings have traditionally been crowned. This is where Dom Perignon learned to ferment Chardonnay, Pinot Noir, and Meunier grapes in the bottle, thus producing the sparkling wine that they call "Champagne" – Champagne is, of course, the name of the region in which the grapes are grown. The weather is so cool here that these grapes do not always ripen, so the Champagne

wine maker would be hard-pressed to make a world-class Pinot Noir; however, ripeness is more important for red grapes than white, ripeness does not matter for grapes made into Champagne, since the wine maker can add sugar to mask the otherwise high acidity of an immature grape. Also, the carbon dioxide gas heightens the otherwise subtle flavor of the slightly immature grape. Such was the practice years ago in New York when big companies like Taylor Wine (bought by Coca-Cola) made champagne style sparkling wine from otherwise undrinkable American grape varieties like the Concord, Delaware, and Catawba. Of course those champagne-style sparkling wines were not in the same league as those from Champagne, France. And being outside the region of Champagne they could not carry the prestigious label "Champagne," for that would raise the ire of French copyright attorneys with their Appellations d'Origine Contrôlée system.

The better location for growing Chardonnay and Pinot Noir grapes are the eastern slopes of the Côte d'Or mountains in the Burgundy region of France, south of Paris and somewhat in the middle of the country. The Burgundians and the rest of the French were famously brought together by Joan of Arc – the grateful French repaid her generosity and bravery by burning her at the stake. The large Burgundian vineyards are owned by many growers,

some of whom might own only a few acres or just a few vines. The Chardonnay and Pinot Noir wines made here are the best in the world, bar none. The soil is, however, infertile, so the grapes do not grow very quickly, which concentrates their energy and consequently their flavors into the grapes and not the leaves – too much leaf growth, called "vigor," is sometimes a problem for Virginia. Finally, the Burgundian weather is cool enough to bring out the varietal character of the lightly colored red wine Pinot Noir.

Pinot Noir is not widely grown in Virginia. One reason is the grape's skin is thin so that it tends to fall apart in the rains of October, which is when the red grapes usually ripen. Still, Shepherd Rouse of Rockbrige Vineyard grows this grape in the Blue Ridge Mountains of Rockbridge county. His Pinot Noir was served to the U.S. Senate at an event on Capitol Hill to promote Virginia wines. Chardonnay, on the other hand, is Virginia's most widely grown grape. It tolerates the sometimes subzero winter weather here fairly well and is widely sought after by the wine buying public.

Most Virginia wineries are making Chardonnay wine and a few, including Naked Mountain and Barboursville, have done quite well in gaining recognition for their quality. Barboursville, for example, took home a medal from the "Chardonnays of the World"

competition in France. Most Virginia winemakers and grape growers would say that Virginia is well-suited to Chardonnay. The only disagreement here is whether to age the wine in Oak or use stainless steel only, but that remains a debate the world over. To please both points of view, many wineries offer their Chardonnay made both ways.

To the west of Burgundy is Sancerre and Pouilly Loire where Sauvignon Blanc is grown. Sauvignon Blanc is not cold hardy. In Virginia, Sauvignon Blanc can lose much crop in times of cold weather. The vine is not usually killed completely, but cold weather will kill many of the dormant buds. New Zealand, perhaps, is where the world's best Sauvignon Blanc is grown, no doubt in part owing the quality to the weather.

At Virginia Tech, the prophets for Virginia's winemakers and grape growers, the state viticulturist Tony Wolf and enologist Bruce Zoecklein, only recommend growing Sauvignon Blanc at locations whose aspect and elevation will mitigate frost and freeze damage. Linden Vineyard's four-mountain location offer respite from the worst weather for this delicate plant; still, owner Jim Law grows Sauvignon Blanc but does not recommend other growers plant this variety. He calls it a "heartbreak grape." Still his results remain remarkable: His 2001 Sauvignon Blanc from Avenius Vineyards was fermented slow and

cold and stored in stainless steel to retain flavor and aroma. The resulting wine is fruity and highly aromatic. It fills the nose with wonderful odors of peaches and apricots and delights the palate with the complexity that arises from a blend of different flavors.

Heading down the Rhône river valley we find the towns of Orange and Agincourt. This is where the Pope famously quit the Vatican and moved his court. He built a castle whose name the French now use as a wine appellation: Châteauneuf-du-Pape or "new castle of the pope." The red wines are made here from as many as 13 different grapes, the top three being Grenache, Mourvèdre, and Syrah. Dennis Horton of Horton Vineyards plants these grapes in Orange County, but few other growers are farming these preferring the more widely planted Burgundy and Bordeaux red wine varieties. AmRhein near Roanoke planted Syrah but it was killed by cold weather in 2003 even though the temperature there never dropped below zero.

The Condrieu region of the Rhône valley is home to the Viognier white wine grape – a variety that once dwindled to a mere six acres in France but is now grown widely in Virginia and elsewhere. It has a pleasant floral nose with lots of flavors of peaches and apricots. Because the grape cluster is loose, air and fungicide can circulate

keeping the grape relatively free of fungal problems made worse in more tightly clustered varieties. Dennis Horton, of Horton Vineyards, was the first Virginia winemaker to plant this variety in the Dominion state. Now it has a national following, being found both in Virginia, California, and elsewhere. Viognier might be one of the so-called "breakout grapes" that defines Virginia in the worldwide market. Chrysalis Vineyards beat the Californians in head-to-head competition with their Viognier at the prestigious San Diego wine competition in 2002. It was voted best white wine out of 2,050 American wines submitted for the competition.

Head west from Rhône and stop at the Gironde River Estuary, which flows into the Atlantic Ocean, and we find Bordeaux. Bordeaux is home to the most expensive wines in the world. In their zeal to buy up the vintage, buyers often buy Bordeaux wines before they are even pumped from the barrel into the bottle on the futures market much like stocks or commodities. The Rothschild's, whose fortunes were such that they often lent the nobility money, own several chateaux here, as does the movie star Gerard DePardieu. His fortunes as an actor are fading fast, but he was once in every French film it seemed. But, unlike DePardieu's career in film, the region holds strong in its success and popularity.

Bordeaux is a city in the department of Bordeaux. A "department" in French is a state or province. In France and in it's oversees territories there are 100 of these because the radical Jacobins of the French revolution wanted everything in their well-ordered world to be divisible by ten. They even tried to have 10 days per week but were thwarted when the earth refused to revolve about the sun in multiples of 10 days per year.

Bordeaux is subdivided into perhaps the best know appellations in the wine drinking world. Pauillac, Medoc, Haut Medoc, Graves, and Margaux are perhaps the regions of the world where the world's wine press writes most of its copy. The famed American wine writer Robert M. Parker, Jr., who comes from Baltimore, rated these wines on a numerical scale in his publication "The Wine Advocate." A wine that ranks 95 or even a rare 100 will sell for $400 or even more. Some critics dismiss such numerical classification, but the wine-buying public flocks to these numbers en masse.

Red Bordeaux wines are subtle. Their complex and sublime nature is best realized if one waits a few years before drinking the wine after it is plucked from the vine and fermented at the winery. For red wines include tannins that come from the skins, seeds, and stems of the grape. White wines generally do not since all of that

is tossed out before the wine is made. Tannins impart astringency to a wine, the slightly dry taste that lingers in your mouth when you drink a red wine. A young Bordeaux red will have too many tannins so must be aged in the barrel or bottle for a period of time. Robert Parker and a British writer, Michael Broadbent, even suggest that these wines be kept in storage for a period of years before they are properly aged for drinking.

The five red wine grapes of Bordeaux are all, in fact, planted in Virginia. These are Cabernet Sauvignon, Cabernet Franc, Merlot, Petit Verdot and Malbec. A Bordeaux red wine is made by blending wines made from these grapes together. The amount of each grape blended into the wine is a stylistic choice made by the winemaker. In Bordeaux, Cabernet Sauvignon and Merlot are the primary wines blended into the finished product while in Virginia Cabernet Franc, Merlot, and Petit Verdot play a more prominent role.

Not many Virginia growers plant Malbec while many plant Cabernet Sauvignon. This is the most widely planted grape in California and, of course, Bordeaux. Still, some Virginia growers refuse to grow it at all, saying it should not be planted on deep clay soils. Deep clay soils are found in many Virginia locations; however, other vineyards have loamy soils or soils that are shallow, meaning the subsoil is located near the

surface. Clay is high in organic material. Cabernet Sauvignon grown there has such vigor that there is too much green growth that can impart a herbaceous taste to the wine. Among the red grapes, it is the last to ripen, and in many years it will not even ripen at all. Still with meager soils Cabernet Sauvignon does well for certain vineyards and wineries.

Merlot is perhaps the subtlest of the Bordeaux red grapes. It is silky and soft, so it often is blended with Cabernet Sauvignon or Petit Verdot to give the wine weight and color. But, Merlot is not cold hardy. It grows well in Virginia because there are a lot of locations where it can be planted above the bud-killing frost of late spring and above the below-zero temperatures of winter. The cold air rolls down the slope of the properly positioned vineyard and spills out into the pasture or river bottoms below.

Grapes, like roses, do not like to stand in water. One Culpeper vineyard made the mistake of planting much Merlot on flat land, with shallow soil, that was not well drained, making this field better suited to corn than to wine grapes. So after standing in water for a few years and suffering the low temperatures of winter, the Merlot vines all succumb to a bacterial disease called "grown gall," which thrives on grape vines that have burst open by subzero weather. That vineyard has now grown

wiser: They ripped out all the Merlot, planted
French Hybrid vines that are more suitable to such
a location, and installed drain tiles to whisk away
the water.

French hybrid grapes play an important role
in Virginia. One hundred years ago the noxious
pest the Phylloxera louse made its way across the
ocean to France – no doubt by the importation
of infected vines. Phylloxera likes to eat the roots
of the delicate *vitis vinifera* old-world European
wine grapes. American vines are tough enough
to be fairly immune to this pest, but the French
vines were not – leaving the entire French wine
industry decimated, as well as much of Germany
and Italy. Some French growers packed up their
berets and wine thieves and headed for the nearby
colony of Algiers. Good grapes were grown there
until teetotaling Muslims grew weary of French
domination and kicked that government out
of the nation by waging war in a revolution.
Some French simply sat and sulked while others
reasoned that they could cross breed American
vines with European ones. The resulting wines
made from these grapes were quite good and are
now widely planted. But other growers reasoned
that they could keep the Phylloxera at bay by
grafting the tender *vitis vinifera* vines onto hardy
American roots. That practice continues today
in both Europe and America. Having found a

solution to the American problem politically connected French growers lobbied the government to ban the so-called "French Hybrid" grapes. Now the French seem embarrassed by the whole episode. They have attempted to mask over this history. Perhaps the only way to uncover this story would be to read "Dictionnaire Encyclopédique des Cépages" written by Pierre Galet.

This is unfortunate for France, because French hybrids combine the best of both worlds: European taste and American resistance to disease and cold weather. But what the French tossed out the Virginia growers have embraced. Urged by the pioneering Maryland grape grower, the late Philip Wagner, French hybrids are now grown in Virginia, in New York, and in such places at the hot coastal areas of South Carolina where *vitis vinifera* is not well suited. In Virginia, grapes like Chambourcin, Vidal Blanc, and Seyval are grown by some whose location is not well suited to *vitis vinifera*. Other wineries, like Oakencroft, grow Chambourcin because it is a good grape to blend with Cabernet Franc. Phil Poton, assistant winemaker and vineyard manager at Oakencroft, says the grape always ripens and it always gets color. Vidal Blanc and Seyval are grown by other premium winegrowers as well.

Before continuing to look at the hexagon of France, it is worth talking for a moment about this

subject of the ripeness of red wine grapes. Good white wine can be made from grapes that are not totally ripe, as mentioned earlier. As long as the grape is mature enough to have developed its varietal character, or the aromas and flavors that distinguish the grape, then it will make a proper wine. But red wine grapes need to be ripe to make the best wine. One reason for this is the skins and seeds of the wine are added to the fermenting must. If they are not ripe they will impart a bitter taste to the wine because of their unripe tannins.

Jim Law, of Linden Vineyards, says that Virginia has some advantages not found in California. Foremost is the concept of "vintages," which means the year in which the grape was grown. A wine from a good vintage is one where the weather was ideal for grape farming. In a bad year there was too much rain or cold so the grapes did not properly ripen before the onset of winter. In California there is no weather at all. In Napa and Sonoma valleys, the premium wine growing regions above San Francisco, it only rains in winter, and like the song says "it never rains in Southern California." The sunlight and heat there are such that grapes will actually get too ripe. However, the riper the grape, the higher the alcohol content, thus California red wines often have as much as 14 and a half percent alcohol, while 11 to 13 and a half percent is the preferred

range. So some California wineries have taken to using an expensive process to reduce the level of alcohol in the wines. A wine with too much alcohol tastes "hot" in the parlance of the wine-drinking professionals. On the other hand if a wine is too low in alcohol it can lack taste and be subject to spoilage. So this is good news for Virginia. When the weather is like it was in 2002 – good everywhere except the most northern regions which experienced too much rain in October – then red wine grapes ripen properly. Compared to the blistering deserts of California, Virginia is fairly cool; of course, the humidity here is what makes the summers so unpleasant. All this portends good news now and in the future Virginia for red wines.

The vagaries of the Virginia weather are one reason that Petit Verdot, a recent newcomer to Virginia, is growing in popularity here. In Bordeaux, Petit Verdot is usually 5% or less of the Bordeaux blend. But in Virginia it is even sold as a varietal meaning it is at least 75% of the blend. Its normal use in Virginia, like Bordeaux, is a blending wine used to given color, aroma, and complexity. Petit Verdot is cold hardy and has a lovely purple color and violet aroma. It tastes of plums. Its aroma remains with the wine when it its aged and bottled. Red wines in general have less aroma than white because the whites are

20

fermented at cold temperatures. But Petit Verdot aroma wafts pleasantly into the nose even after some time in the bottle.

Cabernet Franc is perhaps the red wine grape that is best suited for Virginia; so say many wineries and growers. Of course not all growers, winemakers, nor wine writers would agree with that claim, but still, it is widely planted by most growers and is poured into almost everyone's Bordeaux-style blend. In France, it is the sole red grape planted North of Bordeaux on the west coast of France in the Loire Valley appellations of Chinon and others. Loire is the area of the auto race at Le Mans and the Vendée, whose royalist citizens were dealt with harshly by the French revolution in what the French call their own episode of genocide.

Cabernet Franc also has a relatively loose cluster of grapes and is more cold hardy than either Cabernet Sauvignon or Merlot. By itself it does not have a deep red color, but color can be extracted by letting the wine sit on its skins for a protracted period of time. To add color or complexity, Cabernet Franc is often blended with other red wines – Merlot, Tannat, or Chambourcin – even when it is sold as a varietal.

Finally, there are other grapes beside French that are grown in Virginia. Italian grapes like Nebbiolo, Sangiovese, the prime ingredient of

Chianti, and Barbera are planted in Virginia. As well as Spanish and Portuguese grapes such as Touriga Nacional, Tinto Cao, and Grenache. Barboursville winery, owned by the Italian winemakers Zonin, plant many of the former while Chrysalis and Horton plant many of the later. Barboursville grows the Italian grape Pinot Grigio. It is a clear white wine that does well in Virginia, according to Luca Paschina, general manager of Barboursville Vineyards, but hardly any other grower is planting any of these varieties. Valhalla winery in the mountains near Roanoke was planting Sangiovese but ripped it out of the ground and planted Petit Verdot instead. Christensen Ridge winery in Madison County grows a small amount of Sangiovese and blends it into their delicious Tuscany Red blend. Governor Mark Warner and Ingleside Plantation grow larger amounts of Sangiovese saying it will ripen in the longer growing season at their tidewater Virginia vineyards.

Chrysalis and Horton wineries also plant and promote an American variety: Norton. The European, old-world grapes are collectively known by their family name *vitis vinifera*. American grapes are the *vitis labrusca, vitis riparia, vitis aestivalis,* and others whose Latin names roll easily off the tongue of the experienced viticulturist or ampelographer, one who studies the science of

determining a plant's lineage. These American grapes are generally not suitable for making wine and have a foxy taste that the French call the *goût du renard*. But, Norton is suitable for red wine. It is extremely heavy and has the opaque color of the Concord grape. Dennis Horton first planted Norton grapes in Virginia while Jennifer McCloud of Chrysalis is their primary advocate: she has made the perfection and the sale of Norton wines her mantra, not to mention her passion.

Virginia, like South Carolina, New Jersey, and the whole of the east coast into Canada is blanketed with wild grapes, sometimes called "fox grapes," but there are several different varieties including *vitis rupestris, vitis riparia, vitis labrusca* or others. They hang from practically every tree along every roadside from Princeton to Paris Island, from Charlottesville to the Chesapeake. Unlike the European wine grapes, these vines do no have what botanists called "perfect" flowers. This means nature is as it should be and the vines are either male or female but not both. Conversely, *vitis vinifera* vines are hermaphrodites meaning they have both male (stamen) and female (pistil) sex organs; a condition perhaps due to their thousands of years of domestic proximity crammed all together in that common locker room of the French lycée (high school) they call Champagne or Bordeaux.

Growing grapes in Virginia requires a different approach to agriculture than that practiced in France or California. It gets cold here, rains too much sometimes during harvest, and is hot and humid in summer. It rains too in France as well; the same is true of the wine areas of Hunter Valley of Australia and Montevideo, Uruguay. In California it never rains during the summer, so the wines are kept alive by irrigation in the desert areas or, in Napa and Sonoma counties, by rains that fell during the winter months and spring. In Virginia many growers use irrigation – some do not prefer to stress the vines in dry years to concentrate flavors, in Bordeaux, however, growers do not use irrigation.

Rain causes problems when there is too much of it. In 2001 there was record drought in Virginia so the grapes were able to ripen properly. Properly ripened grapes do not require the addition of cane sugar to produce an adequate level of alcohol in the wine. This is a problem in France as well. If a wine is deficient in alcohol it is more likely to spoil and for certain winemakers and wine drinkers alcohol is an important component of taste. "Véraison" is the French word for the ripening of the grapes. During véraison the grapes lose their chlorophyll green color and sugars begin to accumulate in the fruit. But rain slows or even retards the ripening process especially heavy rain

after a period of dry weather. Further it makes worse certain fungal diseases that are a problem in Virginia as well as France. California has grape diseases as well, but some are of a different sort. These diseases are held in check by proper canopy management and a well-timed program of fungicide spray. Canopy management refers to the practice of positioning the shoots or even snapping off much of the grapevine's green grown to improve air circulation and spray penetration in the canopy. A grapevines green growth is called a "shoot." Each shoot usually has two clusters of fruit, 12 to 15 leaves, and tendrils that hold the vine aloft.

Grapevine disease is a problem the world over, but perhaps made worse in Virginia by heavy rains. These diseases are well contained by the use of fungicide; the French invented the use of copper and sulfur to control this type of disease. This science has progressed even further to where disease control is fine tuned by various topical and systemic sprays. Properly controlled, this is not an issue for the wine drinker; however, it costs a lot of money for the grape grower. Without proper control, disease can cause rotten grapes, which will give a sour taste to the wine. Most diseases do not affect the taste of the wine but are a threat to the health of the plant. If a grapevine loses all its leaves due to disease then it will not accumulate enough

sugars and starch to live through the winter and early spring.

Look closely at grapevines in France and California. Compare those against vines in Virginia and you will notice that in Virginia more than one trunk is grown onto the cordon. The trunk of the vine is its perennial growth. The rest of the vine is pruned off each season while the arms of the vines are called the "cordon." In Virginia and in California the cordon is trained to grow onto a trellis while in much of France the vine is allowed to stand by itself. It takes five or six years to train these so-called "head trained" to stand on their own, while it takes only three to fill out most trellis designs.

While the grapevine is growing it stores up carbohydrates and other sugars before it shuts down and goes to sleep for the winter. As the leaves fall off in the autumn the green shoots turn to woody canes and the vine is dormant. However, in the varied climate of the east, the temperature can fall well below freezing before the vine is dormant thus freezing parts of the vine that have not yet hardened off for the winter. Young vines, meaning less than five years old in particular are subject to such winter injury. There is some debate as to weather older vines make better wine; regardless, one discernible difference between older and newer vines is that truly young vines

tend to ripen a couple of weeks earlier than older vines.

But it is the temperatures that fall far below zero that are of concern both in Virginia and New York where European, old-world grapes are grown. Some farmers bury the bottom parts of their vines in winter with dirt, so that if the top part of the vine is killed then the grapevine can be trained again from the dormant wood that has been protected by the soil. But rarely is an entire vine killed. More often in Virginia some of the dormant buds of the vine are killed rather than the whole grape. In Virginia grapevines are often pruned twice. The first time much of last year's tangle of growth is cut away. The second pruning if often adjusted to retain more buds if many of them were killed during the winter.

During most winters, the grape vines in Virginia whether the weather quite well. Vineyards that are up on the side of a hill are often five or even more degrees warmer than those below it. In the winter of 2001, for example, at a Rappahannock County vineyard that sits on a slope at 680 feet, the low temperature for the season was two degrees. On that same day at Horton Vineyards in Orange County, the temperature dropped to six below zero. This was on a fairly level vineyard located at 300 feet. Recognizing this issue, Horton Vineyards

maintains three other locations including one large vineyard on a steep mountain slope in the same county. Still, that minus six temperature did not kill the vines outright; only the Nebbiolo crop was lost.

1996 is another matter. Then the temperature at Oakencroft winery dropped to 20 degrees below zero. That is rare for Virginia, and most of the vines were killed down to ground. But no vine was killed outright, meaning the roots were kept alive. Phil Ponton, the Oakencroft vineyard manager and winemaker, did like so many other vineyards. He took a chain saw and cut away the dead trunks. Two years later the vineyard was again producing fruit. Of course when this happens the vineyard owner is without the revenue from fruit and the resulting wine for two years, although there is of course still existing wine in the cellar that can be sold. Other vineyards did not fare as well and one large winery in particular laid off many employees because there was no vines to tend to and no new wine to process for several years.

The grapevine wakes from its winter sleep in March or April. In the early spring there is a danger of late season frosts. This is bane to peach, apple, and grape growers and those who grown tomatoes, cantaloupes, pumpkins, and more. In 2002, the last frost was extremely, well, late: May 23. That truly rare event killed many of the tender

young shoots that were just emerging from the vine. So, some farmers whose vineyard sits in a frost pocket, or who don't have wind machines to protect them, lost their entire crop that year. Some wineries even hired helicopters to blast away the cold frost-laden air. Some mountain vineyards, in North Carolina and Napa Valley for example, prefer expensive overhead systems that spray water onto the vines to keep the frost at bay.

The grape growing situation is not as bleak as it may seem, though. While it must contend with issues not found in the deserts of Chile or the Mediterranean Climate of California, Virginia does have advantages over other areas. Rarely does it get truly cold in Virginia and frost is not a problem for those vineyards in proper locations. They do, after all, have frost in Sonoma valley as well and in France.

Ernest Hemingway wrote in "A Moveable Feast," his memoir of life in France, that in the fall, a bit of you dies and in the spring, it is born again. This is certainly true for the grapevine. The annual growth of the grapevine is a miracle that unfolds beginning in spring. As the days of winter grow longer and gentle breezes usher in the Halcyon days of March and April, dormant buds on the grape vine swell and then unfurl. Tender shoots start to grow with red and gold colors highlighting their otherwise green growth.

The vine at this point is living off starches and carbohydrates stored last year in the xylem, which is the soft tissue of the trunk. As the leaves unfurl they begin to produce food by the taking sunlight and hydrogen and producing carbohydrates. Water is slightly cohesive, so as the sun shines on the leaves, the difference in the temperature on the sunny and shaded sides of the leaves produce a temperature gradient that causes a slight tension in the vines. The vines then tug at the water in the soil and lift it through the trunk and into the growing shoots. This tension can actually be measured in the soil by sensitive equipment. The lack of such tension means the soil is dry so it is time to water the vines.

As the shoots unfold they each produce usually two clusters of flowers each. The perfect flowers of the grapevine contain both male and female sex organs. Grape flowers are unlike tulips or roses, in that grape flower petals are fastened onto the vine backwards. So rather than opening delicately from the top they open from the bottom and simply fall off because the petals are then not attached to anything. At this point the pollen is released and fertilizes the female ovaries, which then produce seeds and fruit. Virginia grape growers and growers around the world call this period of time "fruit set."

30

As July ends and August begins, the grapes swell until the bunch is closed. Sugar begins to accumulate in the fleshy portion of the grape that, along with water, surrounds the seeds. The red wine grapes, first the young vines, begin to turn color. Some white wine grapes turn pink or yellow but most remain green. The winegrower crushes a few berries into a container and then uses a device that measures the refraction of light due to the presence of suspended solids to measure the sugar content. When the sugar content of the grapes reaches a certain point, which varies according to the winemaker's style, the prospects for too much rain, and the amount of rot in the grapes, the harvest begins.

To harvest white wine grapes, the vineyard starts early in the morning. Pickers descend en masse on the vines. Those vineyards that are small and without full-time workers cobble together whoever they can find to gather in the harvest. Out come volunteers who are fans of a particular winery or family members and friends. The big wineries like Horton have 20 or more full-time agriculture workers, most of them migrant workers from Mexico. They flood into the vineyard and rapidly fill 25 pound lugs with wine grapes. White grapes go into refrigerated tractor-trailers or other air conditioning, with the goal of keeping

the otherwise warm grapes cool before they are crushed and destemmed.

The destemmer-crusher device plucks the grapes from the bunch leaving behind the stems – these are thrown away or used as compost. The crusher gently cracks open the grapes and the so-called "free run" juice is collected. Then the grapes, now freed of their stems, are dropped into the bladder, basket, or other type wine press. Just like an old-fashioned cider press, the wine press crushes the grapes to extract their juice. But unlike the situation with apples, wine grapes are crushed ever so gently, so that the bitter parts of each grape, the seeds, are kept out of the juice. For white grapes, the skins are tossed away and used as compost.

The juice then goes either into barrels or refrigerated tanks. With white wine grapes the winemaker most often wants to retain the floral aroma and fruity taste of the grapes. These compounds are said to be "volatile" meaning they will dissipate in the air if the grapes are handled too roughly or fermented too fast. So the wine grapes are cooled to slow the fermentation and handled gently by the sometimes-computerized destemmer-crusher.

When the grapes are dropped into the tank the wine maker adds a dose of sulfur dioxide to stop oxidation. Winemakers have used sulfur

dioxide for hundreds of years. Roman winemakers used sulfur candles to fumigate empty barrels. These are still in use today. Sulfur dioxide imparts no flavor to the wine and is the antiseptic cleanser for wineries the world over. After adding sulfur the winemaker adds yeast. Then a fermentation lock is attached to the top of the barrel or tank. Yeast are living organisms that turn the grape sugars fructose and glucose into ethyl alcohol and carbon dioxide. Since carbon dioxide fizzes and sputters the fermentation lock lets it spew from the barrel whole keeping wine-spoiling oxygen outside. If there were no such device the gas would build up and blow the bung, the rubber stopper, from the barrel and shoot it into the air. It takes two weeks to two months to ferment wine grapes into wine. Fermentation is complete when carbon dioxide is no longer vented into the air. Then the wine is left to sit so that it can become clear of sediment and the bread-like flavor of yeast.

Red wine grapes are often fermented in open bins. After the grapes are destemmed and crushed the grapes, as well as the grape skins, are tossed into the fermentation vat. The grape must, i.e. the combination of skins and juice, is fermented for three days to a week before it is tossed into the winepress. The winepress squeezes the juice from the skins while taking care not to fracture the bitter seeds.

The skins impact astringency and color to the red wine that is a pleasant and well-known component to the wine drinker. The skin of the grape is where the color is contained so as it floats in the wine's color is leeched out. This layer of skin becomes a solid layer which the wine makers call the "cap" which floats to the top. The cap should not dry out, so once per day or maybe more frequently it is pushed back under the juice. This is called "punching down the cap." Sometimes the juice is just pumped from the bottom of the tank to the top thus covering the tank. In Burgundy, workers jump into the tanks completely naked and push down the cap with their feet.

The fermenting red wine is allowed to reach temperatures of 80 degrees or more. The chemical reaction is quite violent – carbon dioxide foams and sputters as the yeast work their magic. So that aroma and flavor is not blasted off into the air, the winemaker will add bags of dry ice or turn down the temperature on insulated stainless steel tanks to cool the wine if the temperature gets too high. If the temperature were allowed to run unabated the wine yeast might actually die and the so-called "stuck fermentation" would pose a problem for the winemaker. The fermentation of dry red wines is not complete until the wine reaches 11 to 14 percent alcohol and there is little or no residual sugar. Residual sugar can be measured

by instrument but some wine makers prefer to just taste the wine to know when fermentation is complete.

After the red wine is fermented it is aged in oak barrels or in stainless steel. The decision to use oak depends on the style preferred by the winemaker. Oak contains vanillins – which are a compound that mellows the wine – plus tannins as well. If the winemaker does not like the flavor of oak he or she might use older oak barrels, which give less noticeable oak flavors to the wine. If the winemaker wants the wine to retain its fruity flavors then he or she might only use stainless steel, which imparts no additional flavor to the wine.

The wine is stored in the cellar for six months to three years. During that time gravity and various agents are added to the wine to make the yeast and other residue sink to the bottom thus clarifying the wine. When the winemaker feels the wine is ready, then the wine is bottled. Most Virginia wineries do not have their own bottling equipment preferring instead a mobile bottling truck. The truck is a marvel of technology and efficiency. Wine from the tank or barrel is pumped in one end and out the other end pops a complete wine bottle with cork and capsule. The bottling line also adds nitrogen or other gas to keep out oxygen, optionally filters the wine for improved

color clarity or to make it sterile, and applies the label. Sterilization stops any possible wine spoilage and arrests further fermentation.

Virginia winemakers go to great lengths to train their palette to recognize good wines. The winemaker uses fruit or fruit concentrate to train their nose and tongue to recognize various aromas and tastes in the wine. Pleasant aromas and flavors include citrus, blackberries, cedar, and others. Unpleasant aromas and flavors, resulting from errors in the vineyard or cellar – include rotten eggs (which indicates the presence of hydrogen sulfide) and vinegar (which means the vine is spoiled by vinegar bacteria). The vocabulary of the winemaker is such that he has an aroma and tasting wheel that adds adjectives to the otherwise arcane minutiae of winemaking. The aroma wheel is a round paper device that both gives the winemaker a vocabulary of adjectives and gives him a means to measure what he can discern. Wines can smell and taste pleasantly of raspberries, peaches, oranges, currant, cedar, dirt, or any of a dozen other descriptors. This is all spelled out in great detail on the aroma wheel. Other devices are used to train the nose and palette. To recognize the presence of tannins in the wine, the winemaker might let a tea bag steep in water for an hour and then drink the resulting swill. To learn to recognize acid, the winemaker adds citric

or tartaric acid to an otherwise sound wine. Sugar is a taste that is easily learned by buying a bottle of wine and then adding, you guessed it, sugar.

Beyond taste, red wines have a texture because of the tannins in the wine. Winemakers call this "tactile sensation." Another winemaker's device, the "mouth feel wheel," helps the winemaker recognize whether the wine is "supple," "soft," "silky," or "chewy."

Finally, as an introduction to a study of Virginia wines, one must ask the question: how good are they compared to other wines of the world? There is no easy answer to that question and any writer who attempts to answer it invites controversy. Some Virginia winemakers say that ten or more years ago many Virginia wines were truly bad. Back then, winemakers did not know proper canopy management techniques. But today the national and international press has taken notice because Virginia wines are starting to make a name for themselves. One problem is the Virginia wine business is still small with only 2,500 acres of vines – this is less than the 3,000 acres of vines planted on New York's Long Island alone. But the many boutique wineries are making wines that have won recognition in head-to-head competition with international wines in such events as the San Diego wine competition.

Some Virginia wineries have perhaps exaggerated their standing among their peers by touting the medals they have won. Many wine competitions, like the Grand Harvest Awards in San Francisco, group wines by region. So to say that your winery won a gold medal there just means that among the Virginia wineries your wines were in the top tier – that does not put your winery in direct competition with those in California. In many competitions, like the Virginia Governor's Cup, a great deal of the wines submitted win some kind medal. A gold medal won in a wine competition does not mean your wine beat all the other wines. That designation is called "best of show." Wine competitions are not like the Olympics where only one medal is given to each winner. Medals are handed out based on the relative merits of a wine. If you look at the Robert Parker or UC-Davis system, then a gold medal might mean anything that scores 90 points or higher. Silver medal wines are perhaps 85 to 90 while bronze is 80 to 85. Any wine below 80 is somehow flawed so it certainly is not going to win an award.

But this is not meant to downgrade the great success that Virginia wines have had both at competitions and in selling their wines to the public. Still the discerning buyer needs to know which wineries in Virginia are the best and

recognize those that are not. One Virginia winery evens claims to be among the top ten in the world – there is no such classification. Other wineries are too busy hosting polo matches, weddings, or winemaker's dinners to pay proper attention to the cellar and vines. But wine festivals, weddings, winemaker's dinners, and perhaps even polo play an important role. They all, in one way or another, help to spread the word about Virginia wines among the wine buying public. At this point in time, the sheer number of Virginia wineries, and their increased focus on quality, have achieved a critical mass that might bring Virginia worldwide acclaim.

The Viticulturalist

Virginia's commitment to growing quality wine grapes is apparent in their hiring of viticulturist Tony Wolf. Growing wine grapes on the East Coast – with its heat, humidity, and sub-zero winters – requires someone who has worked for many years in that area.

Spearheading Virginia's effort to move into the wine community's limelight is Virginia Tech University, one of a series of nationally recognized "land grant" agriculture colleges, and Tony Wolf, Professor of Viticulture.

Professor Wolf operates an experimental, 2-acre vineyard located seven miles southwest of Winchester at 950 feet elevation sloping nine degrees to the east. In addition to growing grapes and making wines he and his assistant help new vineyards get started and aid established vineyards

in troubleshooting problems through on-site visits, providing written materials and studies, and teaching classes. Tony Wolf describes his job as "teaching, research, and extension." He says he spends 50 to 70 percent of his time doing research. He does not teach undergraduate classes because he is so far from the main campus at Blacksburg , but he teaches graduate students who want to pursue viticulture, and he is beginning to develop distance learning materials for web-based instruction.

Professor Wolf is himself a Ph.D. graduate of Cornell University; there he wrote a dissertation on the effects of rootstock and nitrogen on the cold hardiness of grapevines. He also studied at Penn State University and West Virginia University, where he worked in an experimental vineyard. In addition to being an employee of Virginia Tech, Professor Wolf is also employed by the Virginia Cooperative Extension agency. This is a state and federal partnership with which most cattle, fruit, and other farmers are familiar.

Professor Wolf writes and edits a bi-monthly newsletter for grape producers called *Viticulture Notes*. The newsletter is electronically distributed and posted on his web site. This document is a compendium of technical information for area growers; it offers seasonal information on vineyard cultural practices, pest management, research findings, and so much more.

Having a scientist to assist area growers is important because the climate in Virginia presents some special difficulties that make raising grapes difficult in certain years. Professor Wolf compares the climate of Virginia to the wine growing regions of the Hunter Valley in Australia and the area around Montevideo in Uruguay with the added difference that neither of those locations have such cold winters as Virginia. Virginia is different from, say, Bordeaux or Napa Valley in that we have high summer temperatures, warm nights, high humidity, and cold winters. These conditions can cause winter damage to the vines and a plethora of diseases. Most of these can be mitigated or prevented by proper viticulture techniques, such as those taught by Professor Wolf.

One of Tony Wolf's goals is to find grape varieties that are well adapted to the Virginia climate, demonstrate their ability to grow here and make fine wine, and then educate the area wineries and perhaps interest them in growing these grapes. To this end he has researched grape varieties and weather patterns around the world and selected varieties for planting in the research vineyard in Winchester. He selected varieties that he predicted might do well during the growing season here and also survive the winter. Aside from the mainstays, such as Chardonnay, varieties that have done well at Winchester include Petit Verdot, Viognier, Petit

Manseng, Norton, Chardonel, and Traminette. In addition, the vineyard includes Cabernet Franc as part of a training system study.

Petit Verdot has been grown at the Virginia Tech location since the late 1980s. It has good cold hardiness. Tony Wolf says Petit Verdot is not generally viewed as a varietal by most vineyards meaning it is mixed with other grapes rather than sold alone. Generally Petit Verdot is mixed with other Bordeaux reds. Petit Verdot is one of the five principal Bordeaux varieties including Cabernet Franc, Merlot, Malbec, and Cabernet Sauvignon.

Viognier is from the Condrieu region of France. This area of southern France has hot weather in August and September but the nights are cooler and the days dryer than in Virginia. Viognier is sold as a varietal and has grown significantly in sales both in Virginia and elsewhere in recent years.

Tony Wolf says the Petit Manseng he plants also does well and is bottled as a varietal wine. It comes from the French slopes of the Pyrenees Mountains on the border between Spain and France. At harvest the grape can have a sugar content (brix) as high as 29 percent and it is highly acidic at eight or nine grams of acid per liter. Consequently this white grape makes a sweet desert wine like Muscat with a lot of flavor. It tastes like a combination of citrus and tropical

fruits such as mango.

Chardonel is a white grape hybrid that originated from a cross between Chardonnay and Seyval. Seyval itself is a hybrid. James River vineyards produces a Chardonel varietal wine. Wolf says it tastes somewhat like apples and pears much like Chardonnay. He adds one perhaps would not necessarily market the wine as "Chardonel" as most consumers would not recognize the name.

Tony also grows a Gewürtztraminer hybrid called "Traminette" that was released by Cornell University. This spicy white wine hybrid was bred in a process that began in 1964 and culminated in actual vines in 1996. Hybrids are made by painting the pollen from a flower's stamen onto the flower pistils of the intended female parent vine, and then growing new vines from the resulting seeds. Traminette has grapes which, like Gewürztraminer, take on a muddy red color when they are ripe. The Cornell University website says Traminette has good resistance to powdery mildew, black rot, and Botrytis bunch rot. The problem with Gewürztraminer itself is that it tends to rot before it ripens according to "The Mid-Atlantic Winegrape Grower's Guide." Hence the need for a hybrid combining old world flavor with new-world hardiness.

The other grape grown in Winchester is the

45

Norton grape, which is native to North America. Norton is well adapted to high temperature and high average rainfall, has low susceptibility to rot, and is tolerant of phylloxera and Pierce's disease. Plus it is reasonably cold hardy. Norton does not require as much spraying as *vitis vinifera* and hybrid grapes. However it is susceptible to late spring frosts and early fall frosts since it requires a long growing season of 180 days. On the downside the fruit can have a high pH in combination with high acidity, which can be a problem since too much acid in a wine can cause tartness or sourness. To increase the respiration of acid the fruit is heated by increasing the exposure to sun through canopy management – the term "canopy management" includes positioning the shoots in the optimal direction and trimming excess vegetation (foliage) from the wine.

There are four or five Virginia vineyards producing Norton wines including Chrysalis who sells their Norton reserve for $35 per bottle. So if price is indicative of quality then this is indeed a fine wine. Norton does make a fine wine, but it does take time in the bottle and oak barrel to make it palatable. Cooper, Chrysalis, and Horton Cellars also produce Norton. Tony Wolf says, "[The] Wine quality can be quite high." He says people either like it a lot or they dislike it; there is little or no middle ground.

Commenting on the drought of 2002, Professor Wolf says that drought is generally good for grapes provided they have irrigation in the early growing season. The ideal growing conditions are, like in Bordeaux, rain during the growing season and dry conditions during the harvest. And since August and September were bone dry, white grapes, which are susceptible to rotting before they ripen, benefited this year. Also drought intensifies the flavors of whites. Tony Wolf says, on the other hand, the positive effect of hot dry weather on red grapes is somewhat exaggerated. Vineyards in the middle portion of the state, say Barboursville and Horton, break bud three to four weeks before the plantings in Winchester, so those vineyards would have been able to harvest Cabernet Sauvignon, which is generally harvested last, before the heavy rains that we had in October. This should be a good year for those vineyards.

Regarding vintages, Professor Wolf rattles off the years of the calendar and the wines they produced with studied attention. Poor years include 1992, which was too cool and too wet and 1996 was just plain wet. Good to excellent years include 1995, 1997, 1998 (good for everyone), 2000 (not bad), 2001 (excellent), and 2002 (excellent).

In addition to the Winchester vineyard,

Virginia Tech has a vineyard in Blackstone just southwest of Petersburg. The goal of that planting is to identify which varieties of grapes would do well in the eastern Piedmont of Virginia – this is the area to the west and east of Petersburg and down to the Carolina border. The weather there is hotter and more humid than in Winchester. As of 2002, no grapes had been harvested from that vineyard yet, so there are no early conclusions.

Other projects that Tony Wolf is working on include trying to identify less fertile soils where grapes can be grown. For example, Burgundy's slopes of limestone are not fertile at all yet they produce some of the world's best wines including Pinot Noir. At the other extreme, overly fertile soil produces too much foliage. Tony Wolf also has been studying different training systems (double versus single canopy) and evaluating Chardonnay clones to see which will produce better wines. Finally he is trying to determine the optimal crop level (tons per acre) to achieve the best wine quality and cold hardiness.

The Wine Country Gateway

Almost everyone in Virginia knows Chris Pearmund; He's ambitious and has his hands in making wines at many of the wineries in the Northern Virginia area. But, now he is making wines for himself at his recently opened winery.

Chris Pearmund is a veteran of the Virginia wine business but his winery in Fauquier County is anything but old, in fact it's brand new. Sitting in the middle of a 15-acre vineyard, Pearmund Cellars is located at what Ray Olszewski, president of the Hunt Valley chapter of the American Wine Society, calls the "gateway to the Virginia wine country." This is certainly true, for the winery is located just off busy highway 29 only a few miles from Gainesville, an area that is slated for heavy development in Prince William County.

The 5,000 case winery includes an Italian tiled tasting room that is decorated with work from local artists. Chris, his wife Lisa, and two of his partners can be found pouring wine and chatting with visitors. The wines poured in this tasting room include Chardonnay made in two different styles, Viognier, Riesling, Merlot, Vidal Blanc, and a Bordeaux-style blend he calls "Ameritage." Chris says his aromatic Viognier is Pearmund Cellar's best selling wine.

Chris's résumé as a winemaker is replete with the names of some of Virginia's best wineries. He started his winegrowing and winemaking 1990 at Naked Mountain winery. From there he worked at Unicorn and then at Farfelu. Even with his own winery, Chris still continues to work as a winemaking consultant at Christensen Ridge, Unicorn, Rappahannock Cellars and Mediterranean, while also working in North Carolina. Understanding both winemaking and viticulture, Chris was also working as a vineyard consultant to Piedmont Winery last year.

Chris is a tireless advocate of the Virginia wine business, giving frequent seminars and having served as president of the Virginia Vineyards Association from 1995 to 2000 and now as Chairman of The Virginia Wine and Food Society. He works hard to spread the word of Virginia wines and to help other growers and

winemakers launch their own ventures. Chris says, "The best thing that could happen to us is to have other quality wineries around."

Chris's attitude is common in Virginia, a young winegrowing region without longevity of experience. Rather than look askance at the competition, the wineries here often work in concert, giving each other advice and loaning each other equipment. For example, Pearmund Cellars and Unicorn share expensive filtration equipment and stainless steel tanks. Hoping to save some money for both wineries Chris and John Delmare of Rappahannock Cellars share an elaborate ozone-generating, yet environmentally friendly, ozone sanitation system. Of Unicorn Chris says, "I use their tanks. They use our tanks. We use a lot of things back and forth. It saves some money."

Chris is working with Mediterranean winery and Kate Marterella to jump-start their new wineries from day one. Chris explains that a new winery incurs mortgage interest and other expenses that cannot be offset by revenue until newly-planted vines begin to produce fruit in the second or third year, so for Mediterranean he is bottling 500 cases from their vineyard this year. Next year Mediterranean will have mature-enough grapevines to do this themselves. Chris says, "This is a way to get a new winery off the ground as soon as the doors open." He plans to help Kate

Marterella in the same manner; Kate currently sells
the grapes from her vineyard to Pearmund.

Explaining further the cooperation between
Virginia vineyards, Chris says that Luca Paschina
of Barboursville is gathering up Virginia wines to
send to Robert Parker, the world-renowned wine
writer and editor of "Wine Advocate." Another
example would be Northern Virginia winemakers,
who gathered recently at Pearmund Cellars to
critique each other's late harvest wines. These
information-sharing meetings are held frequently,
and are invaluable to not only the progress of
each individual winery, but the Virginia wine
community in general.

On the other hand, Chris's approach to
winemaking is to focus on the nuances to bring
out the best possible flavors with the least possible
astringency or bitterness. In order to keep bitter
tannins from grape seeds out of the wine he
manufactures his own gravity, using, of all things,
a forklift to hoist bins high into the air. In this
way the wine can be moved from one container to
another without using pumps that could spread
bitter tannins into the wine.

Chris believes that brand-new oak barrels
impart too much astringency to red wines so he
has negotiated with a California winery to buy
their barrels after the first season. He also believes
that a wine should have a relatively high amount

of alcohol to boost the taste. He says, "Our wines tend to be a little higher on the alcohol side – middle 13, upper 13 percent range. I think if you have a well-made smooth wine, alcohol helps to accentuate flavors. It makes a softer, broader statement of fruit and more complex wine."

Chris prefers not to use sugar to boost the alcohol content in wine even though this is a widely adopted practice in Virginia and even France. Rather, he makes or buys concentrated grape juice when the grapes that he uses are not high enough in natural sugars.

Not all of Chris's wines are high in alcohol, however; He says his Riesling has 2% residual sugar and 12% alcohol. He achieves this by refrigerating the wine to stop the fermentation before it is complete. The result, he says, is a German-style Riesling rather than a California one. Of course the world's best Rieslings are made in Mosel, Germany and Alsace, France with the New York Finger Lakes a close second.

Chris has a lot to say about Cabernet Franc, its suitability for the Virginia climate and soils, and the manner in which it should be made and drank. Pearmund Cellar's Cabernet Franc, made with 11 percent Merlot, is "Rich fruit with hints of herb, spice and dark cherry. Touches of raspberries, tobacco, and white pepper." Chris says Cabernet Franc does better in Virginia than

California because "in Virginia we have cooler growing conditions, clouds, summer rains, clay in our soils just like Loire Valley, where France's best Cabernet Franc grapes are grown." He continues, "I think our vines for Cabernet Franc do very well in Virginia. The wines are expressive. They show the *terroir* of Virginia. They show a spice."

Cabernet Franc should be drunk while it is young, Chris says, "Cabernet Franc is not a long lived wine in the bottle. Five years is as long as anyone would want to save this wine. It has a lighter structure that lends itself to younger drinking."

Cabernet Franc, Riesling, Viognier are only part of what Pearmund Cellars is about; cooperation between vintners and growing the Virginia wine industry is what, truly, Pearmund Cellars is all about.

The Cooper

A nondescript sign advertising "mulch" is the only visible indication that this is where wine barrels from Virginia begin their manufacturing process. Nonetheless, here, in a building located on Highway 229, just two miles north of Culpeper and past a flashing yellow light, is where they are created.

Dedicated wine drinkers know that wine, especially red wine, is often aged in barrels. The barrels serve two purposes: First, they impart a pleasant taste as the flavor and tannins locked up inside the oak wood leech into the wine. Second, they age the wine in a slow, controlled manner; such gradual oxidation mellows out the bitter, harsh tannins of a young wine.

When a Virginia winemaker buys oak wine barrels he or she basically has two choices: He can

spend $600 for a French barrel or $300 for an American one. The distinction between the two is found in where the oak tree is grown and not where the barrel itself is manufactured.

French wine barrels are much more costly because the grain of the French oak tree is such that it must be split by hand, whereas an American one can be sawed by machine. That, and the fact there are also fewer acres of oak trees in France than in the vast United States, make for the huge price difference.

There are two different types of wine barrels: Bordeaux and Burgundy. Each is roughly 55 gallons, but one is slightly bigger than the other. The determination of the size of these barrels is the result of empirical observation as to the optimal surface to volume ratio. For example, home winemakers cannot use smaller wine barrels because they put too much oak in the wine.

This brings us back to the 124-year-old Ramoneda Bros., LLC, company that now resides wholly in Culpeper. Vincent "Vic" Charles Ramoneda, 44, shares ownership with his 76-year-old father, Vincent Louis Ramoneda, of this seventeen-acre property and stave mill. Ramoneda runs the business with his father, and also sits on the planning board of the city of Fredericksburg.

Sporting a close-cropped black beard and jet-black hair, one could easily imagine Ramoneda

playing Escamillo, the toreador from Bizet's opera "Carmen." While he looks like a Spaniard, he was actually born in New Orleans and his ancestors, including their brothers and cousins, however, have been and still are in the cooperage business in Barcelona, Spain.

In 1880, Ramoneda's great-grandfather went to New Orleans and started brokering oak staves for shipment back to Spain. He established the current company there; after that time, his brothers started buying stave mills throughout the South.

"We've been selling Virginia oak and American oak into Spain for over a hundred years," Ramoneda says. "When I was a child growing up in New Orleans, at one point we had three mills ... this one in Culpeper, another in Northwest Alabama, and one in eastern Texas. [Our] customers were mostly European."

Ramoneda Bros. over the years gradually closed the other stave mills. Ramoneda himself first moved full-time to Virginia in 1989, and his father followed a few years later. Their original Culpeper mill was opened in the 1950s about a quarter mile from their current location, which employs seven workers. The company obtains its white oak in an area that forms a 180-mile radius around the current site.

The stave mill is actually three operations: a hog mill, a stave mill, and a bolt mill. The bolt

mill cuts oak logs into quarters, while the stave mill cuts the quarters into staves, and the hog mill grinds up whatever is left over into mulch.

As a forklift goes "beep, beep, beep" across the lumberyard in the background, Ramoneda explains his business. "Basically this is where the blocks come in," he says. "They get quartered. We measure logs in the yard, and cut them with a chain saw. Then we bring them in here and cut them into halves."

Showing off a 100-year-old white oak log, he explains that the circle saw, located in the bolt mill, cuts the logs in half and then cuts them again. The upright band saw, located in the stave mill, cuts the quarters into staves. The stave mill is a precision piece of equipment designed for only one purpose, as Ramoneda makes no other use for it.

Overhead is a conveyor. It ferries the quarters to the upright band saw, an elaborate affair with many moving parts, whirring gears and heavy-duty chains and teeth. A series of transfer chains, turntables, and belts nudge the log along and position it so that it can be cut.

"The critical part is [asking yourself] how do you feed these irregular pieces which are short through a saw and do it consistently," he says, adding, "You give them a nudge to get them into the process."

Stacked behind the mill at Ramoneda Bros.

are row after row of oak staves that have turned grey, as they have dried over an average 2-year period. The boards are carefully placed so that air can flow around each stave. When they are shipped overseas to Europe or by rail to California the coopers sand them to restore the lovely color that you see in a winery's cellar.

So, why do winemakers in Virginia, Spain, and California seek out wine barrels made from Virginia oak? According to one pioneer in the field, Virginia's wood is more subtle than oak from other parts of the United States.

This pioneer would be Duane Wall of Tonnellerie Française Nadalie in Napa Valley; one of Ramoneda's customers. In 1980, he and Jean-Jacques Nadalie set up an American branch of this otherwise Bordeaux firm. Most Virginia winemakers know Wall as he has many customers in the East.

Wall characterizes Virginia oak as having, "less oak dominance, more subtle and vanilla characters than what you would find in Missouri, which is at the other end of the scale. That has a significant amount of flavor and aroma. Virginia oak is much more subtle, which tends toward French oak, which is [also] very subtle."

Stephen Barnard of Rappahannock Cellars seconds that opinion. "It releases a lot of silky tannins," he says. "A lot of the other American

oaks [have] chalky tannins." With Virginia oak, "You get cigar box and cedar smells and aromas, almost chocolate [like]. It's beautiful wood. It's neither dominant nor overpowering [and] very complimentary for the wine."

The grain of the white oak tree is considered unique in that it is impermeable to moisture because of what are called medullar rays that emanate from the center of the tree. Thus, it can produce wine barrels that do not leak. Even red or black oak trees would leak if made into barrels.

But, what makes Virginia oak different from, or of apparent better quality than, those in other regions? It is, in fact, a different species, Wall says. The dominant white oak in Virginia is called *quercus alba*. In Missouri the dominant oak is overcup oak *(quercus lyrata)* and in Minnesota it is the burr oak *(quercus macarapa)*.

Nadalie sources its oak staves in Minnesota, Missouri, Pennsylvania, Oregon and Virginia. Wall explains that his customers often ask for Virginia oak because, "They like the flavor components of that oak."

Are there variations in climate that make *quercus alba* grown in Virginia different from that found in other regions? Wall says that Virginia has less intense winters and the growing region is longer here.

One of the few books in English on the

6 0

construction, use, and maintenance of oak wine barrels is "Cooperage for Winemakers," written by Australians Geoffrey Schahinger and Bryce Rankine. The authors say there are a handful of forests where the French farm oak trees for cooperage; the most famous of these are Limosin, Tronçais and Nevers.

Napoleon II ordered that the Tronçais Forest be planted with oak trees to ensure a steady supply of tall trees for sailing ship masts. They were placed close together and managed so that they would grow tall and straight. The French no longer need masts for their war ships, but Napoleon's vision provided by happenstance straight trees ideal for cutting into staves.

The book illustrates how oak barrels are manufactured. For example, to make the stiff boards yield and curve to form the bilge (bulge) in the barrel one uses steam or fire. Nadalie uses fire only because some people believe steam takes away flavor. As the wood is bent a chime hoop is pounded around the middle as a cable draws the other ends together. A fire made from oak chips is set inside the barrel to blacken the inside and further enhance the flavor of the wine.

Wall adds a final thought as to the stature of American versus French oak.

"French oak has been the one which has been used a standard and is still used as a standard

because it's what we all have grown up with. It's what we all know as the flavor component of what we see in wines."

"Now the American oak [has been] coming on strong over the years and [now even] stronger and stronger," Wall continues. "And in time probably the American oak will take a dominant position, but that may take a number of generations."

The Enologist

Marcus Porcius Cato, consul of Rome in 195 BC, provides several recipes for making wine in his widely-read book on viticulture, winemaking, and farming "*De Agricultura.*" To make what he calls "Greek Wine" you ferment grapes, boil the resulting wine, pour in some salt water, add camel's hay and sweet reed, and then decant the wine into amphorae. Put it outdoors for two full years in the sun then it will be ready to drink. Adding his own tasting notes and commentary Cato writes, "This wine will be no worse than Coan."

Had Cato lived in modern Virginia instead of ancient Rome he might have turned to Virginia Tech for enological, or winemaking, advice. For his salty and perhaps sour wine might have benefited from the technical advice that Virginia

Tech provides free to bonded wineries in the state.

Virginia is fortunate; the Dominion State has engaged Dr. Bruce Zoecklein to run the enology-grape chemistry group at Virginia Tech. Dr. Zoecklein literally wrote the book, as it were, on wine-grape chemistry. His "Wine Analysis and Production" is so important to wineries in Chile, Uruguay, and Argentina that the South Americans have translated it into Spanish – there it is called *"Analisis y Produccion de Vino."* It is used as a textbook at Fresno State and at University of California, Davis, the holy grail of enology programs.

Alan Kinne is a winemaker at the California central coast winery Martin and Weyrich. He worked for many years at many different Virginia wineries before the California lured him out west. Alan says that Virginia is lucky to have on-hand an enologist of Dr. Zoecklein's caliber; "Virginia owes [Zoecklein] a big debt of gratitude for what has happened. He could be anywhere – in California, in Europe. People in Virginia should be thanking their lucky stars. Certainly Bruce could go anywhere."

Dr. Zoecklein explains why his work is important for Virginia vintners: Most of Virginia's boutique wineries are small operations that lack chemistry expertise, he says, "Most of these people are sole proprietorships. They are wearing lots of

hats, and most of them are not chemists." So when the winery needs help in making their cloudy white wine turn clear or getting rid of foul odors, Virginia Tech steps in to help.

When Dr. Zoecklein came to Virginia in 1985, at the urging of governmental, university, and wine-business leaders, his cohorts in California cast a spurious eye at him and suggested that he "was going the wrong direction on the map." Dr. Zoecklein explains that it's no secret that most Virginia wines in those days were not of good quality, although through his extension work, his writing, and his advocacy he has convinced Virginia winemakers to adopt advanced techniques like micro-oxygenation (to improve texture and aroma) and délestage (to reduce bitter tannins found in the grape seeds) in an effort to improve their wines. He also spreads his lore by teaching graduates students, who hopefully will work in the Virginia wine industry. Although this practice did not pan out at first: Dr. Zoecklein's first students bolted to Ocean Spray and other high-paying positions; he says, "They went for the bucks."

Virginia produces fine wines today, but there still is not general agreement on which wines are best suited to the state's climate and soils. Opinions are as varied as the terrain, Dr. Zoecklein says, "This is still an embryonic

industry. It's still safe to say that for the most part we still don't know which grape varieties to plant and how to grow them. That's one of the issues that we are looking at in my lab."

The process of finding the proper grapes for Virginia is painfully slow, He explains, "You have to harvest grapes, make wine, age wine, and have them undergo sensory evaluations, et cetera, which requires both a lot of time and some subjective measurements." In short, he couples wine tasting with a more exacting scientific measurement of wine quality. And, in the end, hopefully, this process will arrive at some clear-cut judgments on what is truly best for Virginia.

66

Regarding terroir and wine sales, Dr. Zoecklein says that he would like to see the Petit Manseng grape do for Virginia what Pinot Noir has done for Oregon; that is, put in on the radar of the wine-buying public. Dr. Zoecklein insists that not all Oregon Pinot Noir wines are good, rather, "it's a function of a few good ones and some real good marketing"

Petit Manseng grape, which comes from the Jurancon appellation on the French-Spanish border, produces honey-colored wine that smells and tastes of honeysuckle, cinnamon, and almonds. Of its suitability for Virginia Dr. Zoecklein says, "Viognier does pretty well here. It's already established with a track record, but

Petit Manseng will provide some unique regional distinction."

Dr. Zoecklein would also like to see Virginia plant and bottle more Petit Verdot and Tannat: Petit Verdot is a Bordeaux red wine grape that is widely planted in Virginia, and Tannat is red grape from the Madiran region of France, which is also widely planted in Uruguay; Tannat is, as the name implies, tannic so it has texture and holds up well under aging.

Dr. Zoecklein does not want to pick favorites by listing any Virginia wineries by name. But you can buy Petit Manseng varietals from Chrysalis Vineyards and Horton Vineyards. Petit Verdot is bottled as a varietal by AmRhein Wine Cellars and Veritas Vineyards. Linden Vineyards adds 50 percent Petit Verdot into their Bordeaux Style Blend called "2000 Glen Manor Red." And, as for Tannat, Horton bottles it as a varietal and adds eight percent of it to their Cabernet Franc, while Veritas Vineyards bottles it under the name "Othello."

The Growers

It has become a cliché that "good wine is made in the vineyard," but growing good grapes requires a lot of time and expense. The growers interviewed for this article want to produce good quality fruit, but some have said they also want to be compensated for the extra expense of meticulous canopy management.

Most Virginia wineries both grow their own grapes and buy them from other growers. An inherent conflict exists, however, between the grape grower and the winery. In order to make a profit, a grower needs to get a high enough price per ton of grapes or produce a large enough harvest. The winemaker, however, wants the grower to restrict his or her output in order to produce the highest quality fruit. Also, in certain cases, the winery may want the grapes harvested

later. This concerns Virginia growers because federal regulations mandate that they quit spraying the grapes a certain number of days before harvest, leaving them to the whims of a rainstorm or other acts of Mother Nature.

Three such growers are, for instance, not producing a profit on their farming operations. In order to produce high quality fruit they prune, hedge and toss away valuable clusters; in doing so they toss out revenue as well.

The growers have said they would prefer a system where they are paid by the acre rather than the ton. That way they can produce a profit while the financial cost of "dropped fruit" is paid by the winery. At least one Virginia winery, Linden Vineyards, is doing exactly that. Such an arrangement also pays the grower for the winery's decision to wait until the last possible moment to harvest the fruit.

Several growers and wineries have said that Jim Law is one of the best fruit growers in Virginia. His canopy management and winemaking seminars at Linden Vineyards are well attended, and he is a recognized expert and writes articles on canopy management for *Wine East* magazine. "Linden buys grapes from Shari Avenius (Avenius Vineyard) and Jeff White (Glen Manor Vineyard)," Law said in a recent interview. "We actually buy 'acres' rather than grapes. Both

are also full time staff at Linden. It is a very unique arrangement and focuses on rewarding quality for both grower and winery."

Law pays his growers a flat fee of $7,000 per acre but said, "It's going up." In the case of severe crop damage (hail, frost or freeze) he pays a per tonnage price. His target yields are three to three-and-a-half tons per acre for red grapes, three to four tons per acre for Chardonnay, and four to five tons per acre for Sauvignon Blanc. Law's per-ton prices are $1,600 for Sauvignon Blanc, $2,000 for Chardonnay, and $2,300 for red grape varieties.

In a *Wine East* article, Law wrote, "At Linden Vineyards we follow a regime of canopy management that is implemented by most premium winegrowers worldwide. It is not magic, it is not revolutionary, it is expensive, and it works. The goal is to have a canopy that is uniform, thin, and open to sun, air flow and spray coverage."

Linden's grower contract spells out the canopy management practices that the grower must follow: "[Dr.] Richard Smart's book "Sunlight Into Wine" outlines the principles that we believe make for quality winegrowing in Virginia." The contract stipulates that the growers should practice shoot thinning, shoot positioning and tying, leaf pulling, hedging, and cluster thinning.

Bob and Doriene Steeves have been farming

grapes on their Stanardsville vineyard, which is located between 600 and 800 feet of elevation on a fairly steep slope, for ten years. During the week Bob Steeves works for the Food and Drug Administration and Doriene Steeves works for John Warner, a Republican senator from Virginia. Their vineyard was a tangle of Riesling grapes that had not been properly managed when they first saw it. Steeves said the previous owner did not spend any effort working with the canopy, but simply ran the sprayer and lawn mower.

They have added 3,000 red wine grape varieties to the existing 3,300 Riesling vines, and now have about 10 acres of grapes. On the weekends they drive down from their home in Fairfax to work the vineyard, where they spray, kill weeds, and thin the canopy to produce the best possible fruit.

Steeves willingly talks about the financial aspect of grape farming, but says that even after 10 years in the business he has yet to make a profit. He sells his Riesling harvest, which is expected to be 16 tons at around $1,500 per ton, to three buyers: Jefferson Vineyards, Afton Mountain and Chris Pearmund. Bob projects a crop this year of 15 tons for his Cabernet Franc, Merlot, and Cabernet Sauvignon vines, which nearby Stone Mountain will pay $1,350 per ton plus harvest it themselves.

These prices are generally in line with statewide averages. According to the Virginia Agricultural Statistics Service average prices paid in 2002 were $1,430 for Chardonnay, $1,354 for Cabernet Sauvignon, $1,562 for Merlot, and $1,801 for Viognier.

Like other growers, the Steeves use outside labor several times per year to work on the canopy. They do the winter pruning of the grapevines themselves over a three-month period from January to the end of March. The Steeves would prefer to be paid by the acre rather than the ton: "I think that would be the fairest."

He suggests that one reason there are so many wineries in Virginia is that farmers who cannot make a profit farming grapes obtain an ABC license and then open a tasting room. He wants to do that as well in the future.

Nelson County grower John Saunders has plenty to say about the notion of crop level. "If the wineries had their way they would have you cropping it at two to three tons per acre, but you can't make money at that," he said.

Not only does thinning the crop reduce tonnage and thus profits, it increases costs. "You need to find a happy medium with your grapes," Saunders said. "If you under-crop or over-crop then the winery is not going to be happy."

Saunders farms 4.5 acres of Chardonnay,

4.5 acres of Cabernet Franc, seven acres of
Merlot and two acres of Cabernet Sauvignon.
The vineyard, which is between 880 and 1,100
feet of elevation, rises straight up above river
bottomlands to the hills above his pastures toward
the George Washington National Forest. The
grapes are planted on the slopes above the pasture
bottomlands to get above the killing frosts; he also
farms 250 acres of apples there.

The first vines were planted in 1999. "We
have not made a profit yet," he said, but he is
incurring additional capital expenses each year
because he is taking out apple trees slowly and
replacing them with grapevines. One advantage
is that he did not have to buy any equipment
because he already owned much of it for his apple
growing business. Saunders employs ten laborers
year-round, and also uses seasonable help; during
harvest he has 35 laborers working with both
grapes and apples.

Saunders says he gets a crop the second year
the vines are planted. He does this by irrigating
the vines thoroughly. Textbooks on viticulture
would say that you must wait three seasons to
produce a harvest from newly planted vines, but
he is able to cut one season off his cash-flow-
projection in this manner.

Debi and Tom Flynn live in Madison County.
When they are not hauling cargo as pilots for

Federal Express they are at work at their Quaker Run vineyard pruning vines or spraying foliage. The Flynns have planted eight acres of Merlot, two of Chardonnay and four of Viognier on a perfectly positioned vineyard located on former apple orchard land at 900 to 1,000 feet of elevation.

They are trying to focus on quality, and have not yet made a profit. Their up-front capital expenditure to establish their vineyard has been "enormous," according to Tom Flynn. Last year they produced a crop on eight acres of grapes, by 2004 they hope to have a crop to sell from their entire 14-acre planting.

"After five years the numbers look pretty good, but you will lose money for every year until five years," he said. Have they made a profit yet? "Absolutely not," he added. "We would love to break even."

In the first few years of their vineyard, the Flynns used their rotating piloting schedules to work the vineyards themselves. "We used to kill ourselves," Debi Flynn said. "You get real sick of grapes, being out there until eight o'clock every night." Now the Flynns have hired one full-time employee and use migrant workers to do the initial pruning and to gather the harvest.

As one of the more experienced grape growers in Virginia, Chris Hill has been growing

grapes since 1981 in Albemarle County. He has been a past president of the Virginia Vineyards Association, but now farms 11-and-a-half acres of grapes and is a local vineyard consultant.

He makes both an operating, cash flow, profit and a net income profit from his grape growing and vineyard consulting businesses. "In a good site you ought to be able to have an operating profit," Hill said.

Some of the newer growers, he added, might not be making a profit because they are including non-operating costs, such as mortgage interest, in their operating profit calculation. "If you want to make a profit it helps to produce the second year," Hill said, which is what Saunders is doing with irrigation.

"Who in agriculture in the state of Virginia is making money?" Hill asked. "All the peanut growers have left because the peanut [price] support program was cancelled last year. Agriculture is not a way to make money. But grapes give you a better chance than other crops."

Jonathan Pond is a grape grower and attorney working in Richmond. His wife, Lindy, is president of the Virginia Vineyards Association. Pond has written grower contracts for several wineries and growers and has often wondered whether the issues of quality and price could be included in those contracts.

"Jim Law's 'by the acre' method is one way of allowing the grower to focus on quality without fear that he will be hanging out there all alone if something goes wrong," Pond said. "In exchange for per acre pricing, the grower hands over some management decisions to Jim."

He has also looked to California to see what growers are doing there. It turns out there is no standard way to measure the quality of the harvest. The state steps into the relationship between the winery and grower, however, by using third party inspectors to measure a grower's harvest and the extent to which it meets the grower's obligation with the winery. Based on the results of the inspection the price paid to the farmer is adjusted downward. The inspections measure the amount of rot in the harvest, the amount of MOG (material other than grapes) and the sugar content for contracts that stipulate a price paid based on percent soluble solids (brix).

"Quality is beyond our realm," said Gary Manning of the California Department of Food and Agriculture. "They take our information and how they use it is up to them."

"A wise grower will use a contract that places the burden of a 'bad' harvest decision on the winery, though," Pond added. "I have seen some 'long-term' grower contracts from California. Some begin with the year of planting and extend

for five or more years. With these caveats, I think
long-term grower contracts are feasible in Virginia,
particularly for wineries who need to expand
wine production, but don't want to take on the
additional acreage themselves."

The Grapevine Nursery

*No vineyard could exist without grape vines.
And most Virginia growers have bought grapes from
Madison County resident and German native
Joachim Hollerith.*

The day I went to see Joachim Hollerith,
owner of American and Lake County Nursery, the
temperature had dropped to two degrees at my
Rappahannock County vineyard – Rappahannock
is next to Madison County, where Joachim lives.
So it was a fortuitous time to talk about the
vagaries of viticulture here on the sometimes-cold
East Coast.

Joachim's experience with the weather is
nothing short of a mélange of time spent in the
vineyards and wineries of Germany, Virginia, and
California. He is well equipped to comment on

the ability of *vitis vinifera* grape wines to weather, well, the weather.

While Joachim calls Madison home, and work for that matter, his actual nursery is in Lake County, California, just a bit north of Napa and Sonoma counties. There he produces 2.2 million grape vines each year that he sells to vineyards both in Virginia – Barboursville for one is a customer – and around the nation.

Joachim describes himself as an old-timer in the Virginia wine business; he came to Virginia from Germany in 1978 to start Rapidan River Vineyard just one year after Gabriele Rausse started planting *vitis vinifera* (old world European) grapes at Barboursville. Joachim says prior to that mainly French hybrid vines were planted here.

Joachim was the general manager at Prince Michel winery and vineyard for 14 years. His family has been in the wine business in for 300 years in Germany where they operate a 25-acre vineyard and winery, producing 5,000 to 6,000 cases of wine per year. Joachim sports a beard and handlebar mustache so, together with his German accent, he appears to be someone out of one of the novels of Thomas Mann.

To understand the importance of Joachim's craft one needs to hear Joachim explain the raison d'être for the art of rootstock production and grafting. This is, of course, the phylloxera louse;

he explains that the phylloxera is native to North America, and this pest likes to eat grape vine roots thus killing the vine. But American vines have lived with this pest for thousands of years and have thus become phylloxera resistant.

In the 1850s some American or Frenchman unwittingly transported this pest to Europe. The results for France, Germany, and Italy were disastrous for this hungry pest spread throughout the continent, eating grape vine roots, and wiping out the entire industry in France, and severely decimating the other countries there.

Here is where Joachim tells a tale that diverges from the words of the viticulturist and wine writer Philip Wagner, perhaps owing to some intercontinental rivalry. Mr. Wagner says the Americans went to Europe to resurrect the European crop. For that they were awarded accolades (*Croix de Guerre*, *Palm d'Or*, or something similar) by the grateful French such as those bestowed on Louis Pasteur who, of course, explained the chemical process of fermentation. But Joachim says it was the French who came to America. They reasoned that if the phylloxera was endemic to the States then perhaps the native grape vines there might produce rootstock that could be grafted on the scion (i.e. the top part of the vine) of the European varieties. This would produce vines that could tolerate this pest. We

will have to let some other historian wrestle with this issue, but the point is both continents worked together to solve a problem that was accidentally created by the Americans.

Joachim says the early grafts were made with *Vitis Riparia* and other American varieties, and that the early results were satisfactory; they kept the phylloxera at bay. But the art of grafting needed fine-tuning to the point that it has now become a science. Indeed, it is a science for Joachim.

Joachim explains that you have to match the proper rootstock to the proper vine to produce the proper results. For example, the Culpeper Loam soil, which is dominant in Rappahannock and other counties, produces highly vigorous growth. Of course, grapevines that grow too rapidly produce too much foliage, which must be trimmed, back in order to improve ventilation, exposure to sunlight, et cetera. So, for Virginia vines growing in red clay, a low-vigor rootstock is used. Joachim grows rootstocks for low to high vigor scions; sandy, medium loam, or heavy soils. Their names are cryptic ones, perhaps not known by the average wine drinker: 3309, 101-14, SO4.

American and Lake County Nursery gets all kinds of customers. There are the professionals who have owned vineyards for a long time, and then there are people with somewhat less

8 2

experience. Joachim gladly answers their many questions. And then there are the absolute beginners who "don't know anything." Joachim spends much time on the phone with these budding vineyard growers, referring them to books and web sites, and urges that they become educated. He suggests they visit other growers to see what they are doing. "Travel," he exhorts, to Europe and California as well. Check with your county agent and state viticulturist.

What portion of his customers are wineries versus vineyards? Joachim could not say, but he says he sells to both. He does a lot of business in Virginia selling to all grape-growing regions of the state. That very morning he had a voice mail in his Madison office from a new customer near Charlottesville, who wanted to plant one or two acres to get started in viticulture or perhaps wine making; Joachim surmised that the customer might buy 800 to 1,600 plants. He said he would give the new grower some advice and sell him some plants this spring if he has them in stock. Usually orders are made far in advance of their delivery date because of the time it takes to graft the vines.

The nursery produces three products: (1) rootstock, (2) dormant rootstock, and (3) potted green vines. Rootstocks are, of course, the part of the vine that becomes the roots. He grows vines

for this purpose, makes a cutting, and then plants
the cutting in the vineyard. For grafted vines,
or dormant rootstock, he plants the rooting in
the vineyard and uses a technique called "field
grafting" – he makes a small t-cut in the rooting
and slides in a bud from, say, a Chardonnay
vine – After grafting the vines get callused (i.e. a
callus or scab forms), then planted in the vineyard
for one growing season from May until about
Christmas. Then he digs them out and puts them
in cold storage for shipping to customers in the
spring. The final product he produces are green
plotted plants sold only in California because of
shipping considerations. A green potted vine is a
grafted vine that is only a few months old and not
one year old like grafted dormant rootstock. He
grafts them, calluses them, and then puts them in
a pot in the nursery. These are sold in June when
the vine has pushed up a shoot of ten inches.

What changes in orders has he seen in recent
years coming from Virginia growers? Joachim
said he sees more orders for red grape varieties
now including Cabernet Sauvignon, Cabernet
Franc, and an increase in Petit Verdot, even some
Syrah, and regarding hybrids, he sells Vidal Blanc,
Chambourcin, Traminette, and Chardonnel. Of
hybrids, Joachim says that if you do not have a
good location, one where you can avoid early and

late frosts and winter injury, then you might have to stick to growing hybrids.

With 25 years in the business, Joachim sees people making the same mistakes over and over again. They own some land and want to plant some vines; simple as that, right? So they engage the viticulturist Tony Wolf, who visits their site. He will tell them their site is not good, yet they plant anyway and "have a disaster." The 2-degree temperature on January 18, for example, would have killed Sauvignon Blanc buds. Worse, for people at lower elevations or in frost-pockets the temperature might have gone five degrees lower than that on that day. Contemplating the possible damage to his customers, Joachim wondered aloud "perhaps I have to make some phone calls."

Growers will be interested in what he has to say about cold weather viticulture practice. Growing multiple trunks is recommended – that way if one is killed another might just survive. He stresses that over cropping a vine, that is, growing more grapes than the roots can support, will weaken a vine. The vine's shoot must have time to harden into canes; there must be ample carbohydrates and starch in the dormant wood – if the tissue remains green then it can literally burst open in the winter causing loss of buds, increased crown gall, a bacteria that thrives on fractured wood, problems, and even loss of the entire scion.

Rarely is the whole vine lost, because if the top
is killed it can be sawed off and field grafted. But
still, this is a disaster for the grower, because of the
lost crop for a year or more.

Cabernet Sauvignon is particularly
troublesome because it "wants to grow until
Christmas." Also, young vines that are not yet
producing fruit are susceptible to cold-weather
injury because they go dormant later than mature
vines.

Joachim also says if you don't spray the vines
after the harvest then powdery and downy mildew
can cause the leaves to fall off or shrivel up early,
thus robbing the vine of its ability to turn sunlight
into sugars – the vines need this stored-up food
to survive the winter and early spring until leaves
start growing again. Carbohydrates and starch are
sugars, thus "they dilute the concentration in the
cell." This is why, Joachim explains, the cells in
the vine will not freeze if they have enough sugar
in the wood and dormant buds.

Joachim also recommends that growers use a
grape plow or other technique to make a mound
of dirt around the graft union of the vine for the
winter. This of course has to be removed in the
spring because the scion could sprout roots thus
defeating the purpose of the graft. But, Joachim
says many growers do not follow this advice
because it is a lot of work.

A good altitude for grapevines is 800 feet with 600 feet to 1200 feet being a suitable range. Although, high altitude can be just as bad as being too low. This range's relatively warm environment, free of frost and biting cold, owes its relative temperateness to thermal inversion. Meaning that cold air sinks to the bottom causing warm air to rise up the slope. This means that having a location with good air drainage is important, as well as meaning it should have some slope.

Joachim talks about the economics of viticulture: Twenty-five acres is enough to make a suitable income either here in Virginia or in California. In California the growers obtain contracts of seven years from the wineries, and then go to the bank to borrow the money to plant the vines. Other growers, however, survive on the logic that they have enough cash and they can simply start their own winery if they cannot sell their grapes.

When you start a vineyard it takes three years of cash expenses before you can realize any revenue, Joachim warns, "It's a high capital investment. Of course it's agriculture – Agriculture is always ups and downs because of drought, [et cetera]. The return is profitable if the market is good."

He advises to find out which varieties are suitable for your location and decide on the tons per acre, or crop level, you want to produce.

California growers also need to know their appellation (e.g. North Coast). Also, spraying and labor costs are higher in Virginia. Joachim says it would cost $400,000 to start a vineyard of 25 acres. Twenty-five acres at four tons of grapes per acre would yield 100 tons per year, which could be sold for an average of $1,500 per ton. This is $150,000 gross revenue. The math adds up to support Joachim's warnings.

"It's a fun lifestyle and you make a good living. We are much more vulnerable here because of the weather. I don't want to be negative; I want to say be careful where you plant your plants. Location. Location. Location."

The Perfectionist

Jim Law is a perfectionist in both the vineyard and cellar. He knows his wines are among the best in the state, and has made it his mantra to teach his technique to others: To promote his philosophy, and no doubt his business, Jim authors articles regularly for Wine East *magazine and holds regular seminars on grape growing and winemaking at his Linden Vineyards.*

In late spring of 2003, I motored off in my car to Jim Law's Linden Vineyards for a canopy management class. Jim Law is a sort of high priest of viticulture on the East Coast – some say he is the best fruit grower on the Atlantic Seaboard. From his mountain vineyard, located at some 1,300 feet, Jim preaches his vision: Perfection in the vineyard leads to the premium quality wines;

work done in the cellar is of lesser importance than work done in the vineyard.

That Linden is perhaps different from other Virginia wineries is apparent as soon as you walk in the door. While the basic tasting is free of charge, guests may engage in a special tasting in the cellar for $10. But, his wines merit the price. This is because he spends a lot of money on viticulture – the resulting wines he makes are among the best in the state. *The Virginia Wine Guide* rates his 1998 Glen Manor Red a 93 on the UC-Davis scale, the highest rating to date given by that panel of professional tasters.

The tasting room at Linden is large and has the look of a chalet. There you can buy venison sausage and goat cheese along with, of course, copious amounts of Linden wines. There is a classroom upstairs, where the canopy management and winemaking seminars are given. Downstairs is the tasting room as well as a restaurant-type setting where you can sit and look out at the marvelous mountain vista while you sip wine and dine on cheese and sausage. The window below this room is trimmed with a giant rootstock vine growing outside. I noticed it right away because it had no fruit and the axils of the leaves were red rather than green.

I first met Jim Law in February of 2003 when I drove over to his vineyard during the heaviest

snowstorm of the year. He invited me to a cellar tasting, which was actually cancelled because of the 35 inches of snow that fell on his winery. A girlfriend and I stood there looking down Jim's mountain as cars slipped and slid; most failed to make the ascent up the steep drive.

Jim does not have the look of a typical Virginia farmer: He sports a ponytail and his demeanor is such that prima façie you would think he hails from California. Being bombarded daily by questions from rank amateurs, he can seem a little standoffish the first time you meet him, but if you have a genuine interest in wine Jim will warm to you rapidly. Like so many other Virginia *vignobles*, Jim holds back no secrets. He willingly tells all that he knows to anyone who wants to listen.

Jim knows his business and his craft; he says that in order to make the best wines in Virginia, one needs to understand what are the best wines in France, Italy and beyond. Jim reads widely in the English and French-language press about winemaking techniques and viticulture. He travels to France, Hungary, and beyond to fine-tune his own winemaking skills by talking with winegrowers worldwide. To understand what makes a truly fine wine Jim spends a small fortune each year buying up the best wines in the world and sharing them with his winemakers and

viticulturists Jeff White and Shari Avenius.

Jim came to Virginia in the early 1980s to work in the wine business. After working one year at a winery and vineyard he said he was an expert because, "I had one year more experience than anyone else." He says the wines made in Virginia those days were truly bad, because growers did not understand nor adopt the most modern viticulture practices.

Jim believes that the best wine is made from the best grapes – it is as simple as that. His approach to winemaking is "non-interventionist," meaning that sound grapes, ones free of disease and properly ripened, will make proper wine all by themselves. He prefers not to doctor up his wines by adding too much acid or tannin. He says if the winemaker spends more time in the vineyard than in the cellar then the resulting fruit quality will make premium wines with little intervention required from the winemaker. He writes in one of his articles in *Wine East* that the only time he spends in the cellar is when it is raining.

Jim does not participate in Virginia's two annual events held at the Great Meadows in The Plains; neither does he host winemakers dinners favored by so many wineries. His explanation for this is that he can make better wines by focusing on his vineyard than focusing on its marketing. The quality of his wines will eventually draw in

the customers needed to sustain his business. That mantra has certainly worked; he boasts ever so gently that he no longer has cash flow problems and even was able to afford to buy his own $30,000 bottling line while most wineries use a portable bottler, which travels from winery to winery.

Jim says the evolution of a new winery goes something like this: At first the winery plants their vineyard and "it looks beautiful." But then they start to build their cellar and tasting room, thus distracting the owners by all the details of architecture. Next, they bottle some wine and worry about selling it, in order to defray some of their heavy up-front expenses. Then it's to festivals, hosting winemaker's dinners, and otherwise paying too much attention to the business of, well, business – and not nearly enough to working with their grapes. So their pristine vineyard begins to suffer. They still produce good wines, but they don't produce great ones. The distinction between the two is subtle, after all. You can only go from producing good wines to great wines by paying astute attention to the countless nuances that eventually wind up in the bottle. For Jim, the great majority of these are the importance of canopy management, work that is done in the vineyard.

Before even getting into a discussion of Jim Law's devotion to perfection in the vineyard, one

must understand what "canopy management" specifically means. "Canopy management" means the practice of taking care of the grapevines so that they produce the optimal level of fruit and foliage that will produce the best possible fruit. After all, "wine is made in the vineyard." By this Jim and so many others mean that good wine can only be made from good grapes. Grapevines are like roses. They must be meticulously clipped and pruned throughout the growing season and winter if they are to properly produce ripe fruit. Grapevines left to their own devices would grow like a jungle producing too many leaves. The fruit would never ripen and it would taste herbaceous and green.

94

Jim, like most growers, practices canopy management as the Australian viticulturist Dr. Richard Smart advocates it: Dr. Smart starts at a basic precept; he mocks the notion that only the French can make premium wines. The reason that the wines of Bordeaux and Burgundy are of such good quality is the soils there are meager, thus the grapes grow slowly concentrating their sugars and flavor in the fruit and not into the leaves. Dr. Smart says what is really happening is that such slow growth simply produces fewer leaves, so the grapes get the proper amount of sunlight. Grapes grown on rich soils high in organic material produce too many leaves. Thus, too little light reaches the fruit. He concludes that there is an

optimal balance between the number of leaves and
the amount of fruit.

Dr. Smart has taken his assertions and turned
them into mathematical formulae, which have been
proven correct by much empirical observation.
To measure the amount of light in the grapevine
canopy, Dr. Smart developed an index. A properly
opened canopy is measured by the number of
flecks of light that penetrate through the leaves
and onto the ground. This is heuristic science, no
doubt. Having proved that the optimal yield of a
grapevine is a function of the vine's annual growth,
Dr. Smart has a formula for the number of shoots
to retain on the vines and the amount of wood to
remove at each annual pruning.

Taking his assertions from the laboratory
to the vineyard, Dr. Smart created several trellis
designs that are designed to make practical his
otherwise theoretical work. A grapevine trellis
consists of the poles and wires that hold the
grapevine aloft. Often the French vineyards don't
use trellises at all; rather, they prefer closely pruned
vines that can stand up by themselves. Still, many
French vineyards do use trellises and have invented
several designs including the French Lyre and the
Guyot system.

In Virginia, however, the three most common
trellis designs are the Vertical Shoot Positioning
System (VSP), the Smart-Dyson system, and the

French Open Lyre. Dr. Smart invented the VSP and Smart-Dyson systems. The lyre is a French musical instrument whose shape, similar to the letter "U," lends itself to the trellis of the same name; it has what is called a "divided canopy" system, meaning there are two curtains of foliage. The GDC system, on the other hand, was invented by New Yorkers in and around the Geneva Research station in Geneva, New York. The same principle applies for both: there are two curtains of fruit, but instead of the shoots growing up, as they do in the French Lyre system, in the GDC system they grow down. Jim Law uses the French Lyre, GDC and VSP systems in his operation.

Jim Law says Dr. Smart's trellis designs do not work well for high-vigor situations common to Virginia. The problem with the VSP or Smart Dyson system is they have a single curtain of foliage. Because grapevines grow so vigorously in Virginia, they will literally burst out of these single-curtain canopies producing enormous shoots of 12 feet or more. The grower will spend much money and time clipping the aggressive vines back to civility. Jim reasons that it is better to give the vines more room to grow by allowing them to grow onto two separate cordons. Dr. Smart does not ignore Jim's ideas, discussing both the GDC and Lyre systems in his book and the relative merits of each.

On the day of the Canopy management seminar I sat in that restaurant area with Kate Marterella and Frank Tuckwiller, a grape farmer from West Virginia, while I sipped Linden's 1998 Glen Manor Red.

At first Frank looked slightly out of place; after all, West Virginia has this stereotypical slower paced image that the state is still finding hard to shake. And as far as growing grapes is concerned, West Virginia might be too cold, for the temperature drops to 20 degrees below zero on a regular basis. But Frank says the temperature at his 3,600-plant vineyard never dropped below five degrees in 2003. Also, the grapevines he has planted, French hybrid vines only, could possibly live through some 20 below zero weather. I was impressed with Frank, an Army Captain in Vietnam during two tours of duty.

Kate is a colorful character. She had gone in 2002 with Jennifer McCloud and other Virginia wine country luminaries on a tour of the vineyards of France. Over there the Virginians marveled at the French vineyard tractors; in France, grapevines are planted so close together that a tractor cannot navigate the rows in between, so the French have very tall tractors that drive right over the top of them. In the mountains of Virginia that might be difficult as your tractor might flip over on its side.

Kate was growing 15 acres of grapes in

Fauquier County on highway 17 near the Aerlie farm where the Warrenton Hunt foxhunting club holds its annual races. She was selling her grapes to Chris Pearmund, owner of Pearmund Cellars, and had plans of building her own winery – Kate was brimming over with enthusiasm about her winery plans. She had already met with an architect to lay the foundation for her tasting room. I looked at the huge diamond on her finger and thought "here is another rich person looking to sink a fortune into a winery." It is, after all, the dreams of such individuals that make the Virginia wine industry a financial possibility.

Other people at the seminar were less outspoken and less clear in their reason for being there. A few were grape farmers hoping to learn Dr. Richard Smart's canopy management techniques, as they are taught by Jim Law albeit in modified fashion. There were a handful of people from far away in Lynchburg, Virginia. Lynchburg is, of course, known more for the Reverend Jerry Falwell and his Moral Majority than for producing premium wine grapes.

Jim has 20 acres under cultivation at one of his vineyards – the other two vineyards belong to his employees. Twenty acres is his ideal vineyard size vineyard. He explains that he still knows every single vine individually even though he does not work the canopy himself. While Jim still

does the spraying, other staff conduct the canopy management labor.

In the end, the primary lesson to take away from Jim's canopy management class is that you must match the proper trellis design to the proper grape variety and soil condition. As a lesson to be followed, Jim showed us a 20-year-old Cabernet Sauvignon vine that had an astounding 24 feet of cordon. Jim said this vine had been planted on high vigor clay soil, and that it would have been better to plant the vine in a poorer soil location, on other locations on his mountain. He said, as expected, that the wine produced from this vine was of inferior quality.

Jim recommends that you try various trellis designs until you know whether your soil is too vigorous to use the VSP – vertical shoot positioning – system. He also says that the VSP system makes the best possible wine grapes, but the extreme vigor of vines grown in Virginia will cause the vines to "burst out" of the canopy. His solution to this is to give the vines more room to grow using the previously mentioned French Open Lyre system or making them grow downward on the Geneva Double Curtain.

The vineyard at Linden, for example, is a collection of the possible soil types. We walked the vineyard and Jim pointed out different areas with different types of soil; because his vineyard sits on

a mountain slope, erosion over millions of years caused certain areas to be pockets of deep clay and other areas to have less deep soil or soil made up primarily of granite. Jim points out that his best wine grapes come from these meager soils.

Jim concludes that it is difficult to project what types of soil produce what amount of vigor, thus he recommends a soil test. If the amount of organic material in the soil is greater than two percent then that is a likely indicator of high vigor. Other indications of vigor are clay, soil depth, and water holding capacity. He suggests getting a map from the soil conservation service, and ask growers with the same soil type what vigor they have observed.

Usually when one plants row crops or contemplates fertilizing their pastures, they order a soil test. This measures the pH (acidity), as well as the levels of nitrogen, phosphorous, and potassium contained in the soil. I had not thought this to be important because I had read that wine grapes thrive in all types of soils, but Jim explained that wine grapes prefer a soil that is in the pH range of six to 6.5, with, of course, a reading of seven on the pH scale being neutral. Numbers above seven mean the soil is alkaline, or basic, and numbers below seven mean the soil is acidic – Thus the amount of deviation from the number seven, in either direction, indicates the level of acidity

present in the soil; however, the pH scale grows exponentially from one point to the next, in either direction. So a soil with a pH of five is much, much more acidic than a soil of pH six.

Jim showed us his soil test report. He disagrees with the soil test report recommendation that suggested he needed more nitrogen. It is important to note that the recommendations on the soil report are based on someone else's opinion, although the actual numbers are based on scientific measurements, such as a pH reading. Like many matters in viticulture, not all experts will have the same opinion on all matters.

Jim says beginning grape growers want to apply 10-10-10 or even Miracle Grow (high in nitrogen) to their young plants. "Sure," he says, "it makes them grow rapidly and they look pretty," but with wine grapes you want low vigor and slow growth. "If your vine is growing during ripening that is bad." Jim says the presence of very large, what he calls "dinner plate" leaves, indicates there is too much nitrogen.

I asked Jim why farmers were spraying Epsom Salts onto their vineyards, and he said that Virginia vineyards are generally deficient in magnesium. Epsom Salts are, in fact, magnesium sulfate. At Linden he sprays five pounds per acre five to six times per year. While you could buy ordinary Epsom Salts at the local pharmacy, it

is cheaper to buy large quantities of it from the agricultural cooperative store.

To illustrate the magnesium deficiency in his grapevines, Jim showed us the results of a petiole, basically the stem, analysis he had taken of his vineyard. After flowering and before fruit set, the grower is supposed to snip off the petiole and send it to a lab for analysis. The lab will measure the amount of minerals in the petiole, thus showing which nutrients are making it into the plant and which are not. A petiole analysis can show a boron deficiency, for example, a common occurrence in Virginia, which can cause a poor fruit set.

Boron and magnesium deficiency are not the only problems one can encounter in dealing with the matter of nutrition. At Linden, the Seyval planted had a poor fruit set this year, owing not to boron deficiency. "Fruit set" means the process by which the grape flowers and then produces fruit resulting from pollination, so a "poor fruit set" means that the grape cluster will have fewer grapes than is normal. Jim traces the problem to a "lack of sun and [the] duration of wetness." A grapevine lives off of stored starch and carbohydrates, sugars, until the newly emerged leaves in the spring can begin to produce food for the plant. But this year it rained almost non-stop and there were practically no sunny days from March until the end of June, causing the poor "fruit set."

Seyval was not the only vine to suffer the vagaries of the weather. He showed us Chardonnay vines whose shoots had been ripped off by a windstorm. Certainly his high-mountain location would be prone to some stiff breezes. Moderate wind is good, because it dries the fruit that accumulates early-morning dew, thus reducing the incidence of disease. But as the cliché says, "too much of a good thing is a bad thing," especially in the case of these battered Chardonnay vines.

On the topic of nutrition through minerals, Jim told everyone his potassium (K) to magnesium (Mg) ratio was at a seven while it should be at a 2. But then on the board he wrote the equation "Mg / K" which is the reciprocal of the function K / Mg. The numerator was where the denominator should be. My college degree in math always at work; a laugh from the crowd.

During a tour of his vines, the first thing one notices about Jim Law's grapevines are how meticulously they are maintained. Jim's workers actually tie each shoot on to the trellis wire of the Lyre trellis system. Such care one might only give to roses; tying each shoot is time consuming and expensive, but Jim says the high winds on his mountain site make it necessary because they otherwise would blow the carefully positioned shoots out of the canopy.

The workers at Linden also trim the vines

of excess shoots, the part of the vine retained from year to year that grows from the cordon of wood, and excess fruit. Each *vinifera* shoot has two clusters of leaves which then become two bunches of fruit. Dr. Smart advocates clipping off extra shoots so that the grapevine canopy will have adequate sunlight and air circulation. But then, how many shoots should be retained? Jim says that the grape vines should have two and a half shoots per foot.

For Petit Verdot, which actually likes to grow downwardly, Jim is using a Geneva Double Curtain (GDC) system also described by Smart; Jim says GDC is best for extremely vigorous varieties like the Petit Verdot. Some varieties, such as Cabernet Franc, refuse to be trained to downward growth. If you try to train it to grow downward it will develop many laterals that turn upward. GDC can look sort of disorganized and unkempt until the grower has time to go into the canopy and brush the shoots downward.

Petit Verdot is one of the five grapes of the Bordeaux region of France. There it is not usually sold as a varietal, but rather it is a blending grape. Jim says that his highly acclaimed 1999 Glen Manor Red was made with 50 percent Petit Verdot, whereas the wines of Bordeaux usually contain 3% of this variety. I like Petit Verdot because it has a wonderful taste, is aromatic, and

has a beautiful purple color. At Horton Vineyards they have barrels of it, so I have on more than one occasion dipped my wine thief into the barrel and drawn out a glass. A couple of interesting facts: It does ripen late, and Tony Wolf of Virginia Tech recommends the grape for Virginia because it is fairly cold hardy.

Jim Law talked about pruning, which is a complicated notion for any beginning grape grower. He told a funny story from a recent trip that some Virginia wine growers had made to the wine growing regions of France. The French asked, "Why don't Virginians do cane pruning" and Jim said, "It's too hard to teach." Jim asked the French "why they don't do spur pruning" and they said, "It's too hard to teach."

Pruning is a complex topic best left to the textbooks to explain, but I will mention it briefly. In Virginia growers mainly practice spur pruning, meaning a grapevine shoot, which at the end of the season hardens into a wooden cane, is pruned back to the number of buds that the grower wishes to retain for the next season. Each bud will in turn produce one shoot that will produce two bunches of grapes each. A bud is formed at the bottom of each grape leaf where it joins the main shoot; the bud will stay dormant, and will hopefully survive the winter, and then next year it will grow shoots for that year's growth.

Cane pruning is widely used in Europe. In fact, in Burgundy the law mandates it. In cane pruning the growers cuts away most of the shoots but leaves entire canes for next season. So the pruned cane looks much different because instead of lots of little shoots there are long canes poised for next year's growth. Pruning is a horrible job by any available measure: Jim starts pruning his vines in November and finishes April 1, which is just after bud break. While pruning occurs in the coldest months of the year, Jim says he rather enjoys it – despite the way the nasty wooden canes slap you in your frozen face.

To speed the work of pruning Jim does what most Virginia growers do, which is to prune the vines twice. The first time he simply cuts away most of the grapevine and then untangles the vines and drags them out of the canopy. These cuttings should be taken away from the vineyard and burned so that they won't spread disease the next year. Later Jim comes back, and, in a slower, more deliberate manner, he prunes the shoots to the proper number of buds.

Winter bud kill is always an issue. Jim adjusts his pruning to compensate for buds, which are killed by below-zero temperatures. Jim says seven degrees below zero is where he tends to experience bud kill. To measure this, he cuts off a cane in winter and brings it inside for a few days to let it

warm, then he slices some buds open with a razor blade, and those that are black inside are dead, those that are green are alive. So if 50 percent of the buds are killed, he keeps twice as many buds on the spurs. For example, if he normally retains two buds at pruning he will keep four instead, since half of them are presumed to be dead. In 1994 he lost his whole Chardonnay crop when the temperature fell to minus 13 degrees.

The initial pruning at Linden is comical. This is because Jim has one worker who is 6' 4" tall, who uses a gasoline-powered hedger. This worker runs down the canopy to do initial pruning. From the distance you can hear the motor run and watch the top of the grape vines topple over as this monster of a man runs down each row. Jim estimates that it takes him 40 to 80 hours per acre to prune. He finished his initial pruning in February.

Jim wants his fruit to be perfectly ripe when he makes it to wine. But grapes on either side of the canopy tend to ripen at different times. The western side of a grapevine is hotter, thus the grapes ripen earlier that those on the east. So, Jim sends his picking crew into the vineyard two or more times. Also to improve the quality of the grapes, Jim does what is called a "green harvest." This means the picking crews pick off green clusters so that the remaining clusters will ripen

more evenly. All of this is expensive and quite labor-intensive. But the results are readily seen in the high quality of his wine.

"The 2000 [vintage] was the most difficult vintage I have ever been through," Jim says. "It was rainy and cloudy until September. [The] 2001 was an ideal year for reds; it was dry and cool so we could pick when we wanted to."

The Metamorphosis

It's February, and Jennifer McCloud, owner of Chrysalis Vineyards, is jumping up and down on the ice of her new irrigation pond. While it's 20-plus degrees outside, the sun has been shining on this pond all morning, so I wonder whether I will get to see more of Chrysalis Vineyards that afternoon or spend the morning rescuing the owner from the broken ice.

We've driven out beyond the tasting room and winery at Chrysalis Vineyards to take a look at Locksley Estate and see some of the new Norton grape plantings. Along the way we stop to pat the estate's new draft horse on the snout and visit a brood of chickens living in the relative luxury of a cedar chicken coop. As Jenni shows off her fancy chicken motel, I wonder how these free-range birds can live out here in the dominion of the wily

red fox. In our wake follow three of Jenni's dogs, Treixadura and Fer Servadou, named for Spanish grapes, and Norton, named for a Native American grape. These pampered pets cast a spurious eye at the dogs that live in the grape vineyards and whose job it is to keep the deer at bay.

Chrysalis Vineyards is located just to the west of Washington, D.C. in Middleburg, Virginia in the Bull Run Mountains. When people write "Middleburg, Virginia" they usually add the adjectives "wealthy enclave;" it's as if the two phrases cannot stand apart. Horses are perhaps more numerous than people here. The winding state road leading up to the Chrysalis winery is sort of prototypical of the juxtaposition of urban wealth and rural aspirations here. While Jenni's neighbor is building a gaudy, William Randolph Hearst-like fortress to himself, the state highway leading up to the vineyard is badly eroded and washing away. Jenni says she and her neighbors like it that way; it's one small agrarian effort to keep the Huns and Visigoths from overrunning the empire with asphalt.

There are several distinct themes at Chrysalis. Foremost is metamorphosis, which lends itself to the name of the winery in the form "Chrysalis." The chrysalis is the home of the nascent pupae coiled up tightly inside and waiting to spring forth as a glittering butterfly. Jennifer is something of a

butterfly herself. She has embraced that name and the concept of transformation in the French and Spanish words for butterfly written across two of her bottles of wine: Papillon and Mariposa.

This story is written in the spirit of those distinct themes. It is broken into three sections, one on Norton and two on the French wine grapes.

Norton

Back at the winery, wearing a portable headset and talking loudly on the telephone to her banker, Jennifer is setting up for a three-hour session of pouring and talking wine. Making the obvious understatement she assets, "I am not a mild personality," while she entertains as she educates. For Jenni is something of a prophet, while her Viognier wine bested all the American wineries at the 2002 San Diego wine show, that is not what gets her excited. Rather it is her single-minded focus on a purple grape that is native to America: Norton.

It's difficult for a wine writer to write about native American grapes. Excellent wines are made from American grapes that have been crossbred with old-world European wine grapes, but grapes that are truly American are more often associated with winos than fine wine. They taste and smell of purple bubble gum and are, for the most, part undrinkable.

But there is one American grape that in the last century briefly garnered worldwide respect and attention when it was proclaimed "best red wine of all nations" at the 1873 Vienna Expo in Austria. This grape, the Norton grape, was discovered and propagated by Dr. Daniel Norton of Richmond, Virginia. It simply is not known whether he crossed this grape with another American grape or whether he discovered such a natural hybrid growing in his vineyard. But what is certain is this grape makes a fine wine whereas other American grapes generally, or in fact, do not.

For a time in the late 19th century, German immigrants seized upon the growing popularity of what was then called "Norton's Virginia Seedling" and planted it widely in Missouri where it was called "Cynthiana." There, at Stone Hill winery, you can still find hundred year old vines still making wine.

The whole tale of the rise of the Norton grape is told well by Missouri native Paul Roberts, owner of Deep Creek Cellars in Maryland, and author of a memoir which describes his efforts to grow Norton grapes and make Norton wine: "From this hill, my hand, Cynthiana's Wine."

Roberts's book is an interesting memoir. It tells the tale of a library curator who knowing nothing about farming starts to grow Norton grapes and build a winery. Having never even

driven a tractor, he heads to the only place he
knows to find instructions – the library.

Robert's enthusiasm for Norton is tempered
somewhat when he realizes that by itself the
Norton grape is too heavy, too acidic, and
tastes too much like grapes to make a fine wine.
Practically no wine tastes simply like grapes – that
is part of the sublime beauty of wine grapes. So
Mr. Roberts experiments, and finds that with
15 percent Pinot Noir added Norton reaches
its apogee of perfection. Armed with 350 ml
bottles of wine, he heads off to wineries in France
and California to show the winemakers there
something novel, which is unlike anything they
have ever tasted.

Jennifer too has learned that blending Norton
with other grapes makes the best wine. She is
attempting to resurrect the heyday of the 19th
century Norton and, like some modern-day
Jenni NortonSeed, is a prophet for its widespread
dissemination. On her farm, she has started a
nursery to supply plants to other wineries. She
rises up behind the bar of her tasting room,
and proclaims her mantra, "To proudly restore
Virginia wines to world= renown, and celebrate
the homecoming of Norton, the *Real* American
Grape!"

As to its position in Missouri, first there
has to be some agreement as to the name. Jenni

fumes and sputters, "When I go to Arkansas and Missouri they say we are growing 'Cynthiana' and I say so you're growing Norton. 'We'll yea, but we call it "Cynthiana.' Well why do you do that? 'Because Norton comes from Missouri.' Excuse me! Norton, like Dr. Daniel Norton, of Richmond, Virginia? That variety? So they kind of shut up when I get going." Still she admits, "Cynthiana is prettier than Norton, but Norton is our man."

Norton grape juice is so dark and heavy that Jennifer learned through trial and error that it couldn't make a rosé wine. To make a rosé wine one takes a red grape, squeezes the juice, and then lets the grape skins stay in contact with the juice for a short time to add a slight color. But after trying this with Norton, her rosé wine turned out purple. Jenni says, "I thought : darn it's not pink!'"

So she started selling this wine as "whole cluster pressed," since that is how it was made. To wit: whole clusters are dropped into the wine press and the juice is pressed out. Winemakers do this with wine whites or red wines when they wish to minimize color and phenolic extraction, which can add either color or bitterness. All but the most learned of Jenni's customers failed to understand what they were buying. She says, "The people get this dull stare in their eyes." So she renamed her wine "Sarah's Patio Red" after Sarah

Getrude Lynn. Sarah was a girl who lived on the Locksley Estate. She died there in 1855 at 16 years of age from consumption. Sarah lends her name to several of the Chrysalis wines. Her grave lies just outside the window of the tasting room.

Sarah's Patio Red tastes tangy. Asked what kind of fruit she tastes she says, "I don't know. It's kind of like grapes. Hey, what about that wine? It tastes like grapes. Norton's got like a grapey character to it."

To say that a wine is "grapey" obviously mean that it tastes like grapes, but one of the fascinating and pleasant facets of wine grapes is that their wines taste like anything but grapes. Ultra-ripe Chardonnays from California can taste like pear and mango, Viognier like peach and apricot, and Bordeaux wines are described as tasting like anything from cassis to cranberries to black cherries and smelling of tobacco or even leather. It is this subtle nuance of flavor that makes a great wine. So for the seasoned wine drinker to say that a wine is "grapey" is a sort of **a** disappointment.

115

While we taste other Chrysalis wines, Jenni next has decanted her 2001 Locksley Reserve Norton. It's a big wine, so she wants it to get some oxygen for 30 minutes or so before we drink it. And, at $35 per bottle, it is expensive.

Jenni says that Norton is best when it is aged – in fact, the newly released wines from the winery

are to be cellared, not drunk. She says, "We're really not giving full justice. Any of these reserve wines are not meant to be drunk." All of her Norton wine in the past has sold out too fast, so Jenni is increasing her plantings so she can build up a sufficient inventory of wine. That way she can sell five and ten-year-old vintages.

We taste the 2001 Locksley Reserve, which is 93 percent Norton and seven percent Petit Verdot and Tannat. It too is a bit tangy and has the opaque color of grape juice. Jenni says, "There's an earthy sort of chocolaty smoking note to Norton." I comment that it is tangy and she says, "A little bit. There's acid there. There's no doubt that Norton is a high acid variety but one of the big problems in Virginia is we don't usually get enough acids in our fruit." Jenni explains that because the Virginia nights are warm, the grape vines do not shut down at night, so they use some of their malic acid for respiration. A wine without acid tastes flat. A wine with too much acid tastes sour. So she asks, "Well, did we tame it? Is it as tame as it will be five years from now? No. Ten years from now. No."

Reserve wines are usually made from what is called "free-run juice" or from the best quality grapes in a vineyard. Chrysalis' approach to making the reserve wine is different. She says, "We don't actually do anything different in the vineyard

between the regular Norton and the reserve Norton. We're trying as best as we can to get balance, balance the vines out and get as extracted and depth in the juice as we can."

She adds, "The reserve is not made; it is sort of discovered in the cellar." She explains that each wine will taste different because each oak wine barrel is slightly different. She says, "The barrel in itself is a natural element that imparts its character to the wine." I notice that the tannins are mild and pleasant. Jenni says, "[this] wine is very balanced."

The acid level in the wine is one reason that Dr. Tony Wolf of Virginia Tech says, "people either love Norton or detest it immensely." But good wines require a sufficient level of acid. Winemakers in fact add citric acid to wines when their acid level is too low. Philip Wagner, a wine writer who did much to promote wine grape growing on the East Coast after World War II, wrote that the Norton grape was too acidic and must be diluted by adding water. But to add water would take away taste. Jenni uses time in the barrel, whole cluster pressing, and a bit of science to deal with the problem of excess acid.

Andy Reagan is the winemaker at Chrysalis Vineyards. He says he is the youngest winemaker in the state, in fact. Coming from New York State, he cut his teeth working at New York's first farm

winery: BenMarl. Andy is soft-spoken, which is probably a requirement for working with someone as outspoken as Jennifer McCloud.

The growing season in 2003 was miserable by all measures. Tony Wolf, the state viticulturist deemed it a great year for "growing grass," because it rained constantly and there was little sunshine. Jenni McCloud says while such weather was devastating for French, Spanish, and Italian wine grapes, it was no problem for her Norton. She says, "It's Norton. It's raining. So what." So she elected to let her fruit hang on the vine for an extended period until the fruit started to raisin. The result was the sugar level went sky high but the acid level did as well. So for the first time ever, Jenni tried a new technique to lower the acid level in her wine.

Andy walks us through the 2003 Norton harvest as we taste young wines still in the barrel. 2003 was the wettest vintage in many years in Virginia, which caused problems for lots of Virginia wine grape growers. Since there was little sun, Chrysalis let their Norton grapes hang on the vine for a long time so the grapes would get perfectly ripe. Andy says, "The fruit dehydrated where we got 25 Brix (sugar level) but since it did that we also got 16.3 grams per liter of total acid." This is twice the normal amount for wine, so Andy explains how the acid in the wine is reduced through cellar techniques.

He continues, "When we picked the Norton this year we broke it out into four different lots of wine we had four lots each 2 ½ tons." Some of the grapes were crushed and some were whole cluster pressed. Then he fermented each lot with a separate strain of yeast.

Jenni's novel technique was to add common chalk to the wine: calcium carbonate. Adding tannins, proteins, and enzymes to wine is common practice. This causes such elements as tartaric crystals to "precipitate." This means the liquid forms a crystal, which then sinks to the bottom. Then the winemaker racks the wine from the debris that has sunk to the bottom. This is how winemakers, for example, make cloudy white wine run clear.

The same principal is true for calcium carbonate. There was some risk to doing this, as there wasn't much literature on how to do this. But the calcium carbonate worked perfectly – it lowered the acid in the wine without stripping out any of the flavor. The total acid of the finished product is a moderate 7.9 grapes per liter. Andy said it would be ready to bottle and release in five months.

Beyond the Locksley Reserve, Chrysalis also bottles a regular Norton and mixes Chardonnay in with her Norton to make Mariposa. The latter is a dry rosé wine. Of the Mariposa Jenni says, "It's got

that strawberry, raspberry, it's got that berry stuff
going on which is a good character in a rosé."

Viognier

Viognier is the white wine grape, which
has garnered national attention for Virginia
winemakers. As already mentioned, the 2001
Chrysalis Vineyards Viognier beat some 2,050
American wines to win "Best of Show White
Wine," and Keswick Vineyards won Best White
Wine in the U.S for their Atlanta International
Wine Summit. These are notable achievements,
indeed.

So prima façie it would appear that
Viognier is our wine grape. It is the grape
that so perfectly matches the terroir that the
results are outstanding. Such is the case with
Gewürztraminer in Alsace; such is the case with
Zinfandel in California. So it might be with
Viognier and Virginia.

In 2002, an entourage of Virginian's most
important winemakers flew off to France for an
extended scientific and note taking tour of the
wine growing regions of Southern France. On
December 16, they stopped at Domaine Gaillard
in Condrieu. This is the French home of the
Viognier grape – a grape that fell out of favor
and dwindled to a mere handful of acres before it
reached its current resurgence in popularity.

There, Pierre Gaillard made a comment to Jennifer McCloud that she will never forget. After lunch Monsieur Gaillard asked Jenni if he could have the Chrysalis Viognier that Jenni had served because it was the best outside any he had tasted in Condrieu.

Back in the tasting room Jenni pops open her 2002 Viognier, which she says is even better than the award-winning 2001. She says, "This is a 2002 Viognier. This is tasting really good right now."

Commenting on the aroma and flavors she says, "Peach, apricot, and browning white flowers like magnolia when they have lost a lot their you know decaying white flowers. When they get that pungency they're not smelling rotten, yet lost some of the white blossoms."

She explains that unlike most white wine grapes, for Viognier it is important that the grape be totally ripe before it is picked. She detects, "Topical fruit, peach, apricot, white flower. That's what you're looking for. Look, Viognier should not taste like grapefruit. It should not taste like Sauvignon Blanc."

She reasons that certain growers get excited by their developing fruit so hasten to pick it before the birds and the weather foul up the harvest. She says, "The problem with Viognier is when you are tasting it in the field it is so appealing, it tastes so sweet, it tastes so good, its gotta make great wine.

But it kind of goes through an evolution in flavor." So the wise winemaker learns to wait until the Brix hits at least 22.

She says that inexperienced wine judges have handed out medals to non-deserving Viognier wines that were not ripe. "I've got a problem with some of the judging in this state that pick Viognier, because the judges don't have experience with this grape, and they don't have a point of reference. I had one judge tell me 'I've never had a Viognier.' Oh Jesus! And you're judging Viognier."

Pulling out her acclaimed 2001 Viognier, Jenni says, "You've talked me into opening one of my few remaining bottles." She explains that wine is a living, breathing animal so this wine, "is not going to be the same wine that won Dan Diego in 2002." The aroma of fruit is one of the first things to die off as a wine ages. In fact the word "bouquet" means the smell of wine after the aroma has gone. This is one reason that Robert Parker says you should only drink Viognier wine when it is no more than two years old, so says Jenni. "It's made to drink when it's young fresh and fruity."

Petit Manseng

As we wind up our trip to Chrysalis Vineyards, I am particularly eager to taste the Petit Manseng. Andy Reagan standing in the wine cellar explains that the 2001 Petit Manseng has 4%

residual sugar and the alcohol is a little bit under 13 percent. Of the grape in the vineyard he said that, "naturally had it hanging on the vine until 29 Brix. The berry itself has a very thick skin, which kind of allows it to avoid splitting or rotting when birds peck out berries. It does pretty well against rot. It's a very healthy vine and the acid content is nice and high and that helps it too hang on the vine a little bit longer as well so it does develop those higher sugar levels."

He describes the taste and aroma as, "Honey, dried apricot, honey hints on the bouquet. I also like in the back their kind of that [volatility] of a nice perfume in the base of your nose a little bit."

The grape was picked at 29 Brix, crushed, whole-cluster pressed and then put into a tank and fermented in stainless kind of like a low alcohol-producing yeast. It gave up after 4% residual sugar." So the 2001 was naturally sweet. Andy adds, "this [wine] never saw oak."

The 2003 Petit Manseng is sitting outside in a tank where the temperature is 18 degrees. The goal is to cold stabilize the wine so that it does not form crystals when it is put into a refrigerator. Because the grapes did not get as ripe in 2003, due to all the rain and lack of sun, Andy will use a technique called "cryoextraction" to boost the Brix in the grapes to 29%. Basically the fruit is partially frozen, this dissipates water and causes the relative

123

sugar concentration to rise. This is how all dessert wines are made in Virginia. (Except for so-called 'ice wines' that are made by allowing the grapes to actually freeze on the vine.)

Andy explains that to get this wine ready for bottling it will be sterile filtered. This means the wine will pass through a 0.45 micron filter which will sweep any remaining yeast and wine-spoiling bacteria away. Before that he will fine the wine with some eisenglass protein to get rid of what Andy calls "a kind of clingy bitterness to it on the palate." His sense of taste is certainly better than mine because the wine tastes perfect to me.

The wine is still too young to bottle says Andy. He says, "Right now it's too young it needs to open up a little bit. I think the nose and flavors are still there."

The Californian

Burly and gregarious, those are words that come to mind when you consider John Delmare, owner of Rappahannock Cellars; his operation has 15 acres of grapes to harvest and 5,500 cases of wine to bottle – is there any surprise that he has 12 children? Such a large family can be handy in the fields, and even in the winery.

John Delmare's tale is Steinbeck's "Grapes of Wrath" told in reverse. In Steinbeck's version of the tale, the Joad family left the dustbowl of Oklahoma for the rich agriculture fields of California, seeking to earn a living picking fruit. John Delmare left the gleaming office towers of Silicon Valley, where he worked as a real estate developer and owned a winery, heading not the dustbowl, but rather to the Virginia piedmont; this time not to pick grapes but to plant them.

John started Saratoga vineyard, now called Savannah-Channel Vineyards, in the Santa Cruz appellation of California in 1992. This is on the San Francisco side of the Santa Cruz Mountains near the aforementioned Silicon Valley. In 1996 John and his wife Marialisa decided that the Silicon Valley was not the place they wanted to raise children, so they packed up their belongings and headed "out east" to Virginia. Virginia called to them first, and loudest, because "this was a great community and a great place to raise kids," not to mention a promising home for his California winemaking experience to be put to use.

And that is just what John did.

Upon John's arrival "the wine industry was still very young and the quality of the wines were not very good." Flying out west to continue working in real estate development, John decided in 1998 to open his winery here. He enlisted two partners, and bought Glenway Farm in 1998; then in rapid succession he planted vines in 1999, built his tasting room and cellar the next year, and opened the doors to the public in 2001. His vineyard is located at an 800 feet elevation between Flint Hill and Front Royal just below Chester Gap. Of this, John says, "So far it looks like a nice microclimate."

Although a newcomer to the area, Rappahannock Cellars has won accolades from

national wine tasting competitions and The
Virginia Wine Guide panel of tasting experts.
They have won Gold, Silver, and Bronze medals
in the Grand Harvest, Florida International, and
Dallas Morning News wine competitions. Also, the
Virginia Wine Guide rates four of their wines with
scores in the mid to high eighties.

Having grown grapes in both California
and Virginia, John is well suited to comment on
the differences in viticulture practices between
both locations: First, he says that pests are more
of a problem here than there; he "never heard of
the Grape Berry Moth until [he] moved here,"
although they do, in fact, have a problem with
leafhoppers in California. In addition, John also
discovered that the woods in Virginia are full of
Grape Berry Moths because of all the wild vines
growing here. Second, John says that California
suffers the same problems as Virginia with Powdery
Mildew and Botrytis, but downy mildew does
not even exist in California. All these fungal and
pest problems are a bane to vineyards the world
over; even the best wine growing regions, like the
Gironde Estuary of Bordeaux, are not free of such
concerns. Unless controlled with fungicides and
pesticides they can defoliate the vines and decimate
the fruit, reeking havoc for sure.

Of California he points out that "[there are]
much more consistent results largely dictated by

the consistent weather. The wonderful thing about California is about the first of May it stops raining and does not start again until after harvest."

John's first concern upon arriving in Virginia is everyone talked about how vigorous the soil is. But, John's site is not as vigorous as some other sites in Virginia, "which is a good thing." "Vigor" in this sense means the capacity of the vine to promote excess growth, and this causes the vine to grow too many shoots, too many leaves, and in turn too much fruit, which results in a canopy that is literally two crowded. Like other growers, Mr. Delmare uses the principles set forth in the book "Sunlight into Wine," that is, to trim back some of this excess growth to promote a healthy vine with lots of exposure for the fruit to sunlight and to improve air flow inside the canopy.

The weather is only one reason why John Delmare has bought, and will continue to buy, grapes from other growers. He tells the story of a Rappahannock vineyard that lost their entire six-acre crop due to a hailstorm. He would have never worried about a problem like that in Santa Cruz. Caution is clearly necessary.

Winter damage is another problem found in Virginia that is less prevalent in the Mediterranean climate of California: For example, in early October of 2002 it was abnormally dry and warm; suddenly the temperature fell off into the twenties;

this proved disastrous for the young Cabernet Sauvignon vines growing at Rappahannock Cellars. Out of 1,700 vines, 500 had to be replanted because of severe grown gall, a bacteria that thrives on wood fractured by cold weather, injury.

Rappahannock Cellar's winemaker is Stephen Barnard, a new comer to Virginia and an expatriate from Cape Town, South Africa. When Stephen first came to Virginia he worked at Keswick Vineyards. There he landed with a big splash that resonated around the state. His 2002 Viognier was voted the "Best White Wine in the U.S." at the Atlanta International Wine Summit competition.

Stephen explains that the Viognier grape is not widely planted in South Africa. But he worked at Flagstone Winery there where they did indeed plant this grape. So this globe-trotting winemaker had hands-on experience with what has become Virginia's best white grape. As evidence to the viability of Viognier in Virginia, Stephen said that even will all the rainy, cloudy weather of the 2004 vintage the Viognier grapes were harvested at 26 percent sugar (Brix).

For the Viognier picked this year, Stephen said, he will add to the super-ripe grapes that he has some Viognier that was picked at only 16 Brix. This will add some natural acidity to the

wine. He plans to ferment the wine in neutral oak barrels to create a "very complex, super aromatic" wine. He calls this type of Viognier "classy." Half of the wine is given a malolactic fermentation and the other half is not – this further enhances complexity.

Rappahannock Cellars has been around for a few years in Virginia. Stephen explains that his goal is to build upon their already-established reputation and not necessarily overhaul it. He says, "Rappahannock over the last three or four years has built up a certain style of wines. So we don't want to deviate too far from that." He characterizes the Rappahannock Cellars red wines as "very tannic, very chewy." Of the Chardonnay he says John Delmare prefers the "California, fatty, buttery Chardonnays where possible."

As of October 2004, none of the wines that Stephen has made have yet been released by the winery. Stephen came to the winery in April 2004. So his first task was to fine, blend, and then bottle the wines from the 2003 vintage.

Tasting the 2003 Viognier, Stephen stands behind the bar in the tasting room and swirls the wine in the glass. He says this wine is 90 percent Viognier and the rest is mainly Chardonnay with some Vidal Blanc. The Vidal Blanc was added to give the wine an aromatic component and a little more viscosity or mouth feel. You can readily see

that Vidal Blanc influence for this had added some yellow almost straw color to the wine.

Stephen also worked to find the optimal mix of red wines that would become the 2003 Meritage. He settled on a mixture that is mainly Cabernet Franc, followed by Cabernet Sauvignon, and then equal parts of Merlot, Petit Verdot, and Malbec.

The weather for wine grape growing has been fairly lousy two years in a row. The years 2001 and 2002 were stellar. But 2003 and 2004 featured heavy, persistent, rains, and hurricane after hurricane that swept across the state dumping buckets full of rain.

Commenting on this situation Stephen says that, "We had rain at the wrong time, preharvest, during harvest." All that rain causes downy mildew and botrytis to flare up in the vineyard. And since "the intention first and foremost is to pick clean" they had to pick the red grapes earlier than they wanted to. Stephen says, "The fruit was falling apart" and lamented that bird damage was causing the rot in the grape to spread to the rest of the cluster.

But all is not loss because the winemaker can fix much of the problems foisted upon the winery by nature. Stephen says, "You can work the wines a little bit and that is what winemaking is all about." But there are annoying complications. Stephen says because there is some rot in the red

grapes he cannot do much post fermentation maceration (skin contact to extract flavors and tannins). He is, "a little bit wary of getting green herbaceous flavors."

In February 2004, Tom Stevenson of *Sotheby's New Wine Encyclopedia* in a report entitled "Virginia Dares" echoed a refrain that has been repeated by Jim Law and *The Virginia Wine Guide* and, of course, mentioned by Stephen Barnard. Mr. Stevenson called this Virginia's "rush to ripeness." By this he meant that red wine grapes should be left hanging longer in the vineyard so that the tannins in the grapes can become fully ripe. He writes, "This can result in an imbalance of phenolics to fruit, which seems to be the case in some of the red wines I tasted, although certainly not in all, indicating that winemakers are learning how to handle the fruit." He then suggests a technique called "hot prefermentation soak" that could extract subtle tannins while leaving out the bitter ones. But in an opinion that overlooks economics he writes, "Ultimately, however, the goal should be to achieve a better balance in the vineyard by maximizing the hang time to achieve riper pips. Some years are going to be a bigger gamble than others, but risks must be taken if winemakers want to achieve international acclaim. Anyone who is not willing to take risks should not be growing grapes."

While this season was less than exceptional for red grapes, the white grapes fared much better. These get riper quicker than red grapes and were picked earlier. John Delmare told Stephen that their Seyval grapes were the cleanest and ripest he had even seen. The Viognier was picked at 26 percent sugar (Brix) which some might characterize as "California ripe." Stephen says, "The Chardonnays and the Viogniers look fantastic."

Rappahannock Cellars ferments their red wines in large walnut bins that are lined with a polymer. The reason that bins are preferred to tanks is that you can simply dump the contents of a bin into the wine press. If you pump the contents then tannin from the seeds can get into the wine. This type of tannin is coarse whereas tannin from the stems and skin are more preferable and necessary to make a good red wine. That is why many wineries like to use gravity-fed type systems that negate the need for pumping wine from one stage in the process to another.

Regarding white wines John Delmare says he, his large family, his staff, and his Mexican migrant farm workers pick the grapes early in the morning before the sun gets too hot. Then they are moved into the below-ground cellar. The goal is to keep the grapes chilled so that they don't lose their aroma. John says the white wines are all

fermented in French oak barrels. At $600 apiece these roughly 60 gallon barrels cost twice as much as American barrels but are worth the money. John says "If you could taste Chardonnay in a nice French barrel and taste it side by side in what I call a standard American barrel you will see a huge, huge difference."

While the wines of Rappahannock Cellars have been earning awards from various wine tasting competitions, what does it mean to say that a winery has won a gold, silver, or bronze medal? In John's view it is "the way they (the competitions) are supposed to work – wines are judged on their own merit. It does not mean you are the best. It's a level of quality." He adds, "Not every competition adheres to the same rating standard."

Mike Potashnick, publisher of "The Virginia Wine Guide," explains the scoring of wines: "I consider a gold medal anything in the range of 90 on our scale. The scale that we use is a modified UC-Davis 100-point scale. An outstanding rating is 95 or above but we have not given that to anyone." Mike explains that scores in the high eighties equate to silver medals. Mike adds this caveat: "You could assume they are approximate assessments of quality. The difference of course is what is in the competition too. Some ratings are significant others are less so. It depends on the competition."

John Delmare says of Potashnick that "he is very complimentary of our wines. The scores, I thought, were very good, especially as he was tasting those wines which were very young."

That said, how has Rappahannock cellars done in national competitions? The 2001 Chardonnay won a Gold medal at the Grand Harvest awards in California; The 2001 Meritage won a Silver medal at the same competition. The organizers of that event say on their web site, "The goal of the Grand Harvest Awards has been and continues to be to identity the finest examples from each viticulture region. At the Grand Harvest, judges taste wines with other wines of the same appellation." It is important to note, however, that the Grand Harvest and the *Dallas Morning News* divide Virginia into two appellations: "Virginia" and "Monticello;" this contrasts with the Bureau of Alcohol Tobacco and Firearms (ATF), who divides Virginia into six American Viticulture Areas (AVAs).

The *Dallas Morning News* wine competition is one that pits wines from one region against wines the world over. There, the Rappahannock Cellars won a Bronze medal for its 2001 Cabernet Sauvignon, and they also won Silver medals for the 2001 Cabernet Franc and 2001 Meritage at the Florida International Wine Competition.

Meritage is a Bordeaux style of wine made

by mixing any of the five dominate red grapes from the Bordeaux region of France: Cabernet Sauvignon, Cabernet Franc, Merlot, Petit Verdot, and Malbec. Rappahannock cellars pays a royalty of $1 per case so that they can put the label "Meritage" on their Bordeaux blend; this payment, made to the Meritage Association of California, goes to the cause of promoting a name that consumers would recognize. John says in the absence of this name "typically what people have done in the past is to make up a name for it;" of course you cannot call it "Bordeaux" because that would raise the ire of L'Institut National des Appellations d'Origine with their system of L'Appellation d'Origine Contrôlée.

Wherever John Delmare goes, he seeks to promote Virginia wine. John was doing this at the United Wine and Grape Symposium in San Francisco, where Gordon Murchie, Executive Director of the Virginia Wineries Associated, says, "Every vineyard represented at these events is pouring against the best produced in the country and the world. Having John at these events to represent Virginia was important. It sent a message to the American wine industry that Virginia wines are growing in complexity and popularity."

Of the Virginia wine industry, John Delmare says, "The biggest thing for Virginia: we need to get the word out. We have lots of Virginians that

don't even know we make wine. They might have
tasted it ten years ago when the industry was not
at it's best. We are making, I hate to use the word
'world-class', but we are making world-class wines
that will stand up against anything. . .We've got
wines being entered in international competitions
– Jennie McCloud of Chrysalis, her Viognier was
voted best of show in San Diego international last
year – Those kind of things are happening."

The Plantation

The Plantation

When one thinks of Ingleside Plantation Winery, it is only natural to recall William Styron's novel "The Confessions of Nat Turner." All the requisite amenities are there: a Virginia tidewater vista and an antebellum plantation. Nobel-prize winning novelist and Virginia native William Styron used this tableau to weave a tapestry of the affection of a slave for his keepers. But this affection flies apart in surreal fashion when the slave murders his masters. Styron's tale, set against the ebb and flow of the Virginia tides, is a fictional account of the life of Nat Turner.

Doug Flemer, who with his parents owns Ingleside Plantation winery, is quick to point out that Stryon's novel did not take place on his plantation. He says that "took place far away

from here." But Doug adds he personally knows
William Styron, having gone to the same private
school, Christ Church School, as the young
protégé and sees him at alumni functions.

The smell of history lingers in the air over the
Flemer family's 3,000-acre Ingleside Plantation.
Robert E. Lee and George Washington were
born nearby. Captain John Smith landed with
his band of English sailors and settlers at nearby
Jamestown in 1607. John Smith famously chased
the beautiful Indian Pocohontas back and forth
across the peninsula between the Rappahannock
and Potomac Rivers where Ingleside Plantation
is located. It's hard to sort out fact from fiction
on this matter. You can believe either the Walt
Disney version of these events, or you can believe
the more probable history described on a poster
hanging on a wall in the Flemer's own Indian
artifact museum. The one indisputable fact in this
plot is there was a major Indian trail that runs
right through the Ingleside property. The Indians
used this to cross from the Rappahannock to the
Potomac Rivers.

Ingleside Plantation is a winery and a nursery
with some 100-plus employees working on-site
with many of them living in the eleven houses on
the property. The nursery is a sprawling affair with
more than 120 trees, dozens of bushes, and a large
collection of ornamental grasses for sale to nursery

and landscape businesses. Drive around the
property and you will see acre after acre of Leyland
Cypress trees, Azalea bushes, and Pampus grass.
Perhaps to add to the plantation lore, the Flemers
have even planted a few Live Oak trees. These
evergreen oak trees, of course, line the driveways
of historic plantations further south in South
Carolina and Mississippi. To caste their abode in
the magnolia and moonlight whimsy of the Deep
South, the Flemers once even tried to import some
Spanish Moss. It died.

Doug runs the winery and his brother runs
the nursery business. Their parent's house sits
just behind the winery in the Ingleside plantation
house built circa 1834. There are several other
historic houses on the property and they each
have their own name. Wirtland was built in 1852.
Twiford in the early 18th century. Doug's house,
called Roxbury, was built around 1860. There is
also a cabin just outside the Roxbury house built
with chestnut oak logs. Pin Oaks and Loblolly
pines line the drive between there and his brother's
1840's English Tudor Style house located at the
corners of Party and Shag drives. A large tree lays
across the lawn, for Hurricane Isabelle toppled it
over and nastily poked one of its limbs through
the window. At Doug's parent's house, his mother
and Lillian Recht, wife of the former winemaker
Jacques Recht, ride about the property in an

electric golf cart. White swans paddle lazily in the pond to the left and transplanted Live Oak trees pop their heads above the hedge.

Doug Flemer is one of the veterans of the Virginia wine business, having started his winery with his father Carl Flemer in 1980. In France that would make you a new winery, but in Virginia that relatively ancient history gives you the right to call yourself a "pioneer." That Doug is a pioneer is evidenced in Lucie Morton's book "Winegrowing in Eastern America," published in 1985. There you can find a photograph of Doug dragging wild grapevines from the woods to make rootstock. Lucie is a world-famous viticulturist who lives in Warrenton, Virginia. She was the first American woman to graduate from the viticulture program in Montpellier, France. Lucie helped Doug learn about grape growing and winemaking when she took him along on a month-long tour of France when she returned to school. Doug had wanted to go to learn more so he could get his winery off the ground.

Ingleside Plantation is a perfectly positioned microclimate for growing grapes. Its terroir is officially known as the "Birthplace of George Washington Northern Neck" agricultural viticulture area. Located east of Fredericksburg in Oak Grove, Virginia. The flat land and row crops of the farming area to the west give way to rolling

hills and white oaks at the Ingleside Plantation.
Doug says that the Ingleside Plantation house sits
at the divide between the two rivers: water from
the front yard drains into the Rappahannock River
while water in the back drains into the Potomac
River. The climate is warmer than the grape
growing regions of the Virginia Piedmont and the
growing season is longer. Doug says because of the
climate here, he is able to ripen both the Cabernet
Sauvignon and Sangiovese grapes. Some Virginia
growers won't grow Cabernet Sauvignon saying it
won't properly ripen and even the Italian winery,
Barboursville, won't grow the Italian Sangiovese
grapes saying it won't ripen at all in their location.

Doug Flemer compares the climate in this
region with that of New York's Long Island which
is home to 4,000 acres of vines and some premium
wineries like Galluccio, Pindar, and Pelligrini.
"We are a lot like Long Island. We have a big
advantage in that we're further south, obviously,
and Long Island has no hills. It's flat. It has no
elevation at all. Here we are over 200 feet, say 225,
which is just enough to allow the frost and cold air
to roll off this hill and down to the river valleys.
So we're right on that Northern Neck divide."

Doug has more to say about the weather at his
winery and its suitability to growing grapes. While
the low temperature at Horton Vineyards was
six below zero in 2003 Ingleside was noticeably

warmer. Doug says, "We got into the teens but that was about it. Generally we don't go below zero. I think we got around 10. The coldest temperature we ever had was minus six in 1996."

Asked what advantages his tidewater location might have over other grape-growing regions Doug says, "Everywhere there is an ideal. Like California is pretty much ideal for growing grapes. But it doesn't mean you can't do that where conditions aren't ideal. Jacques Recht, the original winemaker at Ingleside, used to say that the best wines in the world are produced in marginal climates because you are going to have more vintage variation. You're going to hit it perfect in some years and you're going to have years like this where you have a bit of moisture. So we don't get too hot generally; we don't get too cold. We do have the humidity and rains that other regions don't have."

Doug says that his winery "is the only winery in the state that you can reach by boat." Lots of tourists frequent the area including many that come by way of the Rappahannock River Cruise line, which drops off passengers at the Ingleside dock. Doug has embraced the nearby Chesapeake Bay and used its symbolism to market the line of wines that he bottles under the label "Chesapeake Wine Company." The distinction is to differentiate between what winemaker Bill Swain calls "popular market wines" and the more sophisticated, more

expensive premium wines. By "popular market wines" Bill is referring to sweet wines, blush wines, and other wines preferred by some wine drinkers who prefer those to the more expensive, more complex Bordeaux and Burgundy styles.

Doug explains, "The concept was to put some division between what we were hoping to do as our premium line of wines, our reserve wines, and our varietal wines. Under the Chesapeake Company label we are doing wines that we hope we can retail for $10 and under. Under the Ingleside brand, prices start at $12 and up." The goal, says Doug, was to prevent what happened to Robert Mondavi, whose cheap Woodbridge line of wines have overwhelmed the winery's otherwise premium line of wines in their notoriety.

Ingleside Plantation winery has some 58 acres of grapes on their own property. They plant all the usual varieties planted in Virginia – Cabernet Sauvignon, Chardonnay, Viognier, et cetera. Doug notes that he does not plant Riesling, Pinot Noir (just a few vines), nor Gewürztraminer saying that "it's too hot" and those are better suited to cooler locations like New York's Finger Lakes region.

Doug adds, "The problem with Gewürztraminer is that it is too hot here. Also, the tightness of the clusters accentuates heat-caused problems. In this area it ripens and rots the

same day in the middle of July. It's like you can't grow palm trees in Maine. However, those same weather conditions that prevent us from having Gewürztraminer or Riesling help us when it comes to Syrah. We do grow a little Pinot Noir. It is very hard to grow here. We have it mainly for use in our sparkling wine. Occasionally we do a very limited varietals bottling of it."

Doug uses his Pinot Noir in the Champagne-style sparking wine that he makes. He actually grows and plants all the three grapes that are, under French law, required to make Champagne in France: Pinot Noir, Chardonnay, and Meunier. Maybe no other Virginia farmer grows Meunier.

Champagne is made by adding a little sugar and yeast to wine, which is already fermented, and sealing the bottle. Doug, like other winemakers whose use the *champenoise* method, then seal the bottle with a Coca-Cola style cap. A great deal of pressure builds up inside because the resulting carbon dioxide gas cannot escape. Doug takes the bottles, turns them upside down and places them in a freezer. When the neck of the bottle freezes Doug pops off the top then the little plug of yeast is expelled. Then he uses his ancient, enormous, manual Champagne corker to compress and then insert the oversized cork into the bottle. Finally the cork is wired into place so that the carbon dioxide gas will not blow off the top. This gas

is, of course, what gives Champagne its pleasant
bubbly effervescence.

Besides farming his own grapes, Doug says
he takes care of the 15-acre vineyard located at
Governor Mark Warner's Rappahannock Bend
Vineyard. He also tends the vines at a new 22-acre
vineyard planted by Retired Marine Corp General
Richard Philips.

A tasting of Ingleside's current offering show
the difference between the two labels and the
quality of the premium wines.

First is the 2002 Chardonnay. Winemaker
Bill Swain explains that this wine was whole
cluster pressed. The juice was pumped into a
tank, allowed to settle, and then racked to another
tank. After yeast was added and the juice started
to ferment it was pumped into oak barrels of
which 60 to 70 percent were French. Bill says the
wine was allowed to age for six months *sur lie* and
batonnage was used to clarify the wine. This means
the wine was aged on its yeast lees (dead yeast
cells) and a dodine was used to stir the wine every
few months. This is the way most winemakers
in Burgundy make their Chardonnay and it is
widely practiced in Virginia and beyond. The yeast
helps to extract flavor and it acts as a natural anti-
oxidation to keep wine-spoiling oxygen away from
the wine.

The next wine that Bill brings out is called

"Blue Crab." It has a blue crab on the label and is bottled under the Chesapeake Wine Company label. Blue crabs are, of course, prevalent in the Chesapeake Bay. Long wooden boats, with low gunnels used to collect the crab traps are a familiar site to tourists who frequent Saint Michaels and other crab fishing ports. The Blue Crab wine is sold in a blue bottle. It has residual sugar so it is slightly sweet. The wine is non-vintage meaning that it is made by mixing wines whose grapes were harvested in different years. Bill says the wine is a mix of Seyval, Chardonnay, and Vidal Blanc.

The next wine offered is a 2001 Syrah. Maria, a Venezuelan expatriate who is Bill's wife and assistant winemaker, says that she can taste and smell, "lots of fruit, some pepper, cherry, some berries." Maria graduated from the food science program at Universidad Centro Occidental Lisandro in Venezuela. Bill is a new-comer to Ingleside but has many years making wine on the West Coast and Venezuela where he met his wife. Bill graduated from the holy grail of American enology programs, the University of California at Davis. He worked at Bodegas Pomar in Venezuela, Associated Vintners (which is a group of several wineries including Covey Run) in Washington State, Three Rivers Winery in Oregon (he was the owner), Cresta Blanca in Mendocino, and Charles Krug Winery in the Napa Valley.

Of Syrah, Bill says, "Syrah is an interesting grape. If it is grown in a cool climate it becomes more peppery. In a warmer climate you get more cherry and berry." He adds that it is not at all astringent so it can be drank early unlike some heavy-tannin Cabernet Sauvignon wines, which require years of aging in the cellar.

The most impressive wine served that day was the 1999 Virginia Gold. Doug Flemer characterizes it as his Meritage-style of wine. (Meritage is what some winemakers call the traditional Bordeaux blend.) It is a blend of 55 to 60 percent Merlot followed by Cabernet Franc, and Cabernet Sauvignon. Maria says it smells of coffee, plums, and fruit. This wine includes the German Dornfelder and Lemberger grapes that Doug buys from a German doctor who owns a nearby vineyard. Germany, of course, is not known for producing red wines, yet these are two grapes that are able to ripen in the cool weather in the Bundesrepublik.

Jacques Recht was the first winemaker at Ingleside. He is something of a legend in Virginia and still contributes articles to *Wine East* magazine. He of course still makes wine albeit not professionally any more. Jacques had been a professor of enology in Belgium, a country more known more for its beer than its wine. Plus he had worked in France and Algeria as a winemaker.

149

At his retirement he built his own sailboat and
he and his wife sailed into the Chesapeake Bay in
1980. They had been drawn to the region after
reading James Michener's novel "Chesapeake."
Jacques and Lillian sailed up the Potomac River,
popped open the hatch, and grabbed the attention
of some friends of Doug's dad, Carl Flemer. The
friends paddled out in their dinghy to inspect this
odd-looking craft and noticed that this sailor from
Belgium has a bunch of books on winemaking in
his stateroom. Jacques and his wife had planned
to use their retirement to sail around the world.
But after meeting Carl Flemer, Doug says, "They
never sailed on." Jacques worked for Ingleside for
13 years until his second retirement. His wife still
works selling wine barrels for the French cooper
(barrel maker) Mercier.

Perhaps the event that put Ingleside and
maybe even Virginia on the global viticulture map
occurred 20 years ago in London. In 1985 at the
International Wine and Spirits competition the
1983 Ingleside Chardonnay won a bronze medal.
Doug said he had wholesalers and distributors
coming to him saying "We did not know you were
making wine in Virginia."

The Millionaire

Patricia Kluge brings big money and celebrity appeal to the Dominion State. She has sunk a fortune into her winery and hired the best talent money can buy.

To build a world-class winery, one needs a number of key factors. Among those are top-rate talent, a great location, and very deep pockets. Also, perhaps a bit of modern technology thrown in the mix could be useful. Patricia Kluge has them all: She has assembled a dream team of experts, and, according to *Fortune Magazine*, spent $10 million to build Kluge Estate Winery near Charlottesville, land near which Thomas Jefferson himself planted grapes. The vineyard is located just minutes away from Jefferson's home in Monticello. There, he famously tried to plant *vitis vinifera-*

old-world, European grapes, at the turn of the eighteenth century; they were, unfortunately, later trampled by horses and succumbed to disease. Through Kluges' cavernous pockets, some top-notch talent, and the help of modern agriculture, what was impossible for Jefferson can now be done, making for a truly world-class winery.

When someone as rich and famous as Patricia Kluge gets into the winery business, the national press and regional politicians take notice. In March, when the winery opened its farm wine shop to the public, Virginia's Governor Mark Warner, himself the owner of a 15-acre vineyard, was there to cut the ribbon. *Fortune Magazine*, Bloomberg Markets, and *USA Today* have all written articles on Patricia Kluge's winery, vineyard, and on-site gourmet food shop.

Consider some of the talents Ms. Kluge has engaged to propel her winery into prominence: Her consulting winemakers include the world-famous Michel Rolland, who was on-hand to unveil the winery's Kluge Estate 2001 New World Red at the Four Seasons Restaurant in New York in 2003. Mr. Rolland consults with over 100 clients worldwide and owns several châteaux in France. Also, one of Virginia's most famous winemakers and viticulturists, Gabriele Rausse, is in the cellar and vineyard. Mr. Rausse came from Italy in 1976 to plant the first large-scale

commercial plantings of *vinifera* grapes in Virginia
at Barboursville Vineyards, owned by the Zonin
family of Italy. The Zonins also own the largest
privately held vineyards in Italy, sprawling across
9,140 hectares at various estates. In addition to
consulting for Ms. Kluge, Mr. Rausse is making
wines at Thomas Jefferson's Monticello using, for
the most part, techniques that only would have
been available to Jefferson at that time.

The CEO of Kluge Winery, Patricia's
husband William Moses, is also himself making
quite a splash in the wine world. He and others,
including Lew Parker, president of the Virginia
Wineries Association, lobbied Governor Warner
to sign legislation that, as of 1 July 2003, allowed
out-of-state wineries to make direct sales to
consumers in Virginia without requiring a local
distributor. Then, Virginia wineries were able to
sell directly to customers in those states that have
made reciprocal agreements.

When asked what her intent was in building a
winery in Virginia, Patricia said, "I paid attention
when I saw respected 'French' winemakers
kneel on our fields, grab a handful of soil and
grass, smell it, feel its texture, smile and say
'hmmmmm.' As for my intent, it has always been,
and only is, to build a world-class wine."

The Civil War

Virginia is steeped in Civil War lore. One Virginia winery is named for a Civil War guerilla fighter.

The three best non-fiction books written on Southern culture were all written by writers who were not from the South, and who were not even necessarily American. Perhaps it takes an outsider to step outside the traditions of the region and explain the nuances of the Southern culture to incredulous persons of the masses.

Consider: V.S. Naipal, an Indian born in Trinidad, won the Nobel Prize for literature in 2002. His portrait of the South, "A Turn in the South," starts on an antebellum plantation in Charleston, South Carolina, winds through the Booker T. Washington's Tuskegee Institute,

and ends up in the racial politics of modern-
day Atlanta. Naipal, through his explanation of
Southern whimsy towards all matters historic,
comes to the conclusion that for a Southerner
"history is religion." Also, perhaps one of the most
widely read books on Southern culture, the best-
selling "Midnight in the Garden of Good and
Evil," is authored by a man from New York City.
John Berendt's book allowed outsiders to shake the
hand of, so to speak, and meet the magnolia and
moonlight culture of Savannah, Georgia and her
environs. Other than Berendt and Naipal there
is Tony Horowitz, who won a Pulitzer Prize for
his book "Confederates in the Attic." It explains
to the outsider why the Civil War is so fresh in
the Southern heart some 150-plus years after its
onset and resolution. Tony, a New Englander
whose parents come from Russia, today lives in
Winchester, Virginia. His book really provides
an understanding of this complex topic, the Civil
War.

People not born and raised in the South
do not understand, and even mock, the
Southerner's affinity for history. Above all
they, these outsiders, seem most puzzled with
the South's infatuation with the Civil War, its
memorabilia and its unending lore. Southerners,
regardless of background, boast openly if they
had an ancestor who fought for the Confederacy.

Northerners and foreigners alike are incredulous,
baffled even, that otherwise educated persons in
Carolina and Georgia want to retain the Southern
Confederate Battle Flag atop their respective
capitals. For instance, people outside the region
don't understand why Sperryville still hosts an
annual "Civil War Days" festival or why "The
Rappahannock News" still writes about the "War
Between the States."

Practically every southern town seems
to have a highway or a high school named
"Jackson" or "Lee" after the famous generals of
the Confederacy. Virginia, perhaps more than
most Southern states, is dotted with official and
nonofficial reminders of the Civil War. Perhaps
the root of Virginia's love of the "War Between
States" is that the Civil War both started and
ended in the Dominion State, the capital of the
Confederacy was Richmond, and the war's greatest
hero, General Robert E. Lee, called Virginia home.
True, the first shots of the Civil War were fired
by Citadel Cadets at Fort Sumter in Charleston
Harbor. But the first and last large campaigns were
at Manassas and Appomattox Courthouse both
in Virginia. Regardless of the reason, Virginia has
a love affair, a centuries-old love affair with its
history, especially the Civil War.

Drive west from Washington, D.C., hop
onto Route 66, and you will find a sign for the

Manassas Battlefield National Park looming large in the distance. This area, established by President Ronald Reagan – Manassas and on westward – is the region of Virginia where a guerilla fighter, Colonel Mosby, harried the Union army flanks while General Robert E. Lee engaged the larger Union forces. Mosby, so adept at slipping in and out of the Union Army lines that the Blue Coats took to calling him "The Gray Ghost," has slipped into Virginia's beloved history and into the heart's of Al and Cheryl Kellert. They have embraced this legendary icon and lent his name to their winery: Gray Ghost.

Sitting astride Highway 211 in Rappahannock County, Gray Ghost vineyard is one of Virginia's small-sized wineries producing 3,200 cases of wine per year.

Owners Al and Cheryl Kellert do most of the work and tending required by the process of winemaking while daughter Amy Payette handles marketing. During the busy summer schedule, when the vines can grow an inch per day, this family staff is augmented by paid high school students on summer vacation. At harvest time, when even more help is required, volunteers who have become fans of the vineyard lend a helping hand, making the whole process of creating a wine, fermenting right along side the history of Virginia, really a labor of love.

The winery itself includes a tasting room, a cellar, a production area and twelve acres of grapes. The Kellerts also lease land in other parts of the state, and buy grapes from Rappahannock growers. The obvious reason for this is not all grapevines grow well in all areas. For example, the fickle Gewürztraminer grape, which tends to rot before ripening, is bought from a vineyard located on the Eastern Shore of Virginia. This helps assure that they can gather a suitable harvest; no matter the conditions in different parts of the state.

Like many Virginia wineries, Gray Ghost uses its events calendar to draw in the wine-buying public; for example, Gray Ghost hosts an annual event they call "Sundays in the Library." The library, a 56-degree, below-ground wine cellar where they set aside a few bottles from each year's vintage, is where these Sunday tastings occur. They have in their "library" bottles dating back to 1993, which was their first year of production. These precious few bottles are normally tasted at a bi-annual, optional black tie fêtes where 24 patrons come to enjoy so-called "vertical tastings." This means the same wine from different years, four different vintages, are popped open and their taste is compared with one another. In 2003, the Kellerts wanted to add more people to their retinue, so they held three such events, no black tie required, open to the public; included in the $10

tasting fee per person is a glass with the Gray Ghost logo. This was made from a portrait that Al Kellert painted himself of the Civil War hero.

Gray Ghost also holds an annual "Civil War Authors" program in November. Mr. Kellert says this free event, open to the public, "has become a very popular program" and is well attended. It provides a forum for such authors, authors who write about Virginia's favorite subject, the Civil War, to promote their books.

In February, Cheryl Kellert changes from vineyard manager to cake baker and cooks 15 to 17 chocolate desserts for their "Chocolates and Cabernet" event. Al says the tastes of Chocolate and the red Cabernet wines give an "incredible taste of delight. It's just like eating chocolate covered cherries." Al believes Gray Ghost is the first Virginia winery to host such a Valentine's Day-type event, which has now spread to many of the area wineries. He and his wife learned of this in California in the 1980s. Each year they create a special commemorative glass for the occasion, which is included in the $15 fee.

Gray Ghost also hosts an "Annual Barrel Tasting." This is where the winemaker uses a wine thief to tap into wines that are aging in oak barrels, or stainless steel, to taste the wine that is still aging – the wine has already been fermented, but is still too young to be bottled and sold. Al

says, "People who come have a rare opportunity to taste wines that are in the aging process."

Mr. Kellert says that "2002 will go down as one of the truly great vintages for Virginia." He describes the ideal weather for producing grapes as "a cool damp spring, followed by a warm dry summer, followed by a cool dry harvest period (August to October), followed by rains in winter. 2002 was a drought year which means the vines produced fruit of exceptional quality." The fruit had very high sugars and small berries which increases flavor, the "Wines will be extremely flavorful, very aromatic, and have a little higher alcohol content due to higher sugar levels," and the acid level is good which will produce wines that he calls "bright not flabby." Alcohol and acid levels are important for taste, as well as for creating wine that will last on the shelf and not spoil or even start their fermentation process anew.

Most recently, Gray Ghost's 2002 Cabernet Franc took home a Silver Medal at the San Francisco International Wine Competition. Gray Ghost from year to year generally wins awards for its Late Harvest Vidal Blanc dessert-style wine. Vidal Blanc is a French Hybrid grape grown by many Virginia growers. In 2003, Gray Ghost won the "Best Dessert Wine" award for their Late Harvest 2002 Vidal Blanc at the 2003 Atlanta International Wine Summit, meaning they beat

all the American wineries including those in California.

Future plans for Gray Ghost include plans to grow only slightly from a small winery to a medium-sized one. They want to produce 5,000 cases of wine yet still sell their bottles and cases directly to the public. This is in an effort to not be so large that they have to work with a distributor. "I think that's a comfortable size to be manageable. And quite frankly it still makes the wine industry fun. If you get much bigger than that then you lose the personal touch"

The Governor

Drive east from Fredericksburg into King George County, and the rolling hills of the Virginia Piedmont give way to flat sandy soil. Soybean fields line the roadside and the countryside feels quite different; it appears more coastal-plain as pines replace hardwoods. Turn right off Highway 3 and you pass power crews from Florida Power and Light who have gathered in this sparsely populated corner of King George County to restore power to outlying areas that twelve days after Hurricane Isabel are still in the dark.

Turn right again at an abandoned country store, turn right once more, and drive past a sign reading "Rappahannock Bend," and you are at the vineyard of Governor Mark Warner and his wife Lisa Collis.

Drive the tree-lined driveway, and to the right

you will see row after row of Cabernet Sauvignon, Chardonnay, Viognier, Cabernet Franc, and Sangiovese grapevines held aloft by French Lyre trellises. The rows between the vines are scraped clean of grass. This is the usual practice in California and Australia, but in Virginia where soil erosion is a concern grass is usually grown between the grapevine rows.

Turn left at one fence and you drive past a cluster of Concord Grapes whose large *vitis labrusca* leaves are held aloft by trellises shaped like tall pitchforks. Go further and you can see barns and a riding rink on the right, apple trees on the left. Pull into the deep gravel of the Governor's driveway and you can see the Rappahannock River behind the Governor's House. This is no ordinary residence; a state police trooper is parked out front in a large black sedan. The Governor's two dogs Buster and Bo are roaming about the yard, and the Governor's youngest daughter has just come in with a basketful of eggs that she has collected from the Governor's own hens. Lisa Collis is busy getting ready for a party for the Governor's staff on the lawn that afternoon. Governor Mark Warner sticks his head out the door to say he will be with us in a moment.

Virginia is unique among wine-producing states, beyond California, Oregon and Washington, in that the legislature and the

Governor actively support its wine industry.
Other states, such as Texas, have fine wineries,
but they are hampered by their inability to ship
their products directly to consumers. Boutique
wineries there and elsewhere are too small to
deal with national distributors, so out-of-state
consumers generally are not able to buy their wine.
Governor Warner has cut through that difficulty
with the passage of direct shipment and reciprocal
agreement legislation that will allow out-of-state
customers to buy Virginia wine and Virginia
customers to buy wines from out-of-state. These
new laws overturn the prohibition-era ideas that
were seemingly at work for so long, and still are in
many places.

In addition, Governor Warner has rolled up
his sleeves and personally invested in a 15-acre
vineyard. For a row-crop farmer that is not much
land, but for a grape farmer that is 60 tons of
grapes or more each year. That's a lot of grapes.

Our tour begins.

As geese circle overheard, I ask the Governor
if he likes to hunt ducks or geese. After all this is
the home of tidewater, aristocrat duck hunters and
the Chesapeake Bay Retriever, who is named for
nearby Chesapeake Bay. Across the bay, on the
Maryland side, are Remington Farms, owned by
the Dupont family, and the Wye River Plantation,
a plantation visited by such famous duck hunting

fans as Rush Limbaugh, as well as being the home to the signing of an Israeli-Palestinian peace accord called "The Wye River Accord." Answering my question, the Governor says he has done some hunting but not as much as he would like to do; the last time he went hunting it was broadcast on ESPN Sports Zone.

Governor Warner is tall and has a slightly forward-leaning posture; like a lot of photogenic politicians or celebrities his oversized teeth blossom into a radiant smile. Posing for pictures, he puts his hands on your shoulders, putting you at ease instantly. As the interview begins he sits down at a table and looks you straight in the eye as if to say "ok, let's have it."

Governor Warner's vineyard is located on flat sandy soil, where he planted his first vines in 1988. The Governor says that the money to pay for that came when the company he co-founded, Fleet Call, went public – a company later renamed Nextel is, of course, today a household name.

The Governor's first foray into viticulture including planting Merlot vines, most of which were killed by the frost. Governor Warner says, "We have Chardonnay, Cabernet Franc, Cabernet Sauvignon, and some Merlot." Governor Warner has learned a lot since he first planted his Merlot. He has installed an irrigation system that can both water the vines and protect them from late

season frosts, eliminating that early, although very costly, crisis.

Asked why he decided to plant a Vineyard, Governor Warner said, "I had always been interested in wine and Lisa and I started to put in a vineyard. We talked to Doug [Flemer] and he asked 'do you really want to do this?' because of all the cost involved. I had visited vineyards a couple of times in France, had been to France a number of times, been to vineyards in Napa Valley, but I did not realize the capital [expense]." Asked if his vineyard was now profitable Governor Warner said, "On a year-to-year basis it is depending on the amount of the harvest. We probably haven't recovered our full capital expenditure."

Governor Warner adds, "I started a vineyard, because I wanted to learn more about winemaking. I found that I always enjoyed wine. I enjoy the ambience that goes with good wine and food. Some of our favorite holidays had always been when we have been traveling in France, particularly in the Burgundy region, and Napa and some of the other California vineyards."

Doug Flemer, the aforementioned owner of Ingleside Vineyards Winery, buys grapes from Governor Warner and tends to his vines. Doug bottles about 40 to 60 cases of the Governor's grapes per year under the Governor's own "Rappahannock Bend" label. Governor Warner

says, "You can find a case of our wine in most every charity auction in Virginia. The market value of it went up a little bit on the charity auction circuit once I became Governor." Joking, he adds, "I am not sure if it improved the quality of it."

Talking about the growing preeminence of Virginia wines on national markets, Governor Warner says, "I think Virginia wine is on the cusp of really becoming more nationally and internationally known. I have always enjoyed Virginia wine, but I think in the last three to four years the quality has gone up exponentially."

He points out, "You're starting to see Virginia wines differentiate themselves with grapes like Viognier and Cabernet Franc. I think what some of the awards, like Horton and Chrysalis, have achieved in national stature. The San Diego show (where the 2002 Chrysalis Viognier won "Best of Show White Wine") really put us on the map."

Governor Warner continues, "I think we have got unlimited potential. We have that opportunity to combine, hopefully world-class, winemaking with world-class history and beauty – to kind of develop, I think, a wine industry – but to combine that with our tourism opportunity. That's an advantage that few other regions are going to have – to combine a trip to Monticello – with seeing vineyards that have been around a while."

Also, there is much to see in the Northern

Neck area as well, he says, "Here in the Northern Neck, as we see more vineyards, with the Washington home, the Lee home. There's so much great history around. I think there's a real chance to develop more wine tours."

Governor Warner points to vineyards as a way to preserve open space. He says, "In some communities – perhaps less so here than in the Albemarle, Charlottesville area – you have that tension between how do you maintain open space and quality of life. I mean because a farmer can be profitable with a relatively small amount of acreage in grape growing, it's a great way to have open space preservation. It's a great way to merge with tourism. It's a great way to put a distinctive Virginia grown product, higher value agriculture product than some of our traditional agriculture products. It's a win, win."

Finally the Governor adds, "Anything I can do as Virginia Governor to promote Virginia grapes and Virginia wines I will do."

169

The Politicians

The cynic would doubt that the politicians could do much to help Virginia wines in the cellar or the vineyard. But for one day in 2003 the U.S. Senate and the House of Representatives paid formal attention to the wines of the Dominion state.

The hallowed halls of Congress – whose demeanor is usually buttoned-down and staid – rarely resonate with the sound of wine bottles popping open. But on June 17, the Congressional Wine Caucus invited the Virginia wine industry to Capitol Hill to showcase their wines and present their legislative agenda to members of Congress. Congressman Bob Goodlatte, a Republican from Virginia, not to mention the chairman of the House Agriculture Committee, Senator John Warner, another Republican from

Virginia, former grape grower, Congressmen Mike
Thompson, a Democrat from California, and
winemaker George Radanovich, a Republican
from California sponsored the event. A letter from
the two California Congressmen said, "We believe
Virginia's wine industry would benefit greatly
from a one-day effort on the Hill to promote not
only wine, but also other wine-related impacts
of the state including tourism, commerce, and
agriculture." While Virginia was selected for the
first such event, similar events are planned for
New York, Washington, Oregon, California, and
possibly other states.

172

The event kicked off with a luncheon held
in the Russell Senate office building. For lunch,
Chardonnay from Wintergreen Winery and Pinot
Noir from Rockbridge Vineyard was served to 60
legislators and wine industry representatives in the
Armed Services Committee Room. While several
politicians spoke, Governor Mark Warner was
the featured speaker. After lunch, Virginia farm,
agribusiness, winery, and vineyard representatives
met with members of the Virginia Congressional
delegation.

At 6 p.m., Congressmen, Congressional aides,
and their staff poured into the wine tasting held in
the Agriculture Committee room to taste Virginia
wines that had won Gold or Silver medals in the
Virginia Governor's Cup competition. Three

hundred people were invited but more than 400 attended. The Virginia Company provided famed Virginia Ham biscuits while the Heritage Hunt Golf and Country Club brought salmon and an ice sculpture of the Capitol. The Brotherhood of the Knights of the Vine, dressed in their regalia, poured wines along with Virginia wineries. By 7:40 p.m. there was neither any food nor wine left.

The Virginia delegation presented a briefing book to members of Congress outlining some of the Dominion state's legislative concerns. The issues of concern include reducing wages, transportation, and housing fees paid to foreign workers working under the H-2A visa program, repeal of the Special Occupational Tax, and elimination of the Estate tax.

173

Gordon Murchie is president of the Vinifera Wine Growers Association, commenting on the impact of the event he said, "Now they are suggesting that Virginia might want to consider making it an annual event. As the first state invited to present itself on the Hill it was considered more successful than had been anticipated. The event will serve as a good model for future state wine industries which are invited to present themselves on Capitol Hill."

While the Vinifera Wine Growers Association is located in Virginia its scope is national, Mr. Murchie said, "We will help any other state.

Certainly if Maryland, Pennsylvania, or Ohio
were to be invited, we would work with them."
The Congressional Wine Caucus includes 250
members of Congress and Mr. Murchie points out
"there is a winery in all 50 states."

The Red Grape of Bordeaux

The French have known for hundreds of years that matching the proper grape to the proper location makes the best wine. To protect the quality of their product and their reputation, French grape growers and winemakers have codified their empirical observations into the legal construct known as the "Appelations d'Origine Contrôlée." Contrast that with Virginia who has had only 20 years or so to decide which grapes grow best in the hot, humid, and sometimes rainy growing season of the Dominion State. Yet a consensus has emerged that the perfect red wine grape for Virginia is Cabernet Franc.

Michael Shaps is one of the best-known, most widely respected winemakers of the Monticello appellation of Virginia and, of Cabernet Franc, says, "It does well here. There's no doubt it's our

grape in terms of quality and varietal character."
Mike adds that, "We achieve good balance here."

He continues "Cabernet Franc for all the
reasons just works. It's consistent even in troubled
years, in wet years. In '99, when we had 18
inches of rain in September, the grapes held up
all through the month, and we made some really
intense Cabernet Franc in 1999. It does not have
the intense tannins of Cabernet Sauvignon. It
definitely produces a more approachable wine, and
you don't have to worry so much about getting
the tannins riper. So it makes it a little bit easier."

Michael Shaps has worked as winemaker
or consulting winemaker at many of the
Charlottesville area wineries. He worked in the
past at Jefferson vineyards and now consults with
Keswick and Delfosse in Virginia and Rockhouse
in North Carolina. In addition Michael and his
partner Monsieur Roucher-Sarrazin have just
opened a winery in the Meursault appellation of
Burgundy called "Shaps et Roucher-Sarrazin."
Michael's name is so well known throughout the
Charlottesville region that King Family Vineyards
bottles their own grapes with the name "Michael
Shaps" plastered across the label. King Family
is where Michael spends most of his time, and
where he works with David King in a partnership
arrangement.

In Bordeaux, Cabernet Franc is a blending

grape. There, it is blended with the more familiar Cabernet Sauvignon and Merlot grapes to make the extremely expensive first and second growth grand cru wines. These wines are often bought on the futures market, meaning they are bought in the barrel even before they are even bottled. But there is one Bordeaux Chateaux where Cabernet Franc is the primary grape used in their Bordeaux Blend: Chateaux Cheval Blanc. Their 1999 wine is 42 percent Cabernet Franc and sells for $195 at Morrell Wine Company in New York, who also sell the 1982 vintage for $845 per bottle. Michael Shaps wine is somewhat less expensive at $25 per bottle for the 2001 vintage.

To the North of Bordeaux, where the Loire River empties into the Atlantic Ocean, lies the Loire Valley. There, it is too cool to properly ripen Cabernet Sauvignon, so either by tradition, history, or fiat the French have chosen to exclusively plant Cabernet Franc for their red wines in this region. Around the towns of Tours, Nantes, and LeMans and in the appellations of Chinon and Bourguiel, Cabernet Franc is made into a lightly-colored red wine and even made into a rosé-style wine. Shaps characterizes the Chinon style as a "nice fruity style."

The weather is cooler in Loire than in Virginia most years, but the soil and rainfall are similar. Like Bordeaux and unlike California, Loire has

vintages meaning there is a difference in wine quality from year to year due to the weather. California, of course, has no weather per se so the results from year to year tend to be the same. Some years in Virginia it is cold and wet and other years it is hot and dry. The soil is Loire has gravel but like Virginia it also contains some red clay.

A vertical tasting of Michael Shaps Cabernet Franc wines show the differences in style from one vintage to the next. The years 2001 and 2002 were drought years for Virginia. The grapes were high in sugar and the wine consequently high in alcohol. Because the grapes were so clean, ripe, and free of fungal disease Michael was able to use extended maceration (skin contact) to extract much colors and tannins. The results were a Bordeaux style wine with noticeable, albeit pleasant tannins, good structure, and the fresh fruit taste of a proper Cabernet Franc. The wine tastes and smells of black cherries. It has agreeable astringency on the palette and a broad palette feel. Conversely, the 2000 vintage was wet and cool. The resulting wine has less color, less tannins, has less mouth feel and is more of a Chinon style. Michael says it tastes like cranberries. He says the two vintages 2002 and 2000 illustrate the extreme dichotomies of Virginia vintages in terms of weather.

In Virginia if a winemaker or vineyard manager hails from Europe he has a certain gravitas

straight away. People perk up and listen closely to anyone who carries the monicker "French," "German," or "Italian" on their veritable lapel. This tends to irritate the native-born American, nevertheless foreign credentials add a certain panache and mystique to the Virginia wineries who engage foreign talent as they clamor for increased attention from the wine-buying public and the international winepress. Michael fits into this foreign mold nicely, because while he is an American, he was educated in France.

Mike earned his winemaking degree at Beaune, which is the capitol of Burgundy. While going to school there, he worked for two seasons at two French vineyards where he learned to make Chardonnay and Pinot Noir the Burgundian way. At first, his zeal for all things French tended to overwhelm his winemaking style while at Jefferson Vineyards. Now he has tempered his Old World techniques with some New World practices at King Family Vineyards.

Michael describes how he makes his Cabernet Franc wine at King Family Vineyards. First, the grapes are picked and any non-ripe fruit is culled out. Then the grapes are crushed and de-stemmed lightly, and the juice is collected in bins. Then the bins are hoisted into the air by forklift – this is how Virginia winemakers produce gravity-fed type systems, as discussed earlier – and the contents

dumped into fermentation tanks. Gravity is, of course, preferable to pumping the juice, seeds, and skin with heavy pumps. That process tends to extract green tannins from the seed, which will make a wine bitter.

To this mix Michael adds 10 to 15 percent whole clusters; the use of whole clusters is a white-winemaker's trick used to extract some flavors from the skin. Mike says, "This tends to bring in a little more fruitiness to the wine." Then, in the Burgundian tradition, Mike lets 10 percent of the juice run free from the tank, which drops to the floor and runs down the drain. While this might seem a grand waste of potential revenue, the resulting wine has more contact with the grape skins in the fermentation tank to extract more body, color, and flavor. Finally, like many Virginia winemakers Mike lets the wine "cold soak" for two to six days. This is a technique that uses low temperatures to extract the tannins and color from the skins without carrying over the bitter tannins from the seeds.

Next Mike turns off the refrigeration to the fermentation tank and lets the wine warm so that when the yeast is added it will not go into shock and then die. Once the wine starts to sputter and froth – meaning natural fermentation has started – Michael pours in cultured yeast. Then he pumps the wine over the cap (i.e. the skins which

float to the surface as one tough layer) and uses rack and return *(delestage)* to add oxygen to get the yeast going, and soften the wine. When the fermentation is complete, in three or more days, the wine must is dropped into the winepress, and the free run juice is put into oak barrels. And last Michael uses the French practice of letting the malolactic fermentation take place in the barrel rather than during fermentation. Malolactic fermentation is used to convert the more bitter malic acid, which is present in apples, for example, to the more palatable lactic acid.

Michael Shaps and David King hold regular seminars at their winery – These are informal competitions pitting the best Virginia wines against wines from France and California. Mike says his and other Virginia wines have beaten California Cabernet Franc wines hands down on several occasions.

Mike has his opinions why Virginia Cabernet Franc has not yet achieved a national or international following. He says that while regional and even national competitions are good for the Virginia wines, they do not hold the attention of the influential wine writers of *Decanter*, *Wine Spectator*, and *Wine Enthusiast* magazines. Michael says, "Competitions are great for giving us legitimacy and respect but the wine media do [not] look to those competitions. They

like to do their own reviews. Still, we can promote locally that we won medals."

The Virginia wine competitions are themselves something of a controversial point. Many Virginia wineries say on their web sites that they have won X number of medals. But at the 2003 Virginia Governor's Cup practically everyone who entered won something, with 160 bronze medals handed out at that Virginia Governor's Cup competition. Mike says that the persons organizing the event said they will tighten up the criteria in future years.

In November 2001, Michael Shaps and David King were walking through their vineyard when they noticed that the Cabernet Franc grapes left on the wine had turned to raisins but the fruit was still clear and free of rot. So they decided to ferment it into wine to see what would happen. The result was their 2001 Late Harvest Cabernet Franc wine. But unlike most Virginia wines with "late harvest" on the label, this wine was made dry with no residual sugar. The Cabernet Franc has the aroma of raisins and prunes. Mike says it is similar to a big Zinfandel or the Italian Amarone style of wines.

The Italians make their Amarone style wines by picking their Corvina grapes when they are ripe and then air-drying them. As the water dries from the grape, the remaining sugar becomes

more concentrated. Higher sugar means higher alcohol. When Michael picked his Cabernet Franc grapes they were at 31-degree brix (sugar content). He added a Spanish yeast that is tolerant of high levels of alcohol, and the wine fermented dry in three days to 18 percent alcohol. Michael was a bit surprised, because he thought the wine might stop fermenting at 14 or 15 percent alcohol and have some residual sugar. He mixed this wine with regular Cabernet Franc and bottled the results at 15 and a half percent alcohol. Normally, Virginia wines are 11 to 13 percent alcohol. In California, the alcohol is often higher than 14 and a half percent, so the winery has to subject the wine to a process that actually removes some of the alcohol.

A high-alcohol content wine can taste hot and be unpleasant to the wine taster. Amanda Gec-Taylor, who works in the King Family tasting room, said that knowledgeable wine drinkers who happen by are able to appreciate this wine. Michael Shaps had such success with that wine in 2001 that he is planning to air dry the grapes himself to see if he can reproduce in the cellar the natural results from the dry fall of 2001.

At King Family farms polo ponies canter across the pasture in front of the large winery building. In front of the winery is a new planting of Petit Verdot. The remaining vineyards are at the back of the farm on sloped hill.

At véraison David King has erected kites and all types of whirling flags and other distractions to keep hungry birds at bay, so they won't eat all the grapes before they can be harvested. David has installed loudspeakers that shriek with the shrill of a frightened bird. The noise is deafening and hopefully frightening to the winged creatures. Finally, to take care of those birds that learn to navigate this labyrinth of terror, David and his sons fire shotguns to scare away the most audacious species.

David King and his workers descend into the vineyard every day to keep the vines immaculate. The vines are trained to a Smart Ballerina type trellis. David says that his soil, called "Dyke Clay" by soil scientists, is so high in vigor that this system is required to give the vine some place to grow. The Smart Ballerina system has a single curtain of foliage and fruit but some shoots are allow to flop outside the retention wines thus looking somewhat like a Ballerina doing a pirouette.

David agrees with Michael in his assessment of Cabernet Franc's suitability for Virginia. He says Cabernet Franc is, "Very adaptable to Virginia. Very heat tolerant. Grows well here. Sugars well. Has nice loose clusters."

Chris Pearmund, of Pearmund Cellars, also says that Cabernet Franc grows well in Virginia. He and Michael both say that it does better

in Virginia than in California. Chris says, "In Virginia we have cooler growing conditions, clouds, summer rains, clay in our soils just like Loire Valley. I think our wines for Cabernet Franc do very well in Virginia. The wines are expressive. They show the terroir of Virginia."

Chris adds that Cabernet Franc is not long-lived in the bottle like the traditional Cabernet Sauvignon-dominated Bordeaux blends. He says five years is a long as anyone would want to save this wine. It has a lighter structure that lends itself to younger drinking. He questions, "Let it set for ten years in the cellar? This is not what Cabernet Franc is about. It's a younger drinking wine where you want fresh lively flavor with smoky cedar character from the oak." Chris says that after five years the wine would become smokier and the fruit flavor would go out of the wine.

Philip Ponton is the assistant winemaker and viticulturist at the 20-plus-year-old Oakencroft winery in Charlottesville. He characterizes his 2000 Cabernet Franc as having a raspberry floral note on the finish. His 2001 vintage has more aggressive tannins so it needs more time in the bottle for oxidation to work its magic and mellow out the wine. The fruit has a nice smell of earth. Like Chris Pearmund and Michael Shaps, Philip uses cold soaking to extract color and ripe tannins from the skins while reducing bitter tannins from

the seeds. And like so many Virginia winemakers Philip uses Lalvin D254 yeast with his Cabernet Franc. Chris Pearmund prefers to make four wines from four different yeasts and then mix them all together to get more complexity from the wine.

Loree Jacobs is the marketing manager at Oakencroft. She says "Cabernet Franc has a cult following." She travels the states promoting the wine to restaurant owners and at seminars that she hosts.

Philip is a viticulturist at heart meaning that, like Jim Law of Linden vineyards, he prefers to be in the vineyard rather than the cellar. Philip is currently experimenting with different trellis systems to see which is best for Cabernet Franc. Like David King, he complains that the deep clay soils of the 250-acre Oakencroft farm impart too much vigor to his vines. So he spends a lot of time and money clipping the vines back to civility. He says it is important to find the proper balance between the number of shoots and leaves and the amount of fruit retained on the vine. He says "crop level is important." Too much fruit will not properly ripen and will impart a herbaceous or green grassy flavor to the wine. Of his vineyard Philip says "I want to walk through here and I want to see fruit. I don't want to see leaves covering up the fruit."

Virginia winemakers either bottle their

Cabernet Franc by itself or blend in other types of wine. Horton Vineyard's 1998 Cabernet Franc won a gold medal in the Governor's Cup and was mixed with Tannat. Chris Pearmund's 2001 Cabernet Franc is blended with 11 percent Merlot. Philip Ponton, winemaker at Oakencroft, added eight percent Chambourcin to his 2000 Cabernet Franc. Michael Shaps has added some Merlot in the past or bottled the wine with Cabernet Franc alone.

How does Virginia Cabernet Franc do in international wine competitions? Let's consider one competition: The 2003 San Francisco International Wine Competition sponsored by *Bon Apetit* magazine. Gray Ghost 2001 Cabernet Franc and Barboursville 2002 Cabernet Franc took home Silver medals while First Colony 2001 Cabernet Franc, Breaux Vineyards 2001, and Afton Mountain Vineyards 2001 won bronze medals. The double gold medal went to a winery in Sonoma valley. Out of 20 silver medals two went to Virginia wineries. Out of 27 bronze medals three went to Virginia wineries and one to a winery in Chinon, France. No gold medals were awarded at all.

What does all this mean? The competition web site says that awards are by "vintage within class." So the competition for, say, 2001 vintages is among other 2001 vintages only and not, say,

wines from 2002. Also the web site says "The judges will not grant awards when, in their opinion, no wines are worthy of an award." So the judges decided that one wine was worthy of a double gold but no wine was worthy of a gold medal. Most of the wining entries were from California while France is mentioned hardy at all. Perhaps the French did not participate to the extent that the Americans, Australian, and other countries did. The "Red Bordeaux Blend" category has not one French winner so you would have to assume to Chateau Cheval Blanc opted out of this competition, yet the Germans and the French in Alsace did participate and took home many medals for their Gewürztraminer varietal. They would not have entered Cabernet Franc wines since they do not bottle them as a varietal. Still, for Virginia wines to take home 10 percent of the Cabernet Franc medals is an impressive showing in an international event.

If we look briefly at a couple of more events, no Virginia wine took home any medal for Cabernet Franc at the 2003 Dallas Morning News competition. Rappahannock Cellars won "The Best East Coast Wine" at the 2003 Atlanta International Wine Summit for its 2001 Cabernet Franc.

Finally, there is a web site called winewatchguide.com that sorts the results of

eleven different wine competitions held in the year 2000. They then sort these results based on the number of awards won, the type of award, and the price of the wine – after all it is a web site for bargain hunters. Barboursville Vineyards 1998 Cabernet Franc shows up as number 17 on the list. It is the only Virginia winery on the list.

The Italians

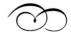

Barboursville is perhaps Virginia's most glamorous winery and one of its oldest. Its events calendar is replete with Opera, Shakespeare, and winemaker's dinners. This winery offers fine Italian and French wines with Italian opera as backdrop. After taking a look at that, we will spend a couple of days working the harvest as Hurricane Isabel races up the East Coast.

The Opera

A menacing cloud floated overhead as the walls of the Barboursville Vineyards winery reverberated to the strains of the Puccini's aria "O Mio Babbino Caro." Soprano Joanne Robinson filled the room as 175 opera patrons looked on and a few more walk-up ticket buyers sat on the veranda. The admiring fans were seated indoors instead of outdoors as

originally planned. Former First Lady of Virginia
and President of the Central Virginia Board of
Virginia Opera, Jeannie P. Baliles, explained that,
"Our tents are filled with water up to our knees;
that is why we are here inside."

For the past two years the Virginia Opera
Company has come to Barboursville Vineyards to
sing amidst the ruins of the mansion of the former
Virginia Governor and senator James Barbour.
His house, designed by Thomas Jefferson, burned
accidentally in 1842. No doubt the Virginia Opera
wanted to recreate that world-famous moment
when the Three Tenors, Pavarotti, Carreras, and
Domingo sang to World Cup fans at the ruins
of Terme di Caracalla in 1990. All the requisite
amenities were there: an Italian-owned vista, opera
singers, and crumbling ruins as a backdrop.

Not even the rain could dampen the spirits of
the opera and wine-loving fans and the ebullient
Barboursville Vineyards manager, Luca Paschina,
who is from Alba, Italy. With his two boys dashing
in and out of the crowd, and his wife Patricia
wearing a rain slicker, Luca remained calm and
composed even as he raced to the winery from the
Vintage Virginia™ wine festival held far away in
Northern Virginia. There Barboursville Vineyards
along with 49 other Virginia wineries sold wine to
festival-goers until a minor flood forced Luca to
pack up one of his two festival tents and send part

of his staff back to the winery.

Barboursville is unique among Virginia vineyards for two reasons: First, they plant 1,940 vines onto each acre; this is triple the usual density for American viticulture but quite common in Europe. The reason for doing this is to keep fruit quality high. Each vine produces a limited number of grapes since it is constrained by space; other Virginia growers accomplish the same goal by meticulous shoot and cluster thinning. Second, Barboursville Vineyards, being Italian owned, plants Nebbiolo, Pinot Grigio and other Italian varieties. This is in addition to the usual varieties planted by Virginia growers: Cabernet Franc, Viognier, Chardonnay, Merlot, and others. Of Pinot Grigio Luca says, "It does very well here. It's our most consistent white wine."

In addition to making wine and growing grapes, Barboursville includes a highly regarded Italian restaurant: Palladio. Chef Melissa Close prepared a buffet for the opera event and was on-hand to talk about the restaurant and winery.

Melissa says that last year Palladio was invited to New York to cook Christmas dinner and serve wine at the prestigious James Beard Foundation. Melissa also says she and Luca are invited to go there again in May 2004.

Melissa, a petite 33-year-old Alabama native and graduate of the New England Culinary

institute in Vermont, joined Barboursville three years ago when local farmers clamored to sell her produce. Today, Melissa works with three or four local organic growers. She says "If I can buy it locally I do."

The restaurant smokes it's own meats, bakes its own bread, and even makes some of its own cheese. In the wine cellar Luca is aging some two-year old balsamic vinegar made by the winery. It will be ready to serve at Palladio when it is four to five years old.

The restaurant includes a prix fixe four-course dinner, each course paired with one of Barboursville's wines. The menu, which is changed monthly, includes two, three, or even four courses at lunch. In the winter, Melissa and other cooking staff fly off to Italy to learn first-hand Italian cooking techniques.

Palladio restaurant even includes Morel mushrooms when they are available. Morels, also called Merkles, are like truffles: they are rare and hard to find. Melissa says some Morels are found at Barboursville Vineyards; others are bought in West Virginia.

The Harvest

At the end of a day spent working the harvest, Luca Paschina served his wine cellar staff pasta and wild goose that he had shot and cooked

himself. Of course dinner must include wine so
Luca popped open two bottles of Italian Nebbiolo.
Luca had brought the Nebbiolo brought back
from Italy and was eager to know the opinions
of his two learned French interns on this wine.
Luca pointed out that there was no warning on
these expatriate bottles against the dangers of
drinking alcohol while pregnant. We were all tired
having worked from eight o'clock in the morning
until ten o'clock at night to process 20 tons of
Chardonnay grapes.

The Barboursville winery and vineyards
face westward. This is a novelty in this generally
eastward-facing Virginia Piedmont region.
Barboursville has 120 acres of grapes across a
sprawling, rolling landscape. The top part of the
vineyard the workers call "The Mountain." One
corner of this sits in Orange County and the
other in Albemarle County. The view of the Blue
Ridge Mountains from here is unencumbered
and breathtaking. To the left are Pinot Grigio
grapevines whose white grapes have turned gray
indicating that the fruit is ripe. The Pinot Grigio
has already been harvested; this grey fruit is a
secondary crop growing on the laterals. A towering
wind machine looms over the Chardonnay and
Viognier vines planted here. Its raison d'être is to
push the bud-killing frosts away from the vines.
Go down the hill slightly and back up again, and

dogs patrol the Nebbiolo grapes on the left and
the Cabernet Franc vines on the right. These dogs
live in cozy dog houses and are kept inside the
canopy by an invisible electric fence such as you
find in suburbia; however, these dogs work for a
living. Their job is to chase off the many deer that
attempt to feed on the ripening fruit.

Barboursville Vineyards is something of a
small town, really. There are several houses on
the rolling 850-acre property. Three interns
working the harvest were staying in one house
behind the winery. The assistant vineyard manager
and mechanic lived in a house just below the
winery. While he said his commute was short, he
complained that his boss could reach out and grab
him at will. The migrant workers working at the
vineyard and some of those permanent workers
who have obtained residency status live on the
vineyard as well as their children. This was made
clear when a yellow school bus pulled up to the
winery and a few small kids hopped on board.
With the dozen or so houses on the winery it is
not much of a stretch to suggest that Barboursville
Vineyards is larger than the town of the same
name which it located just a few yards away.
Certainly someone visiting the Barboursville post
office would notice how truly tiny it is, also the
only place to buy gas and beer in town does not
take credit cards.

Barboursville Vineyards is large by Virginia
standards. Producing 42,000 cases per year
makes the winery perhaps the second largest in
the state with only the 65,000 case producing
Chateau Morrisette larger. Prince Michel might
be a close second or third at 45,000 cases per
year. Barboursville's Tuscan-style building sits
above newly-planted Cabernet Franc grapevines
and looks out towards the ruins of Governor
James Barbour's house which burned in 1842.
The entire winery is laid out in optimal fashion
to produce wine. At the far end of the winery sits
the destemmer-crusher machine and bladder press
needed to remove the stems from the grapes and
press the juice from the grapes. There is a covered
area where tractors can back up to the enclosed
concrete portico and unload newly-harvested
grapes. Just inside the cellar door is a large room
with towering glycol-insulated refrigerated tanks
where the temperature of grape juice and wine is
carefully controlled. Open vats of Riesling wine
are bubbling gently as yeast converts their sugars
to alcohol and carbon dioxide. Sauvignon Blanc
and Pinot Grigio have already been gathered
and fermented so these wines are settling in large
tanks. No red grapes are yet fermenting that week,
because they are the last to ripen. They will be
picked in a few days or perhaps a couple of weeks
depending on the weather. Off to one corner

is an office for the interns, cellar, and vineyard managers who work at the winery. The office is also a lab – whose many machines percolate and hiss with the sound of Bunsen burners and laboratory tests underway.

Next to the lab is the large room and gift shop. The tasting room is filled with tourists during the day as they taste Barboursville wines and buy items in the gift shop. Behind is another room where Barboursville keeps its own wine bottling equipment. Most Virginia wineries do not have their own bottling equipment. They prefer the lower cost of using a mobile bottling line, so Barboursville is somewhat unique in this regard. Walk past the bottling equipment and there are row after row of American and French wine barrels. These are stacked high into the air and construction is underway to provide additional cellar space. To the right of the wine barrels is the kitchen and Palladio Restaurant. Behind the restaurant is a warehouse where bottles are packed in boxes. These are ready to be picked up by tractor-trailer trucks and hauled to wine shops and grocery stores in Virginia, New York, and beyond.

Luca Paschina is the general manager and winemaker at Barboursville. He is tall and unflappable, managing to maintain a smiling demeanor even when the worries of harvest and the burden of management bear down upon him.

His sprawling office is at one corner of the winery and papers from the many projects underway are neatly lined up on his desk. Luca's dog Grappa wanders the property. Grappa is also Luca's e-mail address. Grappa is a fortified wine made by distilling grape skins. Luca's wife Patricia and his two boys stop by in their soccer uniforms. Luca coaches the nearby 4-county soccer team where his boys play. He manages to take time out from this busy harvest day to attend a practice and returns to the winery thoroughly winded from running up and down the field for 50 minutes. When Luca is not working in the winery or traveling to New York or Italy to promote Barboursville and Virginia wines, he is out shooting deer or geese on the property or fishing for small-mouth bass on the lake there. Luca's other hobbies include cooking gourmet meals for his family.

Fernando Franco is the viticulturist and vineyard manager. Wearing a t-shirt from his native El Salvador, speaking Spanish, Italian, and English, Fernando is a multi-lingual wizard of grapevine physiology. He can rattle off the nuances of scientific viticulture with studied attention. Having worked at Prince Michel's Virginia and California vineyards since 1983 he is one of the best fruit growers in the state and certainly one of the most widely respected.

On this the first day where I had come to

witness the harvest, Fernando drives beyond the Barboursville ruins, goes straight, and then turns left to the vineyard that the migrant farm workers call the "Iglesia." This is a Spanish word meaning "church" because the vineyard sits in front of a church. As is the case in most Virginia vineyards, the vineyard workers are predominately migrant workers from Mexico.

We turn left and drive past several acres of Pinot Noir grapes. Fernando says he has been working for 20 years with viticulture in Virginia. 20 years ago there was little knowledge of which grapes grow best in the Virginia climate. Now Barboursville knows that Pinot Noir and Riesling do not do well here, so they are slowly replacing both varieties with Viognier, Chardonnay, Petit Verdot and other varieties which are better suited to the hot, humid, and bone-chilling cold of the Virginia climes. Fernando also says in those 20 years Virginia has learned which clones of each variety grow best here. Virginia has learned that certain varieties do not work at all. Of Pinot Noir, Fernando says "It's a very temperamental grape. It suffers during drought and it suffers during rain." Barboursville does not plant the Italian Sangiovese grape but they do plant Nebbiolo and Barbera. Both Fernando and Luca say Sangiovese (the primary ingredient in Chianti) will not properly ripen in the Virginia Piedmont.

We drive past Pinot Noir, round the corner
and come to the block of Chardonnay that
the pickers will harvest today. Twenty or more
workers are there together with a small fleet of
battered, broken down cars and vans. Like many
farm vehicles, these are sans licenses tags – instead
the words "Farm Use" negate the need for that bit
of bureaucratic paper work.

Fernando gets down from his truck and speaks
to the migrant workers in the vineyard. Five or six
of these men are full-time workers at Barboursville
including one father-son pair. Other workers,
including one middle-aged female, have come
over from nearby Burnley Vineyards to assist for
the day. Yet other workers have been hired for a
short time and have traveled from Waynesboro,
which is west of Charlottesville. The workers have
fanned out across the vineyard and have placed
bright yellow pickling lugs between every other
vine. Each lug holds 25 pounds of fruit. It takes
roughly one hour for the pickers to fill up enough
lugs to fill the three bins that will be processed at
the winery.

The workers use shears to clip off bunches
of grapes and then dump them into plastic lugs.
The workers are paid for each lug that they pick.
One worker tallies the lug count, while others
dump them into bins in the back of the wagon
hooked to the tractor. Donny ferries the bins to

201

the winery by tractor. Donny look like the gruff character Lee-Marvin played in the movie "Paint Your Wagon" with his white handlebar mustache matching his hair. He seems perfectly at ease seated atop that tractor as it moves slowly down the aisle.

Fernando leaves the vineyards where the workers are picking grapes and heads into Albermarle County to take samples of Viognier grapes to see whether they are ready to harvest. Along the way he stops his truck and hops down to catch a box turtle as a pet for his younger daughter.

Barboursville's assistant winemaker is Stefano Salvino. It's cool and dark in the wine cellar. So one can imagine Stefano some kind of Quasimodo lurking about the cavernous Notre Dame of Victor Hugo's novel. But Quasimodo was ugly and hunched over; Stefano is handsome but he is of course hunched over since much of his day is spent connecting hoses to various tanks. To do that, you have to bend over. Stefano is dark and heavy-set. His training is vocational. Stefano was educated at the *Gradisca D'Isonzo Istituto Tecnico Agrario Statale* in Italy. Prior to coming to Barboursville in 1999, Stefano worked at wineries *Aziende Vinicole Puiatti* from 1991 to 1995 and *Aziende Agricola Vazzoler* from 1995 to 1999. Stefano, like most winemakers, is a skilled forklift driver. One clever trick that Stefano uses is the

way he cleans pumps and hoses. To do this he simply turns the pump on backwards, shines a light through the back of the hose, then flips off the pump when the color of wine turns to the color of water.

Joining Stefano in the cellar is Paul Summers. Paul came to Barboursville from Kluge Estate where he worked as assistant vineyard manager. For 12 years he has made wine from his home vineyard. Paul also had a restaurant where he and his brother made beer. Paul says that the rule-of-thumb in these close quarters is not to pull on any hose that offers any resistance. Otherwise you might open a valve and send hundreds of gallons of wine spilling onto the floor.

Scott Stump is the mechanic and assistant vineyard manager. He graduated from a horticulture program at a college near Norfolk and once worked at Williamsburg Winery. Scott's job is to keep the myriad of machines at Barboursville in working order and assist Fernando in the vineyard.

Luca is fortunate to have three temporary interns to augment his staff. This year he has two Frenchmen and one Italian girl working in the winery and lab. All three are in vocational training programs in Europe where an internship is mandatory.

François Jaubert is an affable Frenchman, whose English is good; he has blond hair and a

goatee. François studied at the *Lycée Viticole de Beaune* where they have a 20-hectare vineyard and they make wine. (Lycée is French for "high school." The French of course allow high school students to drink wine.) Barboursville is the third winery where he has worked as an intern. François is quick to point out each step of the winemaking process. Yet he is not so distracted that he cannot take time out to observe the sun setting over the Barboursville ruins in the distance.

Pierre Leclerc has close-cropped hair and does not speak much English. Pierre was trained as a laboratory technician in France. Both he and François currently go to ENESAD, *Establissement National d'Enseignement Supérieur de Dijon* in the Burgundy region of France. Pierre is rather shy, perhaps because his English is limited, and prefers to fiddle with the tractors rather than to engage in small talk. Pierre uses the Internet to keep in touch with friends and family in France. He writes his e-mails *sans accents* since his American keyboard cannot easily make the *circonflex, accent grave, accent aigue, cedilla,* et cetera.

Working in the laboratory is Sabrina Goat (pronounced Go-at). She is an intern from the *Istituto Tecnico Professionale Statale Anjaria.* In the Barboursville laboratory, Sabrina presides over an array of Bunsen burners, test tubes, and various gadgets. Her job is to measure the sugar, acid,

pH, and alcohol in the wine or grape juice. Luca
cautions that one should not use numbers alone
when measuring the quality of the grapes nor
when making the decision when to harvest.

Fernando has dropped off a sample of Merlot
and Viognier grapes for Sabrina. These are
stored in a Ziplock bag. Sabrina crushes these by
hand and then draws a sample. She washes the
refractometer with distilled water and drops some
juice onto the lens. Then she holds it up to the
light and reads the sugar level (brix) off the display.
Luca drops by and loses closely at the seeds. If
they are at all green then the grapes are not ready
to harvest. Green seeds will impact bitterness to a
wine if they are not carefully handled.

Sugar level is an indicator of the alcohol level
of the wine. If the sugar level is too low then the
resulting alcohol level will be too low. The wine
will not taste proper and will be subject to spoilage
by acetic (vinegar) bacteria.

Both pH and acid levels are somewhat
related; pH indicates acidity, thus a pH of seven is
neutral. Numbers higher than seven mean alkaline
and numbers lower than seven mean acidic.
Wine should be slightly acidic as it is a natural
component of taste. As the grapes ripen the acid
level decreases and the pH level increases. Wine
requires proper levels of acid and pH to preserve
color (for red wine), to prevent spoilage, and to

provide the best possible taste. To measure the pH of the grape juice Sabrina rinses the probes on an electronic pH meter with distilled water. Then she simply pops the probes into the juice and reads the resulting numbers off the display.

Measuring acid level is slightly more heuristic. To do this Sabrina again employs the pH measure, and then adds sodium hydroxide (an acid) to the grape juice drop by drop until the acid grape juice turns slightly alkaline at a pH of 7.4. A gauge tells how much acid was needed to make the grape juice neutral – this indicates the acid level of the grape. Luca can do this complicated test quite quickly.

The final test that Sabrina does is to use the ebulliometer to measure the alcohol level of the wine. The reason for this is regulatory – that level must be written onto the wine bottle label. The ebulliometer works by calculating the difference between the boiling points of alcohol and water.

It might be news to the laymen that wine grapes taste quite sweet. Wine grapes taste generally better than the table grapes sold in the grocery store. Perhaps the main reason for this is table grape growers prefer to sell grapes that hold up well under shipment and not those that taste the best. This is, of course, the case with store-bought tomatoes, which generally taste bland. Concord grapes, which are perhaps the sweetest grape of all, are not widely sold year-round

because they fall apart in a few days. The Pinot Grigio (white), Chardonnay (white), Nebbiolo (red) and other grapes that I tasted there were sweet even if the red wine grapes were not quite ready to harvest. Fernando in particular was worried about the Merlot. It was just about ready to harvest, but Hurricane Isabell was bearing down. So he wondered whether he should harvest this now or wait until the forecast six to 12 inches of rain further reduced the sugar level in the grapes or perhaps pop the grapes wide open with the force of the hurricane deluge.

At the winery Donny backs up to the concrete floor while tourists snap photos. Stefano removes the bins of fruit from the wagon attached to the tractor and then dumps the fruit into the crusher destemmer. The crusher destemmer is more properly called a "destemmer crusher." The machine pops the grapes free of the grape stem and racchi (the wood parts of the bunch). The grapes roll into the crusher and the stems are ground up and blow out to a waiting wagon.

The grapes are not actually "crushed." Rather the destemmer crusher is carefully calibrated for each type and size of grape so that they gently pop open the grapes and then let the juice and resulting must (i.e. the juice and pulp) flow around the corner of the winery through a hose and into the bladder press. The grapes are pushed

along this viticulture assembly line by a worm gear at the crusher destemmer and then pumped up to the bladder press by a powerful, specifically designed fruit juice pump.

The bladder press is a marvel of technology. Barboursville has two presses each one computer controlled. The larger press holds four tons of grapes. It stands eight to 10 feet above the floor on heavy legs of steel. The outside of the press includes tiny slats that let juice flow into a holding tank while keeping the bitter seeds out. The bladder is a giant bag that is filled with air. As the bladder expands it squeezes the grapes until the juice is pressed out of the grape skins and pulp.

The decision of how hard to press the grapes is programmed into the bladder press's computer. When the press is first loaded juice is squeezed out of the grapes by the shear weight of the grapes piled onto each other. This is the so-called "free run" juice. This is the best quality juice and Barboursville pumps it into a separate tank from the so-called "press juice."

In a modern winery, the bladder press has replaced the basket press with which most wine drinkers are familiar. That device has wooden slats and a rotating wheel, which forces a plate down onto the grapes.

The goal to pressing wine grapes is to press them evenly and steadily without applying too

much pressure. If you press the grapes too hard the seeds can pop open. Seeds contain bitter tannins, which will make the resulting wine taste bitter.

The bladder press inflates and presses the grapes, deflates, rotates, and then inflates again. The entire process takes about two hours. François with his experience working in this his third winery can tell from the color of the juice how hard the grapes are being pressed. When the juice grows darker he disconnects the press from one tank and attaches it to another to further segment the juice by quality and blending needs.

Like most machines associated with winemaking, the two bladder presses at Barboursville come from Europe and are programmed in metric units. So when the press first runs it presses the grapes at 0.2 BARs and then increases pressure until the final run is at about 1.2 BARS. A BAR is 100 kilopascals or one kilogram per square centimeter. For the American reading this essay – who of course does not understand the metric system – this is 14.5 pounds per square inch.

After the white wine is pressed it is pumped into tanks where it is cooled. The pump and any sour rot or pulp is allowed to settle to the bottle of the tank. Such suspended solids and other unwanted items are said to "precipitate" meaning they settle to the bottom. (This is the driving

principle by which wines are made clear through a process called fining. When the juice is first pumped into the tank and for some months after it has fermented it is hazy. The wine will taste good, but the consumer wants white wine to have sparkling clarity. Once tartaric crystals and other suspended solids precipitate, gravity pushes them to the bottom thus helping to clarify the wine.) The next day François, Paul, and Stefano will pump the grape juice from the material that has gathered at the bottom into a new tank. (This is not exactly the same as "racking the lees" as the lees, or the dead yeast cells from fermentation, have not yet formed.) Then Stefano will add yeast and the Chardonnay wine will begin to ferment.

210

The migrant workers in the vineyard finish picking grapes just before dark but the work at the winery continues long into the night. As the last grapes are loaded into the bladder press we have to wait two hours before we can shut down the equipment and clean up the floor and machinery. François is the fortunate soul who gets to strip off his shirt and climb inside the bladder press to clean it from the inside out. All I can think of is a horror movie that I once saw by Vincent Price. If one were to fall into the crusher-destemmer or bladder press while it was running, the results would be ghastly. For this reason the power is disconnected when François climbs

inside. François has to hose out the bladder press
and then pick individual grapes from the corners
where water cannot knock them free. I stand there
shoveling grape skins into a trailer and washing
the concrete with a water hose. Inside Paul and
Stefano continue working with the days-old
Riesling and Sauvignon Blanc wine.

The second day that I was on hand to observe
the harvest at Barboursville, Fernando wheeled
out the automatic harvesting machine to pick
11 acres of Chardonnay on the site they call "the
mountain." Hurricane Isabel was getting ready
to race up the East Coast so Fernando and Luca
wanted to gather up the fruit quickly before the
deluge of rain. Six to twelve inches was predicted
while only four to five inches actually fell.

When I showed up that second morning
Scott had climbed onto the top of the harvesting
machine to apply grease to the grease nipples and
perform other maintenance. Fernando filled the
machine's fuel tank with diesel fuel. The sound
howls like a small airplane.

The idea of a harvesting machine is to replace
manual labor with automatic. The migrant
workers clearly don't like it as they eye it with
suspicion. The pickers from Burnley Vineyards
look it over once, shrug their shoulders, and go
to another part of the vineyard. The harvesting
machine works by shaking the grape vines so

vigorously that the grapes fly free of the stems. The stems, and leaves caught up in the machinery are chopped into mulch and blasted out the back. Grapes harvested in this manner are broken open thus subjecting them to oxygen. This is not a problem for white grapes as long as you get them to the winery quickly. Red grapes hold up better under exposure to oxygen since their skins impart color and tannins, which both mask any discoloration and act as a natural anti-oxidant.

Barboursville has made their newest planting's on trellises specifically designed for automation. In addition to a harvesting machine, they have automatic pruning machines, as well as a machine which can actually grab a grape vine shoot, positioning it properly, and then fasten a plastic ring onto the retention wines thus holding the grapevine aloft. This replaces the work of many workers. The goal is to drive down costs yet maintain high quality.

Fernando heads into the vineyard and drives the lumbering machine across the top of the grapevines. Scott walks along behind. To guide Fernando, he tilts his outstretched arms left, right, forwards and backwards as if he was flying an airplane. He wants to help Fernando keep the machine level. Fernando just ignores him, because Fernando can see well enough to keep the harvester upright. Later Scott suggests that

Fernando collect grapes from three rows before instead of two dumping the contents. Fernando ignores Scott again.

The harvester goes right over the top of the grape vine canopy and shakes the vines roughly so that the grapes are shaken free. A conveyor pushes them into the hopper. The hopper is dumped into a waiting tractor and the end of every other row and the interns or Scott ferry the grapes to the winery. The machines works well except when it drops into a hole, then a trellis pole is ripped right out of the ground. The harvester is already dented because last year it rolled over onto its side when it fell into a similar hole. Wanting a new machine, Fernando has said that Mr. Zonin has agreed to buy a new $500,000 harvester for next year. This newer, better machine will actually be self-propelled thus negating the need for a tractor and giving the operator a better view as he drives over the top of the vines.

Luca says that the harvesting machine is especially handy when you want to harvest a lot of grapes in a hurry. But he adds that it is a good thing assuming it does not break down. I tell him that for an American to suggest such a possibility is to ensure it. Sure enough the machine malfunctions after a few hours. Instead of popping off grapes and loading them into the hopper, the machine runs wild and grape juice comes spewing

out of the back instead of going into the hopper. Scott, the mechanic, is nowhere to be found; yet Fernando manages to get it working correctly again after an hour or so. In roughly seven hours Fernando has harvested 11 acres of grapes.

At the end of the day, Fernando and Scott kick Pierre off the Internet and go onto the web site of the National Hurricane Center. They are watching the track of Hurricane Isabel, which has drawn a bead on the East Coast. It is forecast to head straight for Richmond and then directly over Charlottesville, which is only 20 miles away.

Los Campesinos
en el Viñedo Horton

There are two ways to learn the Mexican culture:
One is to read the highbrow books of Octavio Paz;
the other is to live in Mexico or work with the many
Mexicans who are working in The United States. The
same can be said of the pursuit of an understanding
of the wine world – a world often complex enough to
scare away the brightest of people. I spent an entire
season working with the campesinos at Horton Vine-
yards in the vineyards, in the cellar, and during the
harvest. This is a firsthand account of that experience;
a story about so much: wine, a culture commonly
found but not commonly understood here in the
United States, and the events of my time at Horton.

The Vineyard

On a cold, wet day in late may in Virginia,
I drove to Sharon and Dennis Horton's Horton

Vineyard located on Berryhill lane in the town of
Orange, Virginia. Horton Vineyard's Berryhill vine-
yard is a rolling pastoral landscape of 57 acres of
French, Spanish, and Portuguese grapes. This is one
of four vineyards where the Hortons grow grapes
for their 35,000-case winery, Horton Cellars.

Many wine-loving tourists are familiar with
Horton's large winery located on Highway 33
in Barboursville, Virginia, but only two acres of
grapes are farmed there. The main Horton vine-
yards are 57 acres in the city of Orange, 27 acres at
Gibson Mountain between Orange and Gordons-
ville, and seven acres in the Horton's own front
yard of their house in Madison County.

I had arranged with Dennis Horton to work
in his vineyards and wine cellar a couple of days
per week to really get a feel for the life in his
vineyards. Dennis works at the winery on the
weekends and on Fridays. On Monday through
Thursday he is at his other business, Automated
Systems, in Sterling, Virginia. To work in his
vineyard I would work with his wife, high school
sweetheart, and his viticulturist Sharon Horton.

Sharon Horton farms 93 acres of grapes and
supervises the work of 18 or so migrant farm
workers. She is a short blond woman who is
deeply tanned from working endlessly outdoors.
She works seven days per week although her
workers generally work six. Wherever Sharon goes

her German Shepherd dog, named "Viognier" after the French white wine grape, follows closely behind. In the summer, Sharon's granddaughter Caitlin hangs around the vineyard to lend some help to this daunting process.

Working in a vineyard is backbreaking labor with long hours; a fact clear already that I would soon come to understand all too well. At the end of summer, after fruit set and before véraison, there is stifling heat and humidity; however, at pruning time in winter there is bitter, sometimes sub-zero cold. And at any time there is the occasional accident. During the harvest of 2002 Sharon rolled over her heavily laden pickup truck tossing 3,000 pounds of white Spanish grapes onto the highway. She was thrown from the cab and broke her back in two places. The paramedics took her to UVA hospital and took her dog Viognier to the veterinarian.

Labor is a persistent problem for Virginia farm wineries and vineyards. Many of the Virginia wineries prefer to hire Mexican migrant workers assuming that they could not hire nor find sober, hard-working American citizens who would be willing to work for such low wages. The Hortons grew tired of working with the roving gangs of migrant farm workers who travel the state – those worker crews were often composed of young, inexperienced, and undedicated workers. So some

years ago Horton Vineyards began to import migrant workers under the H2C farm worker visa program.

Sharon and Dennis hire 18 or so Mexican nationals each year. Under the guest farm worker program, these men are allowed to come to the United States for ten months at a time. Then they must go home for two months before they can come back again. Most of Horton's workers have been with Horton Vineyards for more than one year and their senior worker, who acts as an overseer, has been coming from Mexico for ten years.

Horton's migrant workers all come from Mexico except one fellow who came from Colombia, who quit before the season was over. Most of them speak no English save a few who have learned some working at construction and restaurant jobs in California, Colorado, and other American locations in previous years.

There is no doubting the workers' immigration status or country of origin, for their Mexican passports are stamped with the name "Dennis Horton" squarely on the back. Further their American-issued visas show the date they came into the U.S. and the date by which they must leave. The workers start arriving in January to begin to do winter pruning. And then they go home in November after the harvest work is complete.

The Mexicans apply to work at the Ameri-

can consulate in Monterrey, Mexico. Sharon asks
for the same workers year after year. Under the
guest worker program she must pay them slightly
higher than minimum wage (a so-called "prevail-
ing market wage"), provide them transport to and
from Mexico, and provide their housing. So she
rents two houses for them in Orange, Virginia:
one on Monrovia drive and another on Highway
20 North.

Americans generally refer to the migrant
workers as "*campesinos*," meaning "farmer," in
Spanish or "country person," since the "campo"
means the countryside. If you wanted to be more
exact you might call them "*obreros*" since that
means "laborer."

I spent a season working with the *campesinos*
at Horton, so I could learn more about viticul-
ture, experience a harvest, practice my Spanish,
and then be able to chronicle the whole adventure
into a chapter in this book. I worked with them in
the vineyard, in the cellar, in the rain, and in the
sweltering heat and humidity. I ate tacos at their
rented house, shared many lunches with them,
and even took a few to a dancing club and bar
in Warrenton. But I was also interested in their
culture and wanted to know why they wanted to
come to Virginia.

To a man, all the *campesinos* said was that the
reason they came to Virginia was money. They

said the only work available to them in their home states of Chihuahua or Durango was agriculture work or factory work at any of the *maquilladoras*, which are any of the many American factories that line the border between Texas and Mexico. One man had worked as a policeman in Mexico and another had been and still was a school teacher. Regardless of their profession they all seemed to make the same money there: 100 pesos per day, which is $10 US.

About half of the men had a family in Mexico. Once per week they went to the bank in Orange where they cashed their checks. Then they go to the Food Lion grocery to wire money home via Western Union. On occasion they drive to Culpeper to La Tiendita which is a little Mexican mercado (market). There were two such markets in Culpeper until La Tiendita recently closed.

The *campesinos* get paid by the hour on most occasions. Usually they are encouraged to work slowly and deliberately. But they are paid a "piece rate" at harvest when the goal is to have them work fast. Then they get paid $1.25 per 25-pound lug of grapes that they harvest. The goal is to harvest the grapes as fast as possible in the cool morning air before the onset of the heat of day. Sharon says on such days that the workers can earn a couple of hundred dollars in the morning hours.

The Mexicans pay federal income taxes and

file a tax return. One day one of the workers asked me if I would intercede because the bank had refused to cash a $130 IRS tax refund check. Sharon promised to go with the worker to the bank the next business day.

The *campesinos* are free to come and go across the Mexican-American border and eagerly showed me their H2C visas. I asked them why they don't fly to Mexico City during the season to visit their families since you can fly there non-stop from Dulles Airport. They said it costs too much, besides Mexico City is closer to Washington than Chihuahua is to Mexico City. To get home in November they would board a bus in Richmond and for $150 Greyhound would take them all the way to Monterrey, Mexico.

Reinforcing the American view of their country, the *campesinos* say that Mexico is corrupt and crowded. They warned me to stay away from Mexico City because a gringo like myself would be robbed or kidnapped. Some like Mexican President Vincente Fox because he is not from the PRI political party who they say is largely corrupt. (President Fox is from the PAN political party). Other workers would prefer a president who is from the PRI party, because they say PRI is actually concerned with the poor. Highlighting the drug confrontation with the United States, they tell me that the Governor of Chihuahua has

a 100-acre marijuana field that he guards with the Mexican army.

Regardless of Mexican or American politics, vineyard agriculture is very, very labor intensive. If Sharon was farming 93 acres of corn, cotton, or other so-called "row crops" then she would not need 18 workers. But each individual grapevine must be visited several times during the growing season. In Virginia the grapevines grow vigorously. In order to have wine-quality fruit, extra growth must be meticulously clipped, pruned, and otherwise snapped off. Further the vines must be sprayed every seven days or even more frequently in time of high rainfall. And the grass growing between the canopy rows must be constantly mowed.

Horton Vineyards uses two types of trellis systems to contain their vines. These are the French Open Lyre system and the Geneva Double Curtain (GDC). Norton grapes are planted mainly on the GDC system while the other fruit is grown on the divided-canopy Lyre system.

The Lyre system is good because it gives vigorously-growing grape vines an area to expand. But it is expensive because it cannot be managed using mechanization. So the workers actually have to climb into the canopy to untangle and separate the shoots and clip them back to civility. Otherwise the grapevines would grow into one impenetrable mess that neither man, agricultural spray, nor sun-

light could penetrate. Allowed to grow wild, the fruit would not ripen properly and it would make poor quality wine.

So the *campesinos* generally do the same job day in and day out. First they remove suckers that are growing from the vines trunks. Second they hedge the vines when they have grown too tall. And finally they remove laterals.

The *campesinos* call the laterals "brotes" which is Spanish for "shoot." This is not technically correct because all of the green annual growth of a grapevine is called a "shoot." A lateral is when one shoot grows another shoot itself. If you look closely at a grapevine shoot you will see that where every leaf is attached there is a small dormant bud. This bud is supposed to lie dormant so it will become next year's growth. But when the vines are heavily pruned or grown in vigorous soils these dormant buds start to grow. Some varieties such as Viognier are more likely to have lots of laterals. Sometimes the laterals have no fruit. But Viognier, Cabernet Franc, and other varieties do have fruit on the laterals so the fruit and the laterals must be clipped off with the pruning sheers or snapped off by hand. Fruit left on the laterals ripens later than the remaining fruit on the vine if at all, and it takes energy away from the other fruit as well. The Mexicans also call laterals that grow from last years pruning wounds a "cuatre."

223

The trunks of grapevines sprout shoots also called "suckers." In California or France they would simply pop those off, but here in the east it is necessary to maintain several trunks in case the cold weather kills one. Sharon Horton took this one step further by maintaining two trunks and then growing two other short arms, which could become trunks if there was such a need. The workers pick out the two best shoots that are growing down near the graft union then carefully tie them to the main two trunks taking care to keep them on the opposite side of the drip irrigation system.

The *campesinos* stand in the grapevine canopies all day long positioning shoots to improve the airflow and sunlight exposure, snapping off laterals, and tying up young vines. They show up at Sharon's office at 7:00 AM, grab their pruning and hedging sheers, and then pile into the back of pickup trucks and head out into the vines. Each worker carries a 5-gallon plastic bucket to stand on so that they can reach the top of the canopy. The taller workers do not use these buckets in the latter part of summer. But early in the season Sharon wants the workers to use them because the shoots are fragile and will snap off if not handled carefully. Once the grapes flower and then the fruit sets, the shoots become tougher and can be handled more roughly.

The workers work until noon when they

again pile into the pickup trucks to head back to Sharon's office where they have their lunch outside. They line up orderly to wash their hands, have a 30-minute lunch, and then head back out into the vineyards to work until 5:00 or so. For lunch they have burritos, tortillas, or bologna and ham sandwiches. They always add hot peppers to everything they eat.

They generally take pride in their work. They are eager to impress Sharon, the jeffe (boss), with their knowledge. They run to her when they have found any grape berry moths or discover sick vines.

Some of the Mexicans have brothers who also work in the vineyard. Also, there are no women working there except, of course, for Sharon. Tony Beaza is Sharon's most senior worker and has become the de facto supervisor of the other workers.

Tony has three brothers who work for Sharon Horton – Beto, Carlos, and Susanos. Plus Tony's wife and their young baby live in a trailer at the vineyard on Berry Hill lane. Tony's English is fairly good, better than anyone else's, in fact. He says that while he is coming back in 2004, he might leave his wife and child home, because he says it's too cold for his baby in Virginia.

Beto is another brother. The name "Beto" is a diminutive form of his formal name "Alberto." Beto was the first worker that I worked with in the

canopy. Beto looked almost out of place with the other migrant farm workers because he wore fashionable sunglasses atop his head and had a slightly expensive looking jacket. He was handsome and had good teeth unlike some of the other men who had rotten teeth, with the, doubtless, poor or nonexistent dental care they received at home. Sharon paired me with Beto until I learned how to properly snap off laterals, hedge vines, and tie renewal trunks. But, in July of 2003, Beto was struck by an appendicitis. Since the workers have no health insurance, his brother, Horacio, signed a piece of paper saying that they would pay their bill at the UVA medical center in nearby Charlottesville, no doubt the bill is more than one year's salary.

After lying around Tony's trailer for a few weeks in convalescence, Beto headed home with one of his brothers who wanted to go on vacation and another worker who had to return to his regular job of teaching in the secondary school. So the three hopped into a car and drove to El Paso. From there they said it was a short trip over the border into Chiuahuaha.

Horacio is another veteran at Horton vineyards. Being more senior than the other workers he gets the relatively easy job of riding the riding lawn mower all day long.

Ramon Natividad and Lorenzo Natividad are brothers as are Vicente Canges Arroyo and

Geronimo Arroyo. Ramon and Leronzo are from
Chihuahua state in Mexico and Vicente and
Geronimo are from Durango. Lorenzo and Ramon
are both married and have children, while the
other two men are not. When they want to call
their family they do so by using a calling card from
the house rented for them by Horton Vineyards.
The calling card costs them nine cents per minute.
For their families to call them in Virginia would
cost an outrageous $1.50 per minute, because
Mexico's telephone company is state-owned, thus
making it expensive.

I had gotten to know most of the workers, but
spent the most time talking with these four friends
and brothers. We chatted away as we worked until
Tony came by at which point the men made sure
to get quiet and look busy.

Ramon and Lorenzo are tall men, both
talkative. Ramon explained that he used to be a
policeman in Mexico. According to the *campesinos*,
all cops in Mexico are corrupt, so I wondered
about this when I found out that Ramon had
been one. He said when he was in Mexico he was
quite fat, but the hard work of the vineyards had
slimmed him down a lot.

Vincente like his brother Geronimo has quite
dark skin. Vicente has a mustache and appears to
be less educated and more of a true campesino,
in the Spanish sense of the word, than his brother

who is more worldly. Vincente speaks Spanish at a rapid-fire clip and a lilting cadence; the other workers say he is loco. Much of what Vincente told me the other workers said was not true. Interesting.

Geronimo is a smiling chap with a glint in his eye. He likes women and asked me to take him, his brother Ramon, and Lorenzo to a dance club. I should have taken them to the Spanish dance club Mexico Lindo in Manassas, but I did not know about that club at the point, so I took them to Fantasicos in Warrenton instead.

Geronimo and his friends thought that we could pile five people into my tiny Toyota pickup truck. I said four, but they insisted, so Lorenzo, Geronimo, and Vincente crowded into the passenger area. Ramon, the tallest, sat up front. Even when I have my ten and six year old boys in the car it seems crowded. But with five passengers we might have envied the position of a sardine.

The Mexicans had not left Horton Vineyards one time during the season except to go the store or bank, so the *campesinos* were wide-eyed looking as the hills of the Virginia Piedmont rolled by. This was in stark contrast to Chihuahua they told me. The North Central Plateau region of Chihuahua is so flat that you could see another car on the highway 15 kilometers away.

First we went to their house where they cooked tacos. They heated them by placing them

directly on the burner of the stove, then I drove them to my farm so I could change into some clean clothes. I gave them some Virginia moonshine and we drank beer. The *campesinos* prefer beer to wine. I showed them my vineyard of 120 vines, and had to persuade them to relax, for they immediately wanted to start working on the vines. From there, we drove to Warrenton and the fellows were pleased because there were lots of young women to see. We even met a girl from Madrid who, of course, could speak Spanish, and Geronimo danced with her girlfriend.

I paid the entrance fee for the men to go into the club, and they repaid me by buying me drinks. I reflected that the price of two Scotch drinks at $15 would have required them to work one and a half days in Mexico. I also noticed that Lorenzo's wallet was full of $50 bills. I never carry much cash at all, and like most Americans use my debit or credit card. I wondered if he had a bank account somewhere where he could put away the windfall he had earned working for Sharon Horton.

Jimenez is another one of the workers in the vineyard. When he is not working he reads books in English to try to improve his language skills. Last year he was harvesting grapes and got stung by a yellow jacket. He broke into a rash and could not breathe so the other workers rushed him to the Orange Family Physicians Medical Center.

Conventional wisdom says that allergic reactions get progressively worse. So the next time Luis gets stung he could drop dead before help can arrive. Consequently, the doctors gave him a syringe of adrenaline so that he can eject himself the next time that happens. As anyone who has picked blackberries can attest, ripe, fragrant fruit attracts lots of stinging insects, so there is a great deal of risk for Jimenez, who is from Chihuahua. He has a wife and a 17 and 10-year-old daughter. He has a computer for his family, but they cannot afford Internet. Jimenez said it would cost 500 pesos per month. Like in Europe, the telephone company charges by the minute, even for local calls, but the local toll is far higher than in Europe.

Santiago is another of the senior workers at Horton Vineyards. He is a large burly man sporting a mustache, as do all of the *campesinos*. Being a senior man Santiago is trusted with the most important job of all: spraying the grapevines with fungicides, foliar fertilizers, and pesticides.

The Horton's have several tractors that are sealed airtight to keep out noxious and potentially dangerous fumes spewed forth by the air-blast sprayers. Dennis says to equip such a tractor with an OSHA-certified cab costs $68,000. Santiago whisks back and forth between the trellises spraying the grapevine canopies. He is careful to turn off the sprayer when he is making his turn at the

end of the row or when he is at the edge of the vineyard; this avoids wasting spray, because such sprays are quite expense. For example, Abound, a spray that controls a host of grape fungal diseases like downy mildew, costs $250 per gallon.

Santiago's rank among the workers is obvious. Sharon chose him to put together the go-cart that she bought her granddaughter Caitlin for her birthday. And when the *campesinos* drive from one vineyard location to another Santiago sits behind the wheel of the truck while the workers, and myself for that matter, pile into the back.

In August, the police stopped Santiago when he was driving Horton Vineyard's blue pickup truck. Like most of the other workers Santiago does not have a Virginia driver's license, although he does have a Mexican driver's license. Sharon sent eight of her workers to the DMV to get licenses, but with the post-9/11 crack down on phony documents, none of her workers could obtain one. Virginia had passed new tough restrictions because five of the 9/11 terrorists had their drivers licenses in Virginia. So Sharon wrote a letter to the farm migrant worker office in Richmond and the *campesinos* were able to go back to the DMV to take a test on the computer. Then they got learner's permit licenses; thirty days after that they could go back and take driving tests and then get a regular license. It was quite comical to see all

these grown mean carrying learner's permits meant for 16-year-old kids.

The workers and Sharon stay in touch with each other across the vast vineyard by walkie-talkie radio. She speaks to them in English, which of course they hardly understand except for Tony, who understands much. The *campesinos* tell me that Sharon does not understand Spanish much at all. She has, however, arranged English lessons for her crew. That is a pleasant gesture. Every Wednesday night they gather at the granaria, "winery" in Spanish, to take English lessons from a Mexican woman named Anna, who comes from the area near Alcapulco. Her husband is a soldier in the American army.

Most Virginia wineries concentrate on growing just a few grapes: mainly French Bordeaux and Burgundy varieties or French hybrids such as Seyval, Chambourcin, and Vidal Blanc. Barboursville, owned by Italians, plants Italian varieties as well including Nebbiolo, Pinot Grigio (called "Pinot Gris" in France) and Barbera. But Horton is unique in their experiments with Spanish grapes, French grapes outside of Bordeaux and Burgundy, and grapes from Portugal. Chrysalis Vineyards also plants Spanish grapes but no other vineyard has

such a vast array of varieties. Some critics have said this is not necessarily good. They say a winery, and Virginia as a whole, should concentrate on finding the grapes that grow best in each terroir then planting solely those few varieties that are a perfect match. (Some say for Virginia those varieties are Viognier and Cabernet Franc.) Then Virginia might find a few "breakout grapes" which will bring her world-wide acclaim. But Dennis Horton has his own opinion on this matter.

Dennis, who first brought the Viognier grape from the Rhône Valley of France to Virginia, reasoned that its loosely clustered grapes might be relatively resistant to Botrytis, which is a fungus that can rot grapes. Dennis said he has actually seen one Botrytis infected individual grape shrivel up, wither, and drop from the cluster without infecting the rest of the bunch. Largely because of Dennis Horton, Viognier is now of the one the main varieties grown in Virginia. In France only a few years ago, there was a mere 6 acres under vine; now Viognier is planted in California and, due in part to Georges Duboeuf, in wider areas of France. Its apricot and peach flavors and floral aromas are a pleasant alternative to drinkers who have grown weary of Chardonnay wines. Of course, Horton like most Virginia vineyards grows Chardonnay as well. It is reasonably cold-hardy and does quite well in Virginia's soils and climate.

Dennis' other major contribution to Virginia viticulture has been to introduce and grow Norton grapes on a large scale. Norton is of the family vitis aestivalis whereas European wine grapes are *vitis vinifera.* Concord is also a vitis labrusca grape but it makes a terrible wine with a foxy taste that the French call the goût de renard. But with proper respiration of acid with vigilant canopy management, and a long time in the cellar to dissipate its heavy tannins, Norton makes an extremely heavy red wine that many people have learned to love. Jennifer McCloud of Chrysalis Vineyards has built upon the work of Dennis Horton to promote Norton and sells her reserve Norton for $35. She also sells a whole-cluster-pressed Norton that should have less astringency since there is less skin contact.

It would appear that Dennis knows no geographical limits to where he will go to get grapevines for his vineyards. He is even growing Rkatsiteli in front of his cellar in Barboursville. That is a white grape from Georgia in the former Soviet Union. The wine writer Hugh Johnson says wine was first made in Georgia near the Crimean Sea some 3,000 years ago, so it's ironic that the Georgian grape has made it to what is perhaps the world's newest, highly acclaimed winegrowing region: Virginia. In 2002, it had no fruit at all because like so many other wineries all the buds were killed by the May 23rd frost.

Of more interest to more traditional wine drinkers is Horton's emphasis on the Rhône valley varieties Grenache, Syrah, and Mourvèdre. If your winery is located in Avignon, France and you blend these three varieties you have the much-acclaimed Châteneuf-du-Pape wine. The Hortons call their Rhone style Blend "Stonecastle Red" and mockingly call it "Châteneuf-du-Virginia" on their web site, although the French would write "Virginie" with an "e" and not "Virginia" with an "a."

Sharon and Dennis Horton also grow the traditional Bordeaux and Burgundy varieties at their vineyard, but Dennis refuses to grow Cabernet Sauvignon believing that it won't properly ripen in Virginia since that variety requires such a long growing season. One of their best wines is the 1998 Cabernet Franc. It won a gold medal at the Virginia Governor's Cup. This wine is mainly Cabernet Franc with some Tannat mixed in as well.

One might wonder where Dennis Horton gets all the cuttings to graft onto his grape vines. After all you cannot call up a California or New York nursery and order plants that no one in California nor New York has grown before. To plant new grapevines you don't start with seeds. Rather you take cuttings from vines just after harvest and then graft them onto phylloxera-resistant American rootstock.

The Federal Materials Plant Service is an out-

crop of the famous California viticulture school, the University of California at Davis. Its *raison d'être* is to import plants from foreign countries that are not native to America. The goal is to control the imports in an orderly fashion and to keep nasty nematodes and other foreign pests out of the country.

The Horton's Berryhill vineyard is not located above the frost zone so it is subject to winter and frost damage. To rise above the cold weather and have an area more suitable for cold-sensitive varieties, the Hortons have leased a 27-acre mountainside between the towns of Orange and Gordonsville at Gibson Mountain.

This mountainside vineyard slopes easterly and is situated at 700 to 1,000 feet elevation. This is high above the frost-killing weather and subzero winter temperatures – the heavier cold air drains away below while it stays relatively warm higher up. Dennis and Sharon have leased this mountainside from a turkey farmer and have planted 27 acres of grapes there.

It's odd that the highest point in that area is a turkey farm. I can understand why the state police erected their radio tower there, but why would anyone want to raise turkeys on top of a mountain? Still, there they were: thousands of filthy, stinking birds all huddled together in a well ventilated but fouling smelling, enormous chicken

coop. When I wondered about this Sharon told me that a farmer had bought a nearby mountain and planned to bulldoze it clear of trees and then graze cattle. She was incredulous at that waste of space. Surely both spots are better suited to grapes that poultry farming or grazing cattle.

The mountain slopes of the vineyard are dotted with the grapes previously mentioned plus Petit Manseng, Sangiovese, Touriga Nacional, Tinto Cao, and Albariño varieties. Dennis has quite a lot of Petit Manseng. It is one of the French varieties recommended for Virginia by Virginia Tech. I like Horton's Petit Manseng because they make it as a dry white wine rather than a desert sweet wine which is the traditional way that Petit Manseng is made in France. Petit Manseng is native to the Pyrennes Mountains that straddle the border between France and Spain.

The Cellar

Among Virginia's many wineries, Horton is unique because its size. Most Virginia wineries are small; Horton, however is very large, producing 35,000 cases of wine per year. You can find Horton wines for sale at Giant, Safeway, and other grocery stores. You can find Horton wines for sale in New York City. A big winery like this requires a big wine cellar. Mike Heny is the winemaker at Horton and consequently lords over this sprawling

labyrinth of barrels and tanks.

Educated at the nearby University of Virginia, Mike favors the music reviews of Alex Ross and the essays on finance by James Surowiecki in the highbrow New Yorker magazine. Tall and athletic, Mike can usually be found climbing onto the catwalks above the lumbering 3,300 gallon stainless steel tanks at the winery. His dexterity meshes neatly with the requirements of the job, for winemakers do much more physical work than the average wine drinker might imagine. While Mike does spend time tasting wines and making decisions to fine-tune their flavors, he also operates the forklift and keeps the barrel cleaning and other machinery in working order. A winemaker must be part mechanic for there is much equipment to maintain. When one stainless steel tank full of Viognier sprang a leak, Mike improvised and plugged the leak with a toothpick. Throughout the day he opens valves on the tanks or uses a wine thief or siphon tube to sample any of the 30 plus wines that he makes. After tasting the wine he spits it onto the floor which is what winemakers are supposed to do.

Mike started his career like so many aspiring winemakers as a "cellar rat," so to speak. A "cellar rat" does much of the manual labor in the cellar. The name might refer to the worker crawling among the tanks and barrels perhaps like some

kind of rodent. He worked for Archie Smith at Meredith vineyards from 1991 to 1996. Having graduated to the glorified ranks of winemaker, Mike has his own cellar rats under his purview. Horton's cellar rats are Joe Jackson, Joachim Velasco, and the recently added Milton Cortes.

Joe Jackson has been working at Horton Winery for two years. His job is basically cellar labor but he has learned much about winemaking working side-by-side with Mike Heny. Joe is a funny chap, a bit rough around the edges, but an honest hard-working fellow when he shows up for work. He always has a cigarette dangling from his lips. Joe owns a few acres of land near the winery. When he bought his house it included a tangle of Niagara, Delaware, Catawba, and fox grapes that had been swallowed up by weeds and the lack of pruning. So Joe set about the task of revitalizing this American native variety vineyard. These are not the kind of grapes that winemakers use to make fine wines, but it gave Joe something to do on the weekends and let him explore the world of viticulture. With both viticulture and enology at his fingertips Joe could have been labeled a budding assistant winemaker or perhaps an apprentice vineyard manager.

Horton hosts an annual event where they serve smoked pork barbecue. Dennis has an enormous open-pit cooker that is mounted on wheels

and parked behind the winery. Joe Jackson was cleaning up from the annual barbecue event when he let the lid come crashing down on his hand. He broke it in three places. Ouch.

Joachim Velasco, a 21-year old boyish young man from Mexico, was laid off from his job at Technicolor in Charlottesville, so he drove onto Horton Cellars and stopped Sharon Horton on her tractor and asked her for work. He was promptly hired and put to work helping Joe in the cellar. Joachim came to Horton with no experience but soon he knew how to move barrels with the pallet jack, operate the wine pumps, drive the forklift, and had learned which valves to turn to open the giant wine holding tanks without spilling the contents onto the floor.

Milton Cortes is the most recent addition to the cellar. His sister is married to Joachim. He too was laid off from the CD manufacturing in Charlottesville firm Technicolor. Milton speaks little English, much less than his brother-in-law.

Dennis Horton owns the winery with his wife. Of course, he does not work as a cellar rat. Monday through Thursday's Dennis works at his other business, but on Fridays through Sundays he can usually be found chatting up the tourists in the tasting room and cooking lunch for his tasting room staff. Mike says that he designs the labels for the wine bottles. Dennis knows viticulture well

and can talk about the nuances of raising grapes in Virginia. He has personally picked the grape varieties for his vineyard and like many Virginia winery owners has his own opinions about which grapes work best for Virginia. As far as making wine, Mike says that Alan Kinne, the former winemaker at Horton, set the winemaking style years ago. He and Dennis together decided which wines to blend together and the result is the wine list that is still in place today.

Outside of the harvest season, working in the winery is not always exciting. There is much hard work. It's cold and damp there. And your hands and clothes get stained bright purple by the end of the day. Contrary to the scenes depicted in the movies, there are no scantily clad females crushing grapes with their elegant albeit purple bare feet. Rather a typical day is spent doing such mundane tasks as painting barrels with mildewcide. New oak barrels are painted to keep the oak from getting stained by red wine and to prevent mildew from growing on the wood.

One of the frequent tasks in the winery is to filter wine. This is done before a wine is bottled on most occasions. First you fill a tank with carbon dioxide to displace the oxygen. Then you use a portable pump to pump the wine from barrels into the tank. On the way to the tank, the wine passes through the glass plate and frame filter. The

pores of the filter are 0.5 microns. This size it is so small the filtering is called a "sterile fertilization" because bacteria and other noxious pests are swept from the wine thus making it sterile. Wine with insufficient acid can spoil in the bottle. This is why wines are filtered. Some winemakers say it takes away taste as well. Other winemakers and textbooks say it does not.

Another task is to stir the lees in barrels. Mike asked me to do this one day. I stood there and looked up at 55 gallon oak barrels piled as high and as far as I could see and wondered if I might not be too old for this particular task. But I attacked it with abandon and was soon stirring lees merrily – all the while wedging myself between the barrels and the concrete was so I would not fall to my death. Lees are stirred with a golf-club shaped device called a dodine.

Aging the wine on its lees is called in French sur lies. Lees are the residue that results from fermentation. Basically it's dead yeast cells. Mike said that stirring the lees would aid the fining process. Fining means to make an otherwise cloudy wine clear. And stirring the lees would retard and help prevent oxidation, which can spoil a wine.

Cleaning barrels is another typical daily task in the winery. Home winemakers are warned not to use oak barrels because keeping them sanitary is especially difficult. An empty barrel invites spoil-

age and bacterial infection. So the winemaker tries to keep the barrels full at all times. Wine is racked from one barrel to the next to remove the wine from its lees. It is siphoned rather than pumped so that the sediment in the bottom of the barrel is not disturbed. When you rack a wine in this manner you are left with an empty barrel, which must be cleaned.

To clean wine barrels, Horton cellars uses a kerosene-powered pressure sprayer. The barrel is turned upside down and the bung (rubber stopper) is removed. Water is heated to very hot temperatures and then sprayed around inside the barrel for 10 minutes by a whirling apparatus. Citric acid can be added for further sanitation. Some winemakers burn sulfur candles inside the barrels.

You cannot say you have experienced working as a cellar rat unless you have cleaned a tank from the inside out. Basically you climb inside with a water hose and waterproof boots, someone closes the door, and you stand there with a coal miner helmet light and clean the tank. First the tank is scrubbed with soda ash then is it scrubbed again with citric acid. Soda ash is high in pH (meaning it is alkaline). It will dissolve tartaric crystals. After washing with high pH you use citric acid to wash away the low pH residue.

Winemakers for hundreds of years have added sulfur dioxide to wine. When Mike does this, the

smell tends to fill up the cellar. It is quite noxious to the nose. All wines contain sulfur dioxide. That is why it says "contains sulfites" on the bottle. Evidently this can cause problems for some people with asthma. Sulfur has been used in the winery to kill unwanted organisms since the time of the Romans who used sulfur candles to clean their empty barrels.

The cellars at Horton are laid out in three areas with a storage warehouse, tasting room, and offices on top. In the middle are two rows of huge stainless steel tanks. These are used to ferment wine or hold it as it passes from one step to the next. To the right are three cavernous rooms that hold hundreds if not thousands of barrels each costing $300 or $600 apiece. (French oak costs more because the trees in the forests of France grown more slowly than American oak tree. That plus the lesser number of planted acres is why the wood is so expensive. Also French wood must be split by hand to make staves while American wood can be split by machine.) Above the tanks are catwalks where Mike can gain access to the top of the tanks to fit fermentation locks or otherwise peer into the tank.

The tanks themselves are handsome in their practical elegance. Each is perfectly balanced on adjustable feet so that when emptied for cleaning water will spill onto the floor. The floor is

244

perfectly made with a gentle slope so that water will rush down into the drains and not remain standing. The tanks have various doors and valves positioned at strategic heights. When the tank is full of wine, the winemaker can open the smallest, uppermost valve to let it tickle out into a glass where it can be tasted. Below that are other valves. One is designed so a huge drill can be inserted to mix the wine much like a blender. The valve at the bottom is where special wine pumps are attached. And finally there is a door where the winemaker can peer in and see how much wine remains in the tank. The door is also used to rack wine because you can look inside and see when the wine is gone and only the lees remain. Of course you would not want to do that when the wine tank is full, so there is a valve just above the height of the door. If you crack that open and wine trickles out then you know that the wine is above the height of the door.

The tanks are insulated with glycol, which is cooled by refrigeration, and pumped about the tank to regulate the temperature. The whole cellar is mainly underground so the temperature of the earth keeps the cellar rather cool. Still air conditioning is needed when the doors are kept open. The cellar generally remains at 60 degrees or colder.

On the left-hand side of the wine cellar is Mike's testing lab. There he has all the various gadgets, which are used to measure a wine. A bal-

anced wine must have proper levels of acid, pH, sugar, and alcohol. So there are various devices to measure these. The simplest is the sacchometer, which measures the sugar content of a liquid. It's kind of like a thermometer. You drop it into the wine and a floating level indicates the percent of soluble solids or sugar. To measure the pH of the wine Mike has a pH meter. Simply stick it into the wine and turn it on. More expensive is the ebulliometer, which measures alcohol by calculating the difference between the boiling points of water and alcohol. Free sulfur dioxide (SO2) is measured as well as is malic and tartaric acid. If there is some measurement for which the winery does not have the equipment then they can send off a sample to Dr. Bruce Zoecklein at Virginia Tech's department of enology and he will measure it there.

Horton, like most Virginia wineries, does not have its own bottling equipment. This is a highly specialized machine that costs a lot of money and requires constant maintenance. So rather than pay $250,000 for something that the winery might use only a few weeks per year, Horton engages the services of the mobile bottling line.

A mobile bottling line is a bottling line cleverly stuck into the trailer of a tractor-trailer truck. One could characterize it thus: you pump wine into one end of the truck and from the other end out pops a filled wine bottle with label, capsule, and cork.

That is the theory, but in actual practice like all things mechanical there is the inevitable snafu.

In the waning days of August, when Horton Cellars was waiting for the harvest to begin, Michael O'Donnell of Cellar Door Services set up his bottling rig at the door of the Horton cellar. As owner of the business, Michael did not look like a cellar rat. He motored up in his Mercedes Benz. To the front bumper was attached a sticker from the Middleburg Hunt, the fox hunting club in the wealthy enclave of Middleburg. Middleburg is perhaps the richest rural village in all of Virginia. It is home to the leisured classes – heirs and heiresses, arms dealers, and newspaper publishers. Even the Safeway grocery store there has brass fixtures for lighting. The common theme among the citizenry there is their love of horses. It, like much of the surrounding area, is part of what they call "The Virginia Hunt Country." A woman I know, Louisa Woodville, who writes for "The Washington Post," lives there and she has two horses. No serious foxhunter would own simply one horse when two would do.

Fox hunting is an elegant and ancient sport widely practiced in those two bastions of English genteel manners: England and Virginia. Yet the English middle and lower classes, in their jealously of the Prince of Wales and all his buddies, recently tried to ban this elitist sport. That would never

happen in Virginia for the state constitution guarantees the right to hunt all game regardless of the ruminations of the Environmental Defense League or the English working class.

Shakespeare best summarizes the elegance and daring of fox hunting in his long lyrical poem "Venus and Adonis."

> But if thou needs wilt hunt, be ruled by me:
> Uncouple at the timorous flying hare,
> Or at the fox which lives by subtlety,
> Or at the roe which no encounter dare.
> Pursue these fearful creatures o'er the downs,
> And on thy well-breathed horse keep with
> thy hounds.

248

But Michael was no member of the idle rich class (MIRC) – this is how George Bernard Shaw characterizes rich people in his play "Man and Superman." Chris Pearmund, owner and winemaker at Pearmund Cellars, had talked Michael into setting up a bottling line. Prior to Michael's arrival on the stage, wineries had to make reservations with the bottling line six months in advance to engage the service of the only other bottling line operating in the state. So the winery bottled wine at the bottler's convenience and not the wineries. The other guy's schedule was still full of reservations I am sure but Michael aspired to make a dent in his customer list.

The bottling line is a marvel in its complexity. When Michael bought and assembled it he needed to go somewhere for training. For this relatively benign machine can be dangerous with its various gases, steams, and many moving parts. So Michael flew off the Australia to work for free for two weeks on a similar rig.

The mobile bottling line is like a miniature Coca-Cola plant except the raw material is not Cola syrup. It is, of course, wine. The winemaker attaches a hose from a stainless steel tank to a floor pump, which is connected to the truck. The pump has a float valve. When the valve is open wine is gently pumped from the tank in the cellar into the bottling truck. If the winemaker wants the wine filtered then the wine flows through two PVC pipes, which have filters, stuck inside. The mesh of the filters is so fine at 0.5 microns that they effectively sterilize the wine thus keeping it from spoiling in the bottle.

Two men stand at the end of the bottling line. Pallets of empty wine bottles are lined up at the back of the truck. You pick up a box of bottles, which are opened on the bottom. Then you crash them down onto a rubber pad where the wine bottles fall out and miraculously do not turn over. Then you nudge them forward onto a conveyor belt. Gentle rubber feet push the bottles forward and they line up in an orderly fashion.

Each size and shape of wine bottle requires custom-fitted star and worm gears to push the bottles through the apparatus. Michael says one set costs $6,000 and he needed a different set for each different type of bottle used by his customers. At the beginning of the line the star and worm gear pick the bottle up and turn it upside down. Filtered, sterile water is squirted into the bottle to remove any dust or debris. Then compressed air is blasted into the bottle to dry it out. Next a tube moves down and fills the bottle with a puff of nitrogen gas. Nitrogen like carbon dioxide is heavier than oxygen so it is used to keep wine-spoiling oxygen out of the bottle.

The bottle is pushed down the line by the star and worm gears where it is filled with wine and a cork is pushed in. (A cork is the bark of a cork tree. To insert it into the bottle the corker compresses the same.) The bottle is held upright by moveable rails that must be adjusted for each new bottle size. After the bottle is filled with wine and corked, a capsule is snapped onto the top and then crimped tightly shut. (The capsule is the top part of the wine bottle that covers the cork. Its main function is decoration. The capsule gives the bottle an elegant look more handsome than a cork all by itself.) Next the label is attached to the bottle – one on the front and one on the bank. Finally the bottle makes the long trip back to the rear of

the truck on the conveyor belt. There a worker stands and stuffs the bottles into cases as fast as he can. It is sometimes difficult to keep up as the bottling line operates at 200 cases per hour.

Once the machinery is running, wine is bottled at a rapid clip. But much time is consumed when winery changes from one batch of one to another. Then the rails and star and worm gear must be adjusted or changed. Also the entire machine is steam-cleaned so everyone must wait for the machinery to cool off before bottling begins anew.

That in theory is how the bottling line is supposed to work. But on the day when I first saw Michael's rig in action there were some problems. Mike Heny wanted to bottle port into an oddly shaped bottle. It's lines were like Sophia Loren – wide and the hips and chest and slender in the middle. But the woman's narrow waste caused problems because the bottle, perhaps like Sophia herself, wobbled and it (she) wandered down the catwalk (conveyor). So the bottle would not stand still while the capsule and labels were applied. Bottles came around the curve with either no capsule at all or a capsule that was badly wrinkled. And instead of having two labels, wine bottles came down the ramp with one, two, three, of even four labels attached. Surely the government would be happy, because the warnings against drinking

alcohol while pregnant were plastered all over the darn thing.

This clearly would not do. Michael O'Donnell fiddled with his contraption for a couple of hours and finally Mike Heny told him to give up. Joachim, Joe, and Milton would glue the labels on by hand at some later date. That would take many days for 500 cases were to be bottled. Still there were 300 cases of a Chardonnay and Viognier blend to bottle and we were running out of time.

The odd thing about the Chardonnay and Viognier blend was that it was being bottled under the label of a restaurant or hotel. They did not provide any labels so the poor workers there would have to do the same thing albeit at their facility. So we bottled 300 cases of wine sans labels yet again.

Bottling, like the harvest is a tiring and long ordeal. Michael would be at Horton for one entire week. Each day they would work from 8 in the morning until 8 at night. For his services Mike would collect $1,500 per day or $1.85 per case – these are his starting prices. But when he paid his one worker and recorded the cost of buying, maintaining, and operating his machinery that fee hardly seemed profitable.

The one irony I noticed about the whole bottling affair was its international flavor. We were using largely Italian bottling equipment to pour Virginia wine made from French grapes into

bottles made in Canada. Two of the men laboring with us were Mexican.

The Hurricane and the Harvest

The harvest at Horton Vineyards began on Wednesday, September 17, just two days before Hurricane Isabel was set to race up the East Coast and plough across North Carolina and Virginia. This year had been a tough one for Horton Vineyards as it was all across Virginia. It had rained practically non-stop since spring. All these cloudy days and too much rain had delayed the harvest by about three weeks. And now Dennis and Sharon Horton had a hurricane to contend with.

A Hurricane is not a problem as far as winds are concerned. Some leaves were ripped from the grapevine canopy but this time of year the vines are beginning to shut down anyway and leaves were just starting to fall off as they do every fall. A really big wind could strip the vines of all leaves and leave the later-ripening red grapes without the foliage they needed to ripen the fruit. To make matters worse, this year would see a record early frost on October 2. That would stop growth entirely, make the leaves fall off, so whatever remained on the vine would have to be harvested right away.

The day before Hurricane Isabel was blissfully beautiful even as the radio warned of the

impending storm. I was incredulous that none of the *campesinos* working in the vineyard, none of the Mexican men working at the winery, and none of the migrant workers at Barboursville Vineyards across the street knew anything about the approaching huracán. Even though Joachim and Milton listened to the Spanish language radio station, 94.3 FM, all day long at the winery they were oblivious to what was bearing down. My grandmother lives on the coast of North Carolina. Two years in a row the roof blew off her house and then Hurricane Fran destroyed it completely. My father and brother had both been tugboat captains. My father once sailed into San Juan harbor with the barge he was towing racing in front of him instead of following aft as it surfed on 50-foot waves. And my brother had broken a collarbone when the barge he was towing broke the tow wire. The barge floated onto Fort Lauderdale beach and its photograph made the front page of the newspaper. My mother's second husband had a farm on the coast of South Carolina. When Hurricane Hugo hit, all 200 acres of pine trees were snapped off head high and the trailer home where our caretaker lived floated away. Water had risen up to the roof of our house. So I was well aware of what was coming even if we were farm from any concerns about waves or storm surge.

Sharon Horton's crew leader, Tony Beazo, lives

in a trailer at Horton's Berryhill vineyard. When he drove up to the winery with some 14 tons of grapes on Wednesday I suggested to him that he and his wife should go somewhere else to ride out the storm. Mobile homes are the first dwellings to fly off their foundations in the face of hurricane force winds.

The second day the weather turned ominous and finally the Spanish radio station began to talk about the hurricane. I came to the winery with a sleeping bag, many flashlights, and an electric lantern. I thought I would sleep at the winery since we would work until 10 o'clock at night and I did not want to drive in the storm. The weathermen said by four o'clock or so we would have 50 mile per hour winds and they would increase to 70 miles per hour at 9:00 PM. Mike had moved the giant bladder press into the middle of the winery floor so that we could work even in the heavy rain. By two o'clock it was difficult to stand atop a platform and dump any more grapes into the press because the wind was so fierce. At 3:00 the power winked off. Dennis Horton had called Mike earlier that day and told Mike to turn down the temperature on the insulated tanks to 30 degrees. Then if the power went off the Chardonnay juice which we had processed the day before would not get too warm. (Dennis explained that the juice would not actually freeze because of the large volume to

surface ratio.) But there was nothing that Dennis could do to protect the 30 tons of grapes which we had loaded into two refrigerated tractor-trailers. So when the power went off for the second time Mike and Dennis decided to close up shop and send everyone home.

This was a problem for me. I certainly did not want to sleep in the winery with no electric power. But neither did I want to drive home in the steadily increasing winds. Already trees were beginning to fall and the driving rain made it difficult to see. So I drove 51 miles to my 65-acre farm in Rappahannock County anyway. As I got close the last mile was nearly blocked by trees that had fallen across Scrabble road.

I climbed my 0.4-mile drive in my truck and then went into my house. Luckily I still had electric power and would not lose power during the whole storm. Horton Vineyards winery lost power shortly after I left and it did not come back on for four days. Overall some 1.8 million people in Virginia lost power and 200,000 still did not have power some 12 days after the storm had passed. Of course my Internet had gone off-line since my satellite dish could not penetrate the rain and even my DirectTV signal went out. So I sat there in the howling rain talking to my girlfriend on the phone. I walked outside and watched the first of eight trees that would fall down around my house

gently lean over and then sag to the ground. The second tree that fell came down with a crash. I covered my head and ducked as it smashed against the ground. I had known this tree would fall so I parked my car in the pasture away from any trees. Sure enough that pine tree came down where my car would have been parked. My house shuddered so violently in the wind that I thought it would fly off its foundation. When I went to bed there was one tree looming dangerously over my house. When I woke up the morning it was gone – it had miraculously fallen the other direction and missed my house completely.

At 2:00 AM on Friday, September 19 the eye of Hurricane Isabel passed just north of Charlottesville within just a few miles of Barboursville with sustained winds of 60 MPH. Gusts were even higher. Then the hurricane continued on a Northwest course over Greene, Page, and Shenandoah counties. In Rappahannock Counties the weather station at Rappahannock high school registered a gust of 58 MPH. Unofficial estimates of the rainfall were four inches that day.

Back at the winery Dennis Horton had two tractor-trailers of grapes to deal with and no electricity to power the refrigeration. So he unloaded these quickly by selling them to Chateau Morrisette for the give-away price of $800 per ton. The power did not come back on at the winery

until Sunday afternoon. Dennis somehow got a diesel-powered generator and Mike used it to pump some Chardonnay juice from its precipitated residue – i.e. the pulp that had settled on the bottom. The juice in the insulated tanks was kept cool because the wine cellar is below ground for the most part and Mike kept the doors closed.

Before the storm upset our plans, we processed many tons of grapes. Mike had taken the enormous bladder press out of its plastic wrapping and positioned it under the outdoor canopy at the winery. He had stacked pallets high into the air so that one worker could stand on top and dump grapes inside. Two other workers would stand below to catch empty harvest lugs, wash them, and then stack them empty and upside down onto pallets. Then they would go back into the vineyard and be filled anew with fruit.

There were only three people to do the work: Joachim, his brother-in-law Milton, and me. Mike had fired Joe Jackson that morning because he failed to show up on this, the most important day of the year. The first grapes that we processed were called Chardonnay lot number two from the mountain vineyard. Mike says he likes this fruit because is neutral and subtle and not what he calls "buttery." The *campesinos* had picked 14 tons of this fruit the day before. It was neatly packed into harvest lugs, loaded onto pallets, and put into

refrigerated tractor-trailers. This was so the fruit could be cooled to preserve their aroma until we could catch up with the picking crews and process the grapes.

Joachim, Milton, and I took turns climbing atop the bladder press to dump harvest lugs into the top. It's back-breaking work and perhaps quite dangerous. Later that day we were processing Marsanne grapes and Joachim let the press grab hold of his shirt. It promptly tore it in half. Mike shook his head and looked at us intently as if to say, "slow down, be careful."

Mike processed the white grapes in a manner called "whole cluster press." This means the whole cluster is dropped into the bladder press, stems and all, and the fruit is squeezed. The crusher, destemmer machine is not used at all. Winemakers use the whole cluster press technique to decrease skin contact with the grapes. The goal is to reduce phenolics (tannins) in the wine that can impart astringency.

As we loaded the wine press with 4 tons of grapes – that's how much it can hold in one load – juice began to flow freely even before the press was turned on. This juice is called "free run" juice and is on a good year the very best juice for making wine. But this year the white grapes had some sour rot. Clusters actually contained rotten fruit in the middle that tasted like vinegar. This juice is

squeezed out first since those grapes are the soft-
est. So Mike turned on the fruit juice pump and
pumped this into a waiting tank where it would
be separated from the better quality juice. Mike
added potassium metabisulfite to the grapes as we
processed them. This chemical produces sulfur
dioxide, which is an anti-oxidizing agent. This is
used the world over to keep white grape juice from
turning brown due to presence of oxygen.

Making wine is not exactly a totally auto-
matic process although for the most part it is
gently guided along by nature. Jim Law of Linden
Vineyards writes in Wine East magazine that his
approach to wine making is non-interventionist.
By this he means that if your work is done thor-
oughly in the vineyard then making wine in the
wine cellar is not complicated at all. Jim lectures
against what he calls "doctored wines." But in the
year 2003 the non-interventionist approach simply
would not work. That year there was constant,
record rainfall and, consequently, increased disease
problems. So Sharon Horton and other vineyards
had actually thrown away some fruit because it
was rotted. And much of the fruit that was har-
vested in Virginia was not totally ripe as it was in
the bright, sunny, and dry years 2001 and 2002.
So a trying year like 2003 is where the skills of the
wine maker and all his technical abilities are put
to us.

Of the 2003 vintage, Mike Heny said, "We can still make enjoyable products in these kind of conditions." The way he does this is to separate the good juice from the bad. He uses the same tools that most winemakers use to make this possible. The primary tools are simple gravity and, more complex, enzymes, food-grade acid, tannin, sugar, and other additives. Since I am not an expert enologist, let's turn to the catalogue from Scott Laboratories for an explanation. This is where Mike buys his yeast and other products needed to make wine. It reads, in part:

It is often said that great wine is made in the vineyard. It is equally true that a creative winemaker can elevate good wine to become great. European and winemakers in the Southern Hemisphere have long been comfortable using enological enzymes, specialty tannins, and other products to improve their wines. Recently North Americans have begin to work with such products. Creative winemaking requires involvement from the beginning. Science is used to enhance art, not replace it.

Because the grapes in Virginia would not be totally ripe this year, Mike and other winemakers would have to add sugar to boost the alcohol level in their wine. Wine that is too low in alcohol will not taste good and will be subject to spoilage. Yeast convert alcohol to sugar. When you add cane sugar to grape juice it is converted to fruc-

tose and glucose, which are the sugars present in grape juice. This process is called "chaptalization" and is practiced the world over. It is not allowed in California, but the weather there is such that the grapes are always ripe. And in Burgundy by law a winemaker can only add enough cane sugar to grape juice to boost the alcohol level by two percent.

Mike said his Chardonnay grapes were at about 19 percent Brix. Brix is a measurement of suspended solids in the grape juice. Since practically all the solids in grape juice are sugar this is almost equal to the percentage of sugar in the grape juice. Yeast ferment sugar into alcohol at a ratio of about 0.6. So 19 brix will make a wine of 11.4 percent alcohol. Winemakers want the alcohol in their wines to be in the range of 11 to 13.5 percent. Mike decides that this level is too low so he will add sugar to the wine.

The science of choosing the proper wine is as complex as other aspects of winemaking. After a period of years a winery is literally swimming in these microscopic creatures. So grape juice let to its own devices and not protected with sulfur dioxide will ferment by itself. But such yeast, so-called "wild yeast," are unpredictable. They can run afoul and produce noxious hydrogen sulfide gas (it smells like rotten eggs). So Horton Vineyards and other wineries buy yeast from the

regions of France where they have been grown and cultivated for many years. Each strain is different. Some is used just for champagne. Some are used to make the high alcohol Zinfandel wines found in California. A lot of their names are pleasant, like "Montrachet." Other yeasts are simply known by a combination of letters and numbers.

Regarding the CY3079 yeast, The Scott Labs manual reads:

> CY3079 was isolated by the Bureau Interprofessional des Vins de Bourgogne (BIVB) with the objective of isolating a strain that would complement typical white Burgundy styles. It is a steady, slower fermenter even at cooler temperatures (13 degrees C/ 55.4 degrees F). When properly fed, CY3079 demonstrates good alcohol tolerance and low production of volatile acidity and hydrogen sulfide. It is highly recommended for barrel fermented and sur lie aged Chardonnay. CY3079 releases peptides at the end of fermentation that are believed to enhance aromas such as fresh butter, honey, bright floral and pineapple. Tasting of both CY3079 tank-fermented wines from cool regions and CY3079 barrel-fermented wines from warm regions show richer, fuller mouthfeel compared to other strains.

When the Chardonnay juice is first pumped into the tank the goal is to chill it off and then let the pulp and other suspended solids settle to the bottom. The Chardonnay is chilled to 47 degrees. Wearing short pants and rubber boots. Mike adds enzymes to the Chardonnay juice to help with filtration. Basically that means it speeds up the process of precipitating solids that cause the juice to be cloudy. Once they precipitate, gravity takes over then they settle to the bottom. The Scott Labs manual says the goal of enological enzymes is they are "catalysts that facilitate and increase the rate of chemical reactions. Enological enzymes are used to accelerate natural reactions. These added enzyme activities supplement the lower levels naturally present in wine."

To the free-run Chardonnay juice Mike adds Scottzyme KS enzyme and to the press juice he will add Scottzyme Color Pro. (It's called "press juice" because it is of a different grade having been squeezed from the grapes. As said before, free-run juice is the juice that falls freely from the bladder press under the weight of the other grapes and before the press is turned on.) For both, he will ferment them with the yeast CY3079.

The Scottzyme KS enzyme is a "special prod-uct for difficult to settle or hard to filter juices or wines." Scottzyme Color Pro is used to "create wines that are rounder in mouth feel, bigger in

structure and with improved color stability. Wines made with ColorPro tend to have increased tannins, improved clarity and reduced herbaceous or 'veggie' character."

On the first day of harvest, we processed 13.5 tons of Chardonnay and some Marsanne. Mike says one ton of fruit will produce 650 liters of juice, which is 171.6 gallons. We are pumping juice into a 2,250-gallon tank. Mike says it would overfill and require a second tank. Punching numbers into Mike's calculator I said it would not. One liter is 0.264 gallons so 13.5 tons of fruit should produce 2,316 gallons of juice but we pumped at least 200 gallons into another tank. At the end of the day the tank is almost full but not quite. So this boast from an absolute beginner, with a degree in mathematics, was in this case a correct, albeit lucky guess.

After the free run juice is collected, the bladder press is turned on, and we connect the hose to the 2,250-gallon tank. It is programmed to run for one and a half hours. Inside the bladder inflates with air and then the grapes are pressed against the side of the press and the juice is gently squeezed out. The first press is made at 0.2 BAR (2.9 psi), the second at 0.8 BAR (11.6 psi) and the final at 1.2 BAR (17.4). One BAR is 100 kilopascals or 14.5 pounds per square increase. For each run of the press the bladder inflates, deflates, and then ro-

tates. My job at this point is to man the fruit juice pump and make sure it does not pump air into the wine. In other words, I am to turn off the pump when it is not pressing the grapes.

When I came back the next week lot number two of the Chardonnay from the mountain has been pumped into barrels and stacked high into the air. Mike uses a combination of new and old, French and American oak barrels. Each barrel is fitted with a fermentation lock that lets carbon dioxide escape while keeping oxygen out. The 40 or so barrels of this wine and others are percolating loudly. It is an audible albeit please din.

The cellar of the winery was lined with barrels pleasantly percolating and row after row of fermentation bins. These bins were filled with red wine grapes that had been crushed, destemmed, and inoculated with yeast. Each bin contains about one ton of grapes. If you took the lid off you could watch the fermentation as bubbles pleasantly popped through the surface. I thrust my arm down into the must. It felt warm as fermenting grapes generated lots of heat. When I took my arm out it did not smell like grape juice; rather it smelled of wine. So after all this effort the grapes were beginning to resemble in some far-off capacity the finished product. Mike used a stainless steel plunger-type device to punch the grape skins that had floated to the top down under the surface.

Winemakers call this "punching down the cap."
The goal is to make sure the cap does not dry.

The next step is to put the fermented juice
and grapes (called "the must") into the bladder
press. Mike thrust a stainless steel sieve – that
had been invented by Shepherd Rouse, owner of
Rockbridge Winery – into the must and pumps
the juice into a stainless steel tank. Then Joachim
hoisted the bin of whole grapes and skins up to
the bladder press. Milton and I took turns shovel-
ing the must into the press. Then we pressed the
wine for a quick thirty-minute cycle. It was not
necessary to press this for two hours, as we did
with the white grapes, since the grapes had already
been softened up by fermentation. The juice we
pumped back into the same stainless steel tank and
the skins we threw onto the compost pile. To the
compost we added line and then spread it back
into the vineyard as fertilizer.

Tony brought more grapes from Horton Vine-
yards and other drivers pulled up with grapes that
Dennis had bought from other growers. It was
backbreaking work as Milton, Joachin, and I took
turns dumping the harvest lugs of Touriga Nacio-
nal, Pinot Tage, and Tempranillo red wine grapes
into the crusher destemmer machine. Mike turned
off the crushing part of the apparatus. He said
it mangled the grapes too badly so he preferred
simply to pop the grapes free of their stems. The

grapes fell into fermentation bins, which Mike moved into the wine cellar with the forklift.

Back in the laboratory Mike is continually measuring the pH of the wine with the pH meter. If the pH is too high then the wine can spoil in the bottle, so Mike ads tartaric acid to correct the pH level. Tartaric and citric acid are added to many juices and other products that you buy in the store. It makes the wine taste pleasantly tart if the acid level is correct. Horton has many bags of tartaric acid in the winery most of which comes from Italy. The instructions are written on the package in a dozen languages illustrating that winemaking is a truly global endeavor.

Mike is frustrated when the pH meter quits working. He washes the electrodes with ordinary tap water. (Distilled water has disappeared from the stores as the public hurriedly bought it all up before Hurricane Isabel ruined all the city reservoirs.) But he gets the pH meter working again by taking parts from another machine. His mood brightens visibly when his wife Natasha and his daughter Sophie come to visit. Sophie squeals with delight when Mike dips a wine glass into the Viognier juice that we are processing and the little girl sips it.

October 2; an early frost settled across much of Virginia including Orange and Madison counties. The leaves on the grapevines shutdown and by

October 10 they had fallen off. Without leaves the grapes could not get any riper so Horton Vineyards was working to gather in the rest of the harvest.

By October 10, Lorenzo Natividad and a new vineyard worker, Jesus, joined Mike, Joachim, and Milton in the winery. Mike estimated that Horton had 20 percent of the vineyard left to pick or some 60-plus tons of grapes. The entire winery was chock-a-block with fermenting grapes and young wine. Some barrels had even been moved out to the tractor-trailers outside both because the cellar was crowded and Mike could drop the temperature way down out there.

On this day, red wine grapes pass through the destemming process at a rapid clip. Tinto Cao, Nebbiolo, Grenache, and Syrah grapes are destemmed and collected in fermentation bins. These grapes taste sweet and appear to lack any blemishes or rots from the rainy season. They look positively prim. Mike says they do have a little Botrytis, which was culled out at the vineyard. There is no sour-smelling fruit – the grapes appear well nigh perfect. Certainly the *campesinos* like it for they are eating grapes all day long. One thinks they might have grown weary of grapes having worked with them non-stop for many days on end.

Mike is working with some Petit Verdot that he has pumped directly from the crusher-destemmer into a large insulated tank for six days of "cold

soaking." This means the grapes are collected whole, cooled and allowed to sit for three days before yeast is added. After 6 days the fermenting grapes are racked into another tank and then into waiting barrels. The goal of the cold soaking is to extract as much color and flavor as possible.

Mike also pumps Tannat from one tank to another, in order to rack it from its Lees then pumps that into barrels. It's easy to see how the wine is separated from the dead yeast cells because a thick goo forms at the bottom. This we dump down the train and then wash out the tank with water. The young Tannat wine tastes tart which is how young wines are supposed to taste.

Row after row of Viognier and Rkatsiteli grapes are fermenting in barrels stacked high into the air. The Mexicans don plastic bags as jackets as they hoist even more fruit into the front-end of the process. Mike is again eating tortillas for lunch having embraced the Mexican cuisine as well as its workers. He speaks to Lorenzo in Spanish telling him to hose down the floor. Mike moves from one wine to the next adding tannin to one batch and enzyme to another.

I go upstairs and gather a dozen wine bottles, pack them in a case, and ask Sigrid, who works in the tasting room to give me the employee discount. I asked Dennis to sell me some of his 2001 Viognier even though his 1999 vintage is cur-

rently what is offered for sale. The 2001 Viognier is flawless; it tastes of kiwi, smells wonderful, and has pleasant acidity. I also bought a bottle of Petit Manseng. This wine tastes and smells of honeysuckle. I also buy more of the 1998 Cabernet Franc and 1999 Nebbiolo.

I leave Horton for the final time, having worked there for six months. I have loaded the back of my pickup truck with grape skins to toss onto my compost pile. I go by the Food Lion on the way home and leave the grocery spilling red wine onto the parking lot.

About the Author & Cover

Walker Elliott Rowe is a freelance writer and hobby wine grape grower living in Rappahannock County, Virginia. His wine writings have appeared in *Wine Business Monthly*, *Richmond Times Dispatch*, *Wine and Cuisine*, *The Virginia Wine Guide*, *The Virginia Wine Gazette*, and *The Rappahannock News*. Rowe has spent the last three years visiting the vineyards in and around Virginia; attending seminars, meetings and training; planted his own Bordeaux, Rhône Valley, and American hybrid wine grapes; and worked for six months at Horton Vineyards with Mexican migrant workers to understand the craft of the winemaker and grape grower. Born in South Carolina and wide-

ly read, Walker Elliott Rowe has an understanding of the culture of the South and weaves anecdotes of the Civil War and Southern idiosyncrasies into his narrative style of writing.

About the Cover

The photo on the front cover was taken by Chrysalis Vineyards proprietor Jennifer McCloud on the morning of Chrysalis' first harvest. It's titled "First Harvest Morning."

The photos on the back cover include Barboursville Vineyards, the *campesinos* and staff of Horton Vineyards, Ingleside Vineyards, and photos of grapes from Chatham Vineyards.

Special Thanks

Apprentice House would like to recognize the following publications for allowing us to reprint Mr. Rowe's articles:

Rappahannock News
The Virginia Wine Gazette
Wine and Cuisine
Wine Business Monthly

Printed in the United States
57889LVS00001B/58-75